THE COMPLETE ETCHINGS OF REMBRANDT

Reproduced in Original Size

Rembrandt van Rijn

EDITED BY
GARY SCHWARTZ

DOVER PUBLICATIONS, INC.
NEW YORK

Bibliographical Note

This Dover edition, first published in 1994, is an unabridged, slightly corrected republication of the verbal text of the work originally published in 1977 by Oresko Books Ltd., London, and Gary Schwartz, Maarssen, as *Rembrandt: All the etchings reproduced in true size*. The illustrations have been reproduced in their entirety from the second edition, 1988, of the Dutch-language edition of the same work: *Rembrandt: Alle etsen op ware grootte afgebeeld*, published by Gary Schwartz/SDU, Maarssen/'s-Gravenhage (first edition, 1977).

Library of Congress Cataloging-in-Publication Data

Rembrandt Harmenszoon van Rijn, 1606–1669.
 [Rembrandt]
 The complete etchings of Rembrandt : reproduced in original size / Rembrandt van Rijn ; edited by Gary Schwartz.
 p. cm.
 "Unabridged, slightly corrected republication of the verbal text of the work originally published in 1977 by Oresko Books Ltd., London, and Gary Schwartz, Maarssen, as Rembrandt: all the etchings reproduced in true size"—T.p. verso.
 Includes bibliographical references.
 ISBN-13: 978-0-486-28181-0
 ISBN-10: 0-486-28181-7
 1. Rembrandt Harmenszoon van Rijn, 1606–1669—Catalogs. I. Schwartz, Gary, 1940– . II. Title.
NE2054.5.R4A4 1994
769.92—dc20 94-27405
 CIP

DESIGNED BY ALJE OLTHOF

Manufactured in the United States by Courier Corporation
28181708
www.doverpublications.com

Contents

A note on this book

This edition of Rembrandt's etchings is exceptional in two respects: it is the first complete publication of the etchings in our century to reproduce all the prints in their true size, and it offers for the very first time a set of reproductions made (with a few exceptions) not from photographs but from the originals themselves. The importance of studying the etchings in full-scale rather than reduced reproductions will be immediately apparent to anyone who opens the outsize sheets appended to this volume and compares them to the reduced illustrations of the same works in the pages of the book. The gain in quality achieved by making the reproductions from originals rather than photographs may be less striking, but it made it possible to reproduce the etchings with next to no correction of the litho films and to achieve, with the simplest of means and at a very reasonable price, a standard of quality that could never be attained from even the best photographs, which always depart from the original in some way, if only in size, texture and the fineness of the finest lines.

The basis of the present edition was formed by the outstanding and little-known group of Rembrandt etchings belonging to the Teylers Museum in Haarlem. This 19th-century collection was put together with considerable feeling for quality in a period when a discerning buyer could still shop the market for first-rate impressions. The character of that collection determined to a large extent the character of this book – the impressions singled out tend to represent the ripest visual qualities of each plate, rather than its experimental side. The Teylers group includes an abundance of fresh, clean impressions of mature states, marked by rich contrasts and brilliant printing. The selection for this book is guided by the principle underlying that classical collection – showing each plate in its fullest pictorial form. Exceptions to the rule were allowed in order to illustrate a few early trial proofs, of B 149 and B 232. The less than finished prints in the book were either never finished, or reached their final form in the hands of someone other than Rembrandt.

Two hundred nineteen impressions meeting the required standards were to be found in the Teylers Museum, giving the present edition the further value of being the first extensive publication of that collection. In general, preference was given to Teylers impressions, except where a much better quality was to be found in the printroom of the Rijksmuseum. This far larger collection, with its multiple examples of nearly every plate, was assembled on different grounds, with a premium on rarity, technical idiosyncrasy and comprehensiveness. As a means of recourse from Teylers, it was able to provide for this book sixty-six etchings of outstanding character, including several unica – impressions that are one of their kind in the world.

As a corollary to the principle we have tried to define, priority was given to impressions on European paper rather than Japanese paper, vellum or silk, which do not print as crisply; to impressions printed from the wiped plate rather than with surface tone; to drypoint plates with less rather than more burr. Yet the selection also contains examples printed on Japanese paper with surface tone (generally of etchings that Rembrandt seldom printed otherwise), and with fresh burr. The captions give details concerning technical specifications, to aid the reader in interpreting the differences between one etching and the next.

One incalculable advantage of working in the Teylers and Rijksmuseum collections is that neither has ever used disfiguring collectors' marks on the face of their sheets. To see how distracting this practice can be, one need only turn to the reproductions of Bartsch numbers 182 and 184, from the Bibliothèque Nationale in Paris, with their 18th-century Bibliothèque Royale stamps.

This brings us to the exceptions mentioned above. Between them, the Haarlem and Amsterdam printrooms own good impressions of all but six of Rembrandt's etchings, most of them unica. For those we had to turn elsewhere – to the Albertina in Vienna for B 154 and B 366, to the Bibliothèque Nationale for B 175, B 182 and B 184 and to the British Museum for S 399. These, and the reduced illustrations of the largest plates, are the only etchings in the book that are reproduced from photographs, for obvious reasons.

The arrangement of the etchings in this edition follows the numbers given to them by Adam Bartsch in his catalogue of 1797. This has three disadvantages: the numbering is not consecutive, since 89 of Bartsch's 375 numbers are no longer accepted as original Rembrandt etchings; three plates not known to or accepted by Bartsch have to be appended to the catalogue by their 'Seidlitz numbers'; and new interpretations of subjects have turned certain etchings, in Bartsch's thematic arrangement, into enclaves in foreign categories. The first two disadvantages have to be lived with; to mitigate the third, the subject categories concerned open with cross-references to the etchings of the same sort located elsewhere in the book. The great single advantage of the Bartsch numbering, aside from its being reasonably consistent and easy to grasp, is that it remains the most widely used system of reference to the Rembrandt etchings, and this outweighed all other considerations.

The information provided in the captions is as follows:
Bartsch number: abbreviated B
Title: usually the traditional title, except where this is considered too misleading, in which case it is added in brackets after the new title. Traditional Dutch titles are treated in the same way.
Pre-printing techniques employed beside etching, if any: these are limited to drypoint and burin, while some plates were made with these techniques only, and no etching at all.
State of impression reproduced, and total number of states: the numbering of states follows in all but a few cases that of

Christopher White and Karel G. Boon, *Rembrandt's etchings*, Amsterdam etc. 1969.

Signature and dating inscribed in the plate, if any: no attempt has been made to reproduce the actual form or punctuation of the inscriptions. The monogram *RHL* usually looks like an *R* and *L* connected by a thin line.

Deviant printing techniques and materials, if any: specifically the use of surface tone (inking outside the grooves of the plate) and Japanese paper.

Collection: Haarlem stands for the Teylers Museum; Amsterdam for the printroom of the Rijksmuseum, known as the Rijksprentenkabinet; Paris for the Bibliothèque Nationale; Vienna for the Albertina; and London for the British Museum.

Dating, if the work is not dated by inscription: with few exceptions, the dating agrees with that given in White and Boon.

Signature and/or dating in other states, if any.

The above is provided for all the etchings. Additional information on some of them includes:

References to chapter and verse of biblical subjects.
Biographical information on portrait sitters.
Identifications of the sites of landscapes, when known.
Succinct interpretations of obscure subjects.
Brief explanations of any aspects of the illustrations that may be misleading, such as disturbing scratches in the plate or later inscriptions in pen.
Cross-references to related etchings.
Characterizations of the most outstanding impressions.
The number of surviving impressions of the rarest prints.
The more important material or compositional changes between states (three etchings – B 76, B 78 and B 282 – are reproduced in two states).
Comments on the form of unusual signatures.
Notice of the six etchings reproduced from photographs and the fifteen that are reduced in the pages of the book and reproduced full-scale in the appended outsize sheets.

The sheets referred to in the final point above are a unique addition to the Rembrandt library. The body of the book, in the generous format of 30 × 24 cm., contains captioned reproductions of *all* the etchings. Fifteen of the originals, however, are larger in at least one dimension than the maximum format of the book, and had to be reduced. To have inserted them as folding sheets would have been prohibitively expensive, and would have meant that they would have to remain folded for good. Instead, all the oversize etchings are reproduced again, in full scale, on three separate sheets appended to the book. They are printed back to back in such a way that they can be cut apart and kept separately in a roll or portfolio. While this is admittedly a compromise solution, it has the merit of providing a complete, full-scale set of reproductions at a reasonable price.

The user of the book, to understand its worth and its limitations, should also know something about its production. The paper upon which it is printed comes very close in color to the typical European papers that Rembrandt used. Its texture is smoother, however – a necessity imposed by the demands of modern offset printing. Printing on a more structured, less smooth paper would have entailed a severe loss in the deepness of the blacks and the openness of the drawing.

Proofs of all the photolithos (with the same six exceptions mentioned above) were compared closely to the originals, to be redone when necessary. Except in the case of the very darkest plates, whose modelling defies precise reproduction in one-color offset printing, the tonal values of the others are virtually indistinguishable to the eye from those of the originals. Most reproductions of etchings tend to be less than sharp and to be printed too darkly, corresponding in this to the general notion that an etching should be 'velvety.' In fact, most of Rembrandt's, except for those in 'the dark manner,' tend to be extremely finely drawn, detailed with great clarity, and printed with a restraint that will surprise those who are more used to reproductions than originals. It is hoped that the reproductions in this book will bring us closer to the true appearance of Rembrandt's graphic work.

The publishers would like to express their gratitude to Mr. J.H. van Borssum Buisman and Mrs. M. Sieswerda of Teylers Museum in Haarlem and Dr. J.W. Niemeijer and the staff of the Rijksprentenkabinet in Amsterdam for their cooperation in this unprecedented project; to the photolitho firm of De Lang in Zwanenburg and Lund Humphries in Bradford for their special efforts; and to Jan Piet Filedt Kok for his greatly appreciated advice.

GARY SCHWARTZ

Note to the Dover Edition

For the present edition the quality of the reduced images of the fifteen etchings contained on the outsize sheets has been improved with new plates. Another improvement with respect to the original edition is that five superior impressions from the Amsterdam printroom were substituted for etchings from the Teylers Museum: B 24, B 51, B 91, B 96 and B 365. In all other respects, except for a few minor corrections in the text, the present edition is identical to the original one.

G.S.
Maarssen, November 1993

Chronology of Rembrandt's life and etchings

This concise chronology lists some of the major events of Rembrandt's life and career, and all his dated etchings. Rembrandt dated more than half of his etchings, and since the undated ones follow the same pattern of chronology, subject and quality, the dated plates provide a reliable framework for the whole etched work.

Unless otherwise specified, all the dated etchings through 1632 are signed *RHL*–Rembrandus Hermanni Leidensis– and all those of 1633 and later *Rembrandt f.*–Rembrandt fecit.

1606

Rembrandt is born in Leiden.

1620

Matriculated in Leiden University after completing a seven-year course at the Latin school, preparing him for classical studies. Later in the year he apparently left the university to study painting with Jacob van Swanenburgh, a Leiden painter of hell scenes.

1624

Rembrandt completes his formal training as a painter with the Amsterdam history painter Pieter Lastman and returns to Leiden.

1625

The first dated painting, *The stoning of St. Stephen.*

1626

The first etchings–*The rest on the flight into Egypt* (B 59) and *The circumcision* (S 398) – are generally thought to have been made in 1626.

1628

From around this time dates the first recorded comment on Rembrandt as an artist. The Utrecht humanist Arnout van Buchell noted in his diary that 'the Leiden miller's son is much praised, but before his time.'

B 352 *The artist's mother: head only, full face*
B 354 *The artist's mother: head and bust, three-quarters right*

1629

Probably in 1629, the influential politician and poet Constantine Huygens wrote an enthusiastic report on Rembrandt in his autobiographical sketch. Rembrandt was not yet in the habit of signing and dating his etchings, and although there is only one plate dated 1629, scholars have assigned 15 more to that year. The dated etching is a self portrait. The first painted self portrait to bear a date (Munich) is also from 1629.

B 338 *Self portrait bare-headed: bust, roughly etched*

1630

Rembrandt's father dies and is buried in Leiden. Somewhat neglecting his painting, the 24-year-old artist turned out etching after etching in this year – mainly small, informal plates. In no year to follow did he etch more than in 1630.

B 10 *Self portrait, frowning: bust*
B 13 *Self portrait open-mouthed, as if shouting: bust*
B 24 *Self portrait in a fur cap: bust*
B 51 *Simeon's hymn of praise*
B 66 *Christ disputing with the doctors*
B164 *Beggar man and woman conversing*
B174 *Beggar seated on a bank*
B 292 *Bare-headed man in right profile.* RL
B 294 *Bald-headed man in right profile: small bust*
B 304 *Man wearing a close cap: bust*
B 309 *Old man with a flowing beard*
B 316 *Self portrait in a cap, laughing*
B 320 *Self portrait in a cap, open-mouthed*
B 321 *Bust of a man wearing a high cap, three-quarters right*
B 325 *Bust of an old man with a flowing beard, the head bowed forward, the left shoulder unshaded*

1631

It was probably towards the end of this year that Rembrandt moved to Amsterdam, where he lived with the art dealer Hendrick van Uylenburgh and had a studio in his home. The stream of etchings continues, slightly diminished, but with more ambitious and finished plates. In Amsterdam he paints his first commissioned portraits, and his life was never to be the same.

B 7 *Self portrait in a soft hat and embroidered cloak*
B15 *Self portrait in a cloak with a falling collar: bust*
B16 *Self portrait in a heavy fur cap: bust*
B134 *Old woman seated in a cottage with a string of onions on the wall.* Rt. 1631 [?]
B135 *Peasant with his hands behind his back*

B 138 *The blind fiddler*
B 142 *A polander standing with his stick: right profile*
B 150 *Beggar with his left hand extended*
B 171 *The leper*
B 190 *A man making water*
B 191 *A woman making water*
B 260 *Bust of an old bearded man, looking down, three-quarters right*
B 263 *Bearded man, in a furred oriental cap and robe*
B 315 *Old man with a flowing beard: bust*
B 348 *The artist's mother seated, in an oriental headdress: half-length*
B 349 *The artist's mother with her hand on her chest: small bust*

1632

Rembrandt makes a smash success as a portrait painter in Amsterdam and The Hague. Fifty paintings are dated 1632 and 1633 – more than in any other two years in the artist's career. All but four of them are portraits and studies, topped by the *The anatomy lesson of Dr. Nicolaas Tulp*. The number of etchings declines dramatically.
B 101 *St. Jerome praying: arched print.* Rembrandt ft.
B 121 *The rat-poison peddler*
B 152 *The Persian*

1633

At this point the etchings begin to gain in importance, as the artist works out in copper the biblical histories he had no time to paint. The larger plates are clearly intended for widespread publication. Rembrandt extends his range as an etcher into genre, allegory and commissioned portraiture.
B 17 *Self portrait in a cap and scarf with the face dark: bust*
B 52 *The flight into Egypt: the small plate.* Rembrandt inventor et fecit.
B 81 *The descent from the cross: the second plate.* Rembrandt f. cum pryvl⁰
B 90 *The good Samaritan.* Rembrandt inventor et Feecit.
B 111 *The ship of fortune*
B 266 *Jan Cornelis Sylvius, preacher*
B 351 *The artist's mother in a cloth headdress, looking down: head only*

1634

Rembrandt marries Saskia van Uylenburgh, the niece of Hendrick van Uylenburgh and orphaned daughter of a burgomaster of Leeuwarden. The portrait commissions continue to come, though in lesser numbers. In his etchings Rembrandt works with greater concentration than before, turning out only finished plates of great finesse.
B 18 *Self portrait with raised sabre*
B 23 *Self portrait [?] with plumed cap and lowered sabre*
B 39 *Joseph and Potiphar's wife*
B 44 *The angel appearing to the shepherds*
B 71 *Christ and the woman of Samaria: among ruins*
B 88 *Christ at Emmaus: the smaller plate*
B 100 *St. Jerome reading*
B 177 *A peasant calling out 'Tis vinnich kout'*
B 345 *Woman reading*
B 347 *Saskia with pearls in her hair*

1635

Rembrandt's first child, a boy Rumbartus, is born and dies within two months. The subjects of the etchings show the same mixture as before, except for the intriguing *Great Jewish bride*.
B 69 *Christ driving the moneychangers from the Temple*
B 97 *The stoning of St. Stephen*
B 102 *St. Jerome kneeling in prayer, looking down*
B 124 *The pancake woman*
B 129 *The quacksalver*
B 279 *Jan Uytenbogaert, preacher of the Remonstrants*
B 286 *The first oriental head.* Rembrandt geretuc.
B 288 *The third oriental head.* Rembrandt geretuck.
B 340 *The great Jewish bride.* R.

1636

The decline in Rembrandt's painting production is matched by a drop in the number of etchings. The vast *Christ before Pilate*, begun in 1633, is completed at a moment when the artist's etching style has already grown away from it. The work is related in concept to the paintings of the Passion of Christ Rembrandt was making for the stadholder.
B 19 *Self portrait with Saskia*
B 77 *Christ before Pilate: larger plate.* Rembrandt f. 1636 cum privile
B 91 *The return of the prodigal son*
B 269 *Samuel Menasseh ben Israel*
B 365 *Studies of the head of Saskia and others*

1637

B 30 *Abraham casting out Hagar and Ishmael*
B 268 *Young man in a velvet cap*
B 313 *Bearded man in a velvet cap with a jewel clasp*
B 368 *Three heads of women, one asleep*

1638

Birth and death of a daughter, Cornelia. The portrait trade comes to a dead halt after a gradual decline since 1633. Certain of Saskia's relatives accuse Rembrandt of squandering his wife's property.

B 20 *Self portrait in a velvet cap with plume*
B 28 *Adam and Eve*
B 37 *Joseph telling his dreams*
B 311 *Man in a broad-brimmed hat*. RHL
B 342 *The little Jewish bride*

1639

Rembrandt buys a house in the Breestraat, two doors away from Hendrick van Uylenburgh. His self portrait of this year shows him at his grandest.

B 21 *Self portrait leaning on a stone sill*
B 99 *The death of the Virgin*
B 109 *Death appearing to a wedded couple from an open grave*
B 133 *A peasant in a high cap, standing leaning on a stick*
B 281 *Jan Uytenbogaert, the goldweigher*

1640

Birth and death of a second daughter, Cornelia. A few months later Rembrandt's mother dies. The first landscape etchings are produced (B 207, B 210), four years after the first landscape paintings.

B 92 *The beheading of John the Baptist*
B 265 *Old man with divided fur cap*

1641

The publication of the second edition of J. Orlers' *Description of Leiden* contains the first printed biography of Rembrandt. Titus is born, the only child of Rembrandt and Saskia to reach maturity. The production of etchings takes a sudden leap, with major plates in all categories but self portraiture.

B 43 *The angel departing from the family of Tobias*
B 61 *Virgin and child in the clouds*
B 98 *The baptism of the eunuch*
B 114 *The large lion hunt*
B 118 *Three oriental figures*
B 128 *Woman at a door hatch talking to a man and children*
B 136 *The card player*
B 225 *Landscape with a cottage and haybarn: oblong*
B 226 *Landscape with a cottage and a large tree*

B 233 *The windmill*
B 261 *Man at a desk wearing a cross and chain*
B 271 *Cornelis Claesz. Anslo, preacher*
B 310 *Portrait of a boy, in profile*

1642

Saskia dies, after years of ill health. A nursemaid, Geertge Dircx, enters Rembrandt's household to take care of the infant Titus. *The nightwatch* is completed. Rembrandt's output of etchings drops back to a moderate level from which it is never to recover. For the next 18 years it averaged 6 plates per year, about two-thirds of them signed and dated.

B 72 *The raising of Lazarus: the small plate*
B 82 *The descent from the cross: a sketch*
B 105 *St. Jerome in a dark chamber*
B 188 *The flute player*
B 257 *Man in an arbor*

1643

B 157 *The hog*
B 212 *The three trees*

1644

B 220 *The shepherd and his family*

1645

B 34 *Abraham and Isaac*. Rembrant
B 58 *The rest on the flight: lightly etched*
B 96 *St. Peter in penitence*
B 208 *'Six's bridge'*
B 209 *The Omval*. Rembrant
B 231 *The boat house*. Rembrandt [rather than Rembrandt f.]

1646

In his fortieth year Rembrandt creates his depictions of erotic love, as well as his plates of nearly nude young men.

B 170 *Beggar woman leaning on a stick*
B 186 *'Ledikant' or 'Le lit à la française'*
B 193 *Nude man seated before a curtain*
B 196 *Nude man seated on the ground with one leg extended*
B 280 *Jan Cornelis Sylvius, preacher*

1647

B 278 *Ephraim Bonus, Jewish physician*
B 285 *Jan Six*

1648

Geertge Dircx makes a testament leaving nearly all her property to Titus. She had become Rembrandt's mistress, but was being replaced in his affections by Hendrickje Stoffels. The final etched self portrait, after a gap of six years, dates from 1648.

B 22 *Self portrait drawing at a window*
B 103 *St. Jerome beside a pollard willow*
B 112 *Medea: or the marriage of Jason and Creusa*
B 126 *Pharisees in the Temple*
B 176 *Beggars receiving alms at the door of a house*
B 232 *Cottage with a white paling*

1649

This is the only year in Rembrandt's career in which not a single painting or etching is dated. The artist's private life was troubled and probably not conducive to work. He was being sued by Geertge Dircx for breach of promise, and twice failed to show up in court. His financial situation was also growing desperate, as he stopped both mortgage and tax payments.

1650

Rembrandt has Geertge Dircx put away in a penal institution, apparently in order to evade most of his obligations towards her. None of his efforts can save his finances anymore. In the entire decade of the 1650s he painted fewer commissioned portraits – the backbone of his income as a painter – than in the single year of 1632. Many of them, moreover, were portraits of his creditors, obviously made in part payment of his debts. The landscape etchings show for the first time elements of fantasized far-away places.

B 159 *The shell*
B 217 *Landscape with three gabled cottages beside a road*
B 218 *Landscape with a square tower*
B 235 *Canal with an angler and two swans*
B 236 *Canal with a large boat and bridge*

1651

B 42 *The blindness of Tobit: the larger plate*

B 53 *The flight into Egypt: a night piece*
B 195 *The bathers*
B 234 *'The goldweigher's field.'* Rembrandt.
B 272 *Clement de Jonghe, printseller*
B 370 *Sheet of studies with the head of the artist, a beggar man, woman and child.* RL.

1652

B 41 *David in prayer*
B 65 *Christ disputing with the doctors: a sketch*
B 222 *Clump of trees with a vista*
B 224 *Landscape with a hay barn and a flock of sheep*

1653

Only one etching (and one painting – *Aristotle contemplating a bust of Homer*) is dated 1653.
B 78 *The three crosses*

1654

Hendrickje is condemned by the church council for 'fornication with Rembrandt the painter.' Four months later she gives birth to a daughter named Cornelia after Rembrandt's mother, like the two that Rembrandt and Saskia had lost.

B 47 *The circumcision in the stable*
B 55 *The flight into Egypt: crossing a brook*
B 60 *Christ returning from the Temple with his parents*
B 63 *The Virgin and child with the cat and snake*
B 64 *Christ seated disputing with the doctors*
B 83 *The descent from the cross by torchlight*
B 87 *Christ at Emmaus: the larger plate*
B 125 *The golf player*

1655

The notable concentration on biblical subjects in the etchings of 1654 and 1655 is matched only in part in the paintings. In this year Rembrandt painted two subjects – *Christ and the woman of Samaria* and *Joseph accused by Potiphar's wife* – twice, perhaps under the pressure of his approaching insolvency.

B 35 *Abraham's sacrifice*
B 36 *Four illustrations to a Spanish book*
B 76 *Christ presented to the people: the oblong plate*
B 123 *The goldsmith*
B 275 *Pieter Haaringh*

1656

Rembrandt applies for and is granted an arrangement whereby the courts disposed of his goods for the benefit of his creditors. His goods are inventoried.

B 29 *Abraham entertaining the angels*
B 89 *Christ appearing to the apostles*
B 276 *Jan Lutma, goldsmith*

1657

The contents of Rembrandt's house are sold at an auction that lasted for three weeks. He etches the saint of voluntary poverty.

B 107 *St. Francis beneath a tree praying*

1658

The artist's house is auctioned, but he is allowed to remain there for another two years. He etches a *Christ and the woman of Samaria* close to one of the pair he painted in 1655. His only etched female nudes after 1631 were all made in 1658 and 1659.

B 70 *Christ and the woman of Samaria*
B 110 *The phoenix or the statue overthrown*
B 197 *Woman sitting half dressed beside a stove*
B 199 *Seated naked woman with a hat beside her*
B 200 *Seated naked woman*
B 205 *Negress lying down*

1659

B 94 *Peter and John healing the cripple at the gate of the Temple*
B 203 *Jupiter and Antiope*

1660

Titus and Hendrickje form a company to deal in art, apparently to circumvent the new guild ruling prohibiting any painter who had held a general sale of his works from operating independently in the art market. The family moves to the Rozengracht. Perhaps because he had to leave his etching press behind him at this point, Rembrandt virtually abandoned etching for the rest of his life.

1661

B 202 *The woman with the arrow*

1662

Rembrandt's painting *The conspiracy of Julius Civilis* is hung in the new town hall of Amsterdam, only to be removed within a short time and returned to the artist. His last important portrait commission – *The syndics* – also dates from 1662.

1663

Hendrickje dies, not yet 40 years of age.

1665

Titus comes into his share of the 1657-58 sales, an addition to the family funds that probably made Rembrandt's last years somewhat more bearable. The final etching (B 264) was made in this year for a Leiden publisher who however could not use it for his purposes. He had specified an engraving in his commission.

1668

Titus is married, and dies a few months later.

1669

Titia van Rijn, Titus's posthumous daughter, is born. Rembrandt dies and is buried in the Westerkerk on October 8.

The technique of etching in Rembrandt's time

The basic idea behind etching is fairly simple: the etcher covers a copper plate with an acid-resistant ground, traces his design in the ground with a needle and exposes the plate to acid. Wherever the ground has been scratched away, the acid will bite semi-circular grooves in the copper. If the plate is then cleaned, inked in the grooves, cleaned again and run through the press with a sheet of paper, the ink will be pressed out of the grooves onto the paper.

Nowadays etching is a popular medium, with tools and materials freely available – ground, acid, prepared plates, special presses. In Rembrandt's time not only were manufacturing and distributing services insufficient for the relatively small demand, but the technique itself was barely a century old, and not all that well understood. Performing the steps described above, simple as they are, was a major operation fraught with dangers. The more sensitive steps, especially the preparation and application of the ground, could easily misfire. Even an able technician like Abraham Bosse, the French artist and author of the first treatise on etching, tells that more than once he cleaned off a bitten plate only to discover that the acid had worked its way beneath the ground and ruined all his work. Rembrandt too once had a similar disaster, with the largest plate he ever made, a first version of *The descent from the cross* [B 81].

Etching was originally intended to serve as an alternative to an even more demanding way of making a printing plate – engraving. The engraver has to do everything by hand. He cuts the grooves directly into the metal plate with a tool known as the burin. The work is wearing both physically and psychologically – mistakes are not easily corrected. Making and correcting an etching is less tiring and quicker, but the technique has a different disadvantage. The lines of a printed etching are formless and unvaried compared to the razor-sharp lines of an engraving, which can be carved in any desired breadth and depth. The early etchers taxed their ingenuity to find ways of achieving the same richness in etching as in engraving.

Rembrandt recognized this disadvantage, but his reaction to it was new and important. He accepted it for what it was, and even aggravated it to transform it into a positive value. Instead of the hard resin ground that most early etchers used, and which offered considerable resistance to the needle, Rembrandt preferred a soft ground with an admixture of wax in which he could draw almost as freely as on paper. Now he stood even further from the engraving. In fact, he often treated the etched plate as an intermediate stage, and even before printing a single impression would work it up by hand, deepening some grooves with the burin or the drypoint needle. (The difference is that the drypoint leaves an uneven ridge of metal, called burr, beside the groove, which takes up ink and leaves a fuzzy line in printing for the few impressions before it wears off. The burin, on the other hand, makes a neat ridge that can be cleaned of ink before printing.) These means helped Rembrandt to achieve

considerable variety, with pictorial effects different than those of an engraving, but no less interesting. Even richer results could be attained by the simple device of leaving a thin film of ink on the surface of all or part of the plate before printing, so that the sheet takes up not only lines but also surface tone. The choice of paper too is vital to the final results. Chinese and Japanese papers, as well as vellum, are smoother, harder and take up less ink than European papers, giving a noticeably diffuse effect. Rembrandt used all these means and more, and in doing so discovered new expressive possibilities that no previous etcher had ever dreamed of. As important as Rembrandt's paintings and drawings are, it was Rembrandt the etcher who most palpably changed the course of the history of art.

In the 16th and early 17th centuries the technique of etching was a secret that could only be learned by a paying pupil from his master. In that respect Rembrandt was well connected. His final master Pieter Lastman had learned etching from Gerrit Pietersz. Sweelinck, the first Dutch artist to turn his full concentration on etching. Moreover, Lastman's father was a goldsmith, and the early etchers, most of whom were trained as painters, often had to turn to goldsmiths for advice in working with metal.

The first treatise of any importance on etching was written by the above-mentioned Abraham Bosse and was published in Paris in 1645, after which it went through many reprintings and translated editions in the decades and centuries to come. It is an admirable piece of work, clearly written and telling all the author knows about his subject. Although Bosse favored the esthetic of the engraving and although Rembrandt and others had already worked out experimental variations before 1645 that Bosse does not describe, the technique of etching as he treats it is basically that employed by Rembrandt. We quote the abridged English translation of 1662 brought out, under his own name, by the etcher William Faithorne, as *The art of graveing and etching, wherein is exprest the true way of graveing in copper. Allso the manners and method of that famous Callot, & Mr Bosse in their severall ways of etching.* Published by Will^m Faithorne and sold at his shop next to ye signe of ye Drake, without Temple Barr. 1662.

The illustrations, from the Dutch edition, also of 1662, are copied from Bosse's.

Of soft varnish. How to make it, and the uses it is to be put to

Take an ounce and a half of virgins wax, the best and whitest; one ounce of Mastick in tears, neat and pure, half an ounce of Spaltum [asphalt varnish] severally very fine; then melt your Virgins wax in an earthen pot well leaded, and when it is very hot, strew in your beaten Mastick all over, and stir them together with a little stick till such time

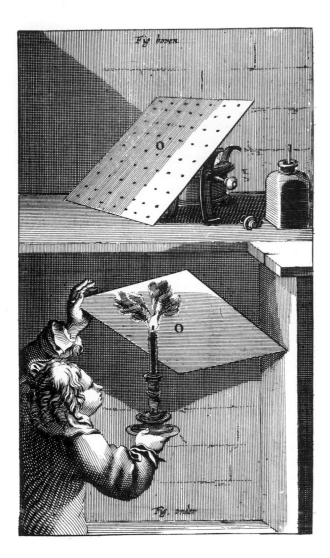

as you may judge the Mastick to be wel incorporated with the wax, & after that strew in also the Spaltum, as you did the Mastick before, and stirre the whole mixture together upon the fire, till the Spaltum be likewise well dissolv'd and mixt with the rest, which is likely to be done in the space of half a quarter of an hour; then take it from the fire, and let it cool a little; then pour in the said composition into a basin of fair water, and first wetting your hands (which must be very clean) in the water, take out the said mixture before it be quite cold, and having moulded it to squeez out the water, roll it up into pieces about an inch diameter, and two or three inches long.

You are not to put in so much of virgins wax in the Summer as in Winter.

[The preparation of the etching ground – the etcher's actual medium – is a particularly delicate process. Not only must the ground have the right consistency and resistance to the needle, but it must also meet the most exacting standards of homogeneity and impenetrability, if the etching is not to turn into a shambles. Bosse provided formulas for both hard and soft grounds, with variants for summer and winter. Rembrandt used a soft ground of his own invention. In 1660, before the appearance of Faithorne (who does not mention Rembrandt), another English writer spoke of 'the Ground of Rinebrant of Rein.']

How to know good copper from bad, and how to planish [i.e. burnish] and polish your plate

Copper is best for graveing with a Graver, or *Aqua fortis*; Brasse is too brittle. That Copper is best which is free from flawe, and not too hard, which you may perceive by its yellowish colour, almost like brasse; if it be too soft, you may perceiv it by its too much pliableness in bending. When you are to make use of it, you shall perceive (in that which is good) a firm, yet easie force in the entring of the graver: and that Copper which is best for graveing, is also best for etching.

Those Plates which you intend to forge and planish, must be fully as thick as an half-crowne, because in their forging and planishing they will become somewhat thinner.

[Many of Rembrandt's plates have survived, and we know from them that he favored exceptionally thin plates.]

The manner of laying your soft Ground or varnish upon the plate

Having your plate well polisht and cleansed from grease, take the soft varnish, wrapped up in a piece of fine linnen cloth or Taffata, two or three times double, and put the said plate over a chafing-dish wherein a moderate fire hath been kindled, and heat it in such sort, that the varnish may easily dissolve as it passes through that which enwraps it: The plate being thus heated, take the varnish cover'd as aforesaid,

In the upper illustration the plate is being heated on a chafing dish to prepare it for receiving the ground. After the rather transparent ground is applied, the plate is blackened with a candle to enable the etcher to follow his own work. There are also various ways, all of them more complicated, to whiten the plate, which certainly gives the etcher a better view of what he is doing.

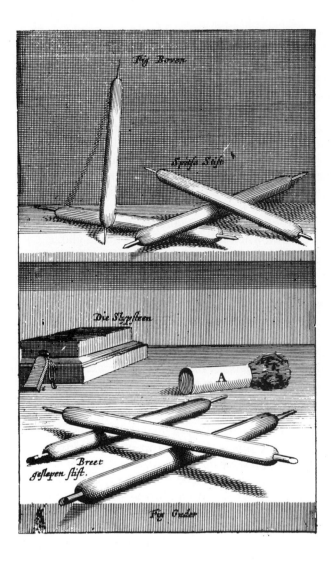

and applying it by the end of the roller, spread it upon the plate while it is hot, carrying it lightly from one side to the other, untill the plate be covered thin and equally all over: this being done, and having a quill that hath a smooth feather, take it, and with the broad side thereof sweep it gently over the varnish and swiftly, to the end it do not burn.

As soon as you have evenly spread your varnish upon your plate, black it over with the flame of a candle. After that, let your plate cool, and when you shall think fit to work upon it, place your design upon it.

How to choose your needles wherewith to make your tools to etch with, and to whet their points

Choose some broken needles of several sizes and bignesse, such as break neat without bending, and of a fine grain. Then take round sticks of a good firm wood, not apt to split, of the length of half a foot or somewhat lesse, of the thicknesse of a good large quill: at the ends of which sticks fix in your needles, so that they stand out of the sticks.

There are two ways of whetting your needles, the one round, the other sloping. In etching you will have occasion to make divers sorts of lines or hatches, some bigger, some smaller, some streight, some crooked. To make those you you must use severall sorts of lines or hatches, some bigger, some smaller, some streight, some crooked. To make them you must use severall sorts of needles, bigger or smaller as the work requires.

[The vital step that follows is unaccountably omitted by Faithorne. Bosse tells how to transfer a drawing onto the plate: cover the back of your drawing with red chalk strained through a fine cloth and distributed evenly over the surface. Shake the sheet off and brush it with the palm of your hand seven or eight times to affix the remaining chalk. Attaching your drawing to the plate, take your round needle and trace all the lines and figures in it. When this is done, all the strokes you went over with the needle will appear in the ground.

[Of all Rembrandt's surviving preparatory drawings, only three show signs of having been traced over. In most cases he seems to have worked directly in the ground, probably with a preparatory drawing in front of him.

[The next step was to incise the drawing into the ground with the needle. At this point it would often occur that the needle would inadvertently scratch the plate and produce an unintended burr. The softness of the soft ground can be guessed from Bosse's warning to etchers working in this medium to turn the buttoned side of their sleeves around to avoid contact with the ground.]

How to prepare the Aqua fortis

The *Aqua fortis* is made of vinegar, Salt Armoniack [ammonium chloride], Bay-salt [sea salt], and Vert de griz.

The thinner needles, with sharp points, are illustrated above, and the broader ones below, with the whetting stone for shaping the points. The brush is for keeping the etching ground clean once it has been applied to the plate.

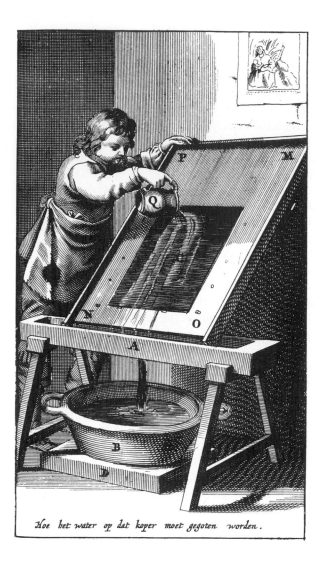

Hoe het water op dat koper moet gegoten worden.

Here the acid is being poured over the plate in a holder put together expressly for that purpose.

The vinegar must be of the best sort of white-wine Vinegar. The Salt Armoniack must be clear, transparent, white, pure, and clean.

The Bay-salt must be also pure and clean. The Vert de griz must be clean, and free from any scrapings of brasse.

Take three pints of Vinegar, six ounces of Salt Armoniack, six ounces of Bay salt, and four ounces of Vert de griz; or of each according to this proportion, as you will make your quantity more or lesse: put them all together in an earthen pot well varnished, large enough, that it may not boyl over: Cover the pot, and put it on a quick fire, and let it speedily boyl two or three great walmes [i.e. gushes] and no more: then take off the pot from the fire, and let it cool; but keep the pot covered, and when it is cold poure it into a glasse bottle, and let it stand stopped a day or two before you use it.

[Rembrandt is thought to have used a rather weak acid, one which would act slowly and not deform the thinnest lines, as stronger acids tend to do.]

The manner of casting the Aqua fortis *upon the plate; as also how to cover the places, that are faintest and most remote from the eye, with the fore-mentioned mixture, as occasion shall require*

Having a sufficient quantity of *aqua fortis* in your pan, fill your earthen pot, and poure it upon your plate, beginning at the top, and moving your hand equally so that it may run all over the plate, taking great heed that the pot not touch the plate. Having so pour'd 8. or 10. times, you must turn it crosse-wayes, and poure on it as it lies that way ten or twelve times as before: that done, turn your plate suitably corner-wise, and as it lies so, poure thereon eight or ten times; pouring the *Aqua fortis* thus at severall times, for the space of half a quarter of an hour, more or lesse, according to the strength of the water, and nature of the copper.

How to take the ground or the varnish off the plate, after the Aqua fortis *hath done its operation*

Take a char-cole of willow or some such soft grain'd wood, and take off the rinde of it, and pouring fair water on the plate, rub it with the char-cole with an even hand, as if you were to polish copper, and it will take off the varnish. Be carefull that no dust or filth fall upon the plate, as also that the char-cole be free from all knots and roughness, for it might occasion small scratches in the plate which it would be difficult to get out. [Rembrandt does not seem to have followed this advice as religiously as he should have.]

This done, you will perceive plainly if there be any places that require to be touch'd with the graver [burin], as it for the most part happens, especially in those places that are to be most black. For you may well judge, that when there are many strokes and hatchings one close to another, there is so

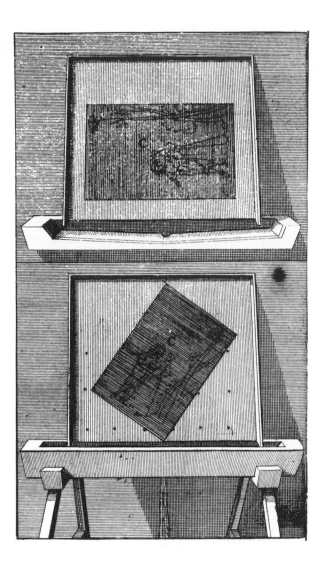

After the acid is poured over the plate ten or twelve times, the latter has to be turned in various other positions in order to ensure equal biting.

little varnish between, that the *Aqua fortis* commonly takes it off, because it eats under it.

[Rembrandt was quick to put this possibility to use. Generally he worked so cautiously that only with a magnifying glass can you see where he used the burin and where the drypoint. The latter technique, by the way, is ignored by Bosse. He would have disapproved of it because it often left a ragged line, on account of the burr. For that matter, Rembrandt seems more than once to have removed the burr from his plates with the burnisher before printing them.]

Here followeth the manner, after that your plates are eaten into by the Aqua fortis, *how to touch up, or re-grave that which haply you may have forgotten, or that which you would amend or supply*

Before I make an end, I thought fitting to shew you the manner, how to touch over again many things according as need may require, by the means of *Aqua fortis*, as when it happens that having made upon your copper any thing that doth not please you, and that for this cause having covered it with your oyly mixture, to the end that the *Aqua fortis* should not perform its operation, or that you would add any ornaments either in Drapery, or any other thing which might be thought on, upon severall occasions. In this case therefore take your plate and rub it over well with Oyl-Olive, in those places where there is any thing graven, in such sort, as that the blacknesse and foulnesse, which is likely to be in the hatchings or strokes may be taken away. Afterwards take out the grease so thoroughly with crumms of bread, that there may remain no grease nor filth upon the plate, nor in any of the strokes or hatchings.

Then heat it upon a char-cole fire, and spread the soft varnish upon it with a feather. That which you are to take speciall care of is, that the hatchings, which you would have to remain, be filled with varnish: That being done, black it, and then you may touch over again, or add what you intend. And lastly, make your hatchings by the means of your needle according as the manner of the work shall require, being carefull before you put on the *Aqua fortis*, to cover with your oyly mixture the first graving which was upon your plate. Having then caused the *Aqua fortis* to eat into your work, take away your varnish from your plate, by the means of the fire.

[This piece is particularly interesting for understanding the work of an incurable improver like Rembrandt. There are few plates from his hand that did not undergo the process here described, often more than once, as they went from state to state. In order to execute these corrections a special transparent ground had to be used to allow the etcher to see the surface of the plate while he worked.

[Rembrandt reworked his plates not only to correct errors and to add 'ornaments,' but also to get more than

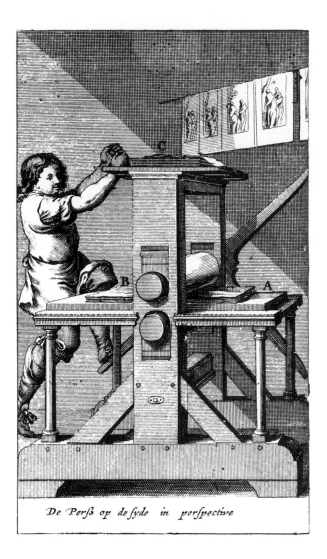

De Perß op de syde in perspective

one work of art out of a single plate. This can be seen most clearly in the case of etchings like *Christ presented to the people* [B 76] and '*The three crosses*' [B 78], where the differences between the early and later states are notably extreme. But the partial covering of a plate could serve another purpose, described by Bosse elsewhere: creating differences of thickness between lines. Because the acid bites the metal at the same rate everywhere, the only way to etch some grooves more deeply than others is to bite them longer, which could only be done by the process described.

[When the plate had reached this stage it was ready to be printed. Most etchers would pay a printer to do this for them, or let a publisher take over from there for the printing and marketing of the etchings. But Rembrandt, as far as we know, always printed his own etchings, and probably published them too.

[Bosse's chapters on the building of a press and the printing of etchings are very technical, and would take us too far afield in the present context. We close therefore with his illustration of an etcher at the press.]

An etching going through the press. The printer's stance shows that he is exerting himself and that the plate is being subjected to considerable pressure. Printed etchings are hung up behind the press to dry. This was necessary not only on account of the ink, but because the paper is dampened before going through the press.

18

The literature on Rembrandt's etchings

The classic form of literature on the work of an etcher is the catalogue of his complete œuvre. Serious art dealers and collectors (including the curators of printrooms) tend to accumulate filing cards on the works of artists that interest them, and sooner or later many of them get around to publishing their findings in catalogue form. The first one to do so for Rembrandt's etchings was the Paris art auctioneer Edmé François Gersaint, whose work saw the light of day in 1751, after his death. The book came out in English a year later, a sure sign that it was in demand. Since then about twenty other catalogues of Rembrandt's etchings have appeared, each relying on, and adding to, the material of its predecessors. Perhaps because Rembrandt's etchings nearly all exist in more than one impression, and are therefore more readily studied than his paintings and drawings, the disagreements concerning the authorship of specific plates are fewer than in Rembrandt studies in general.

The Vienna curator Adam Bartsch, an indefatigable cataloguer of graphic work, brought out his Rembrandt catalogue in 1797, not under his own name but as a 'new edition' of Gersaint and several others. This modesty did not prevent Bartsch's book from becoming the standard catalogue of the etchings; its numbering system is still the one most widely used in literature and printrooms, and it has been adopted for this book as well.

After determining which prints are by the master and which are not, the next most pressing problem to the student of Rembrandt etchings is to distinguish between the states that so many of the plates went through. The development of photography made it possible to refine the study of the states considerably, but the definitive publication in this field had to await the perfection later in the 19th century of photo-reproductive techniques. In 1890 the Russian scholar Dmitri Rovinski published a monumental set of volumes with reproductions of all the states of all the etchings in true size. Since then there have only been relatively minor shifts and additions in the cataloguing of the successive states of the etchings. The most influential catalogues to appear since Rovinski are those by Woldemar von Seidlitz (1895), Arthur M. Hind (1912), Ludwig Münz (1953) and the most recent catalogue, with more illustrations of states than any publication since Rovinski: Christopher White & Karel G. Boon, *Rembrandt's etchings* (Amsterdam etc. 1969). The authors of that book were, while writing it, attached to the two institutions with the greatest collections of Rembrandt's etchings in existence, the British Museum, London, and the Amsterdam Rijksprentenkabinet.

Catalogues of another kind – those of exhibitions and collections – illuminate the material from a different angle. Whereas a general catalogue, by its nature, treats all the impressions of a single plate under one and the same category, catalogues of exhibitions and collections can concentrate on single impressions, studying them as works of art in their own right. Three fairly recent catalogues of this kind are *Les plus belles eaux-fortes de Rembrandt choisies dans les quatre principales collections de Paris* (Musée du Louvre, 1969–70), *Rembrandt: experimental etcher* (Boston, Museum of Fine Arts, and New York, Pierpont Morgan Library, 1969–70) and J. P. Filedt Kok, *Rembrandt etchings and drawings in the Rembrandt House* (Maarssen 1972).

Building on the work of the cataloguers, art historians can then write general books on Rembrandt the etcher, in which they try to say more about the artist and his etchings than a catalogue can convey. When Arthur Hind wrote a monograph on Rembrandt in 1932, he naturally had much to say on the etchings. And by the same token, Hind's general history of engraving and etching has a long section on Rembrandt. Devoted entirely to the subject are the books that Boon and White each wrote separately – K. G. Boon, *Rembrandt: the complete etchings* (London 1963), and Christopher White, *Rembrandt as an etcher: a study of the artist at work* (2 vols., London 1969).

Self portraits SEE ALSO B 174, B 316, B 319, B 320, B 338, B 363 AND B 370

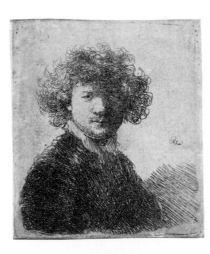

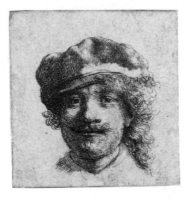

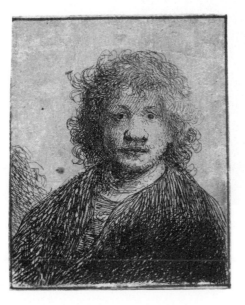

B 1
Self portrait with curly hair and white collar: bust. Second state of two. Signed *RHL*. Haarlem.
About 1630.

B 2
Self portrait wearing a soft cap: full face, head only. Only state. Haarlem.
About 1634.

B 4
Self portrait with a broad nose. Only state. Amsterdam.
About 1628.

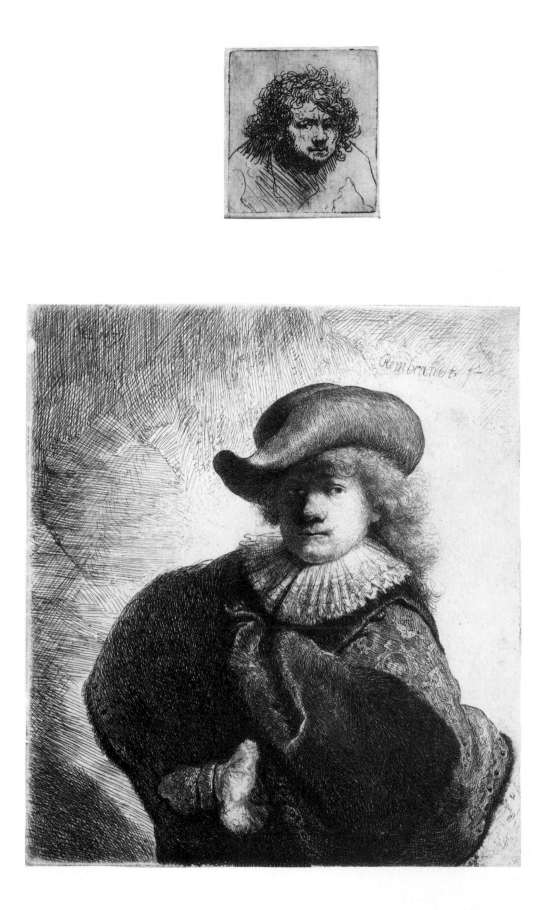

B 5
*Self portrait leaning forward:
bust*. Third state of three.
Haarlem.

About 1628. Printed from a
plate that was cut out of the
upper righthand corner of B 54
after Rembrandt ceased work on
that etching.

B 7
*Self portrait in a soft hat and
embroidered cloak*. Tenth state of
eleven. Signed and dated
Rembrandt f. and *RHL 1631*.
Haarlem.

The earliest states show the
head only. Rembrandt initially
inscribed this plate *AET 27*,
giving himself three years more
than his real age. This was
changed to *AET 24*, then to
RHL 1631. *Rembrandt f.* was
never used as a signature before
1633, and may indicate that the
tenth state was not reached until
that year or later.

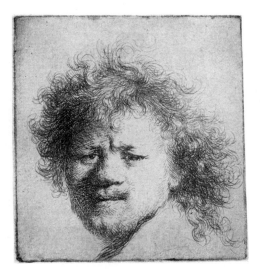

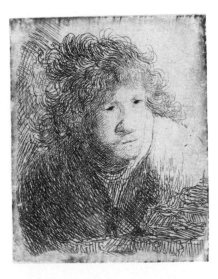

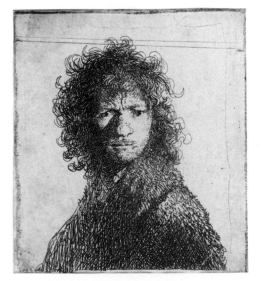

B 8
Self portrait with long bushy hair: head only. Second state of six. Amsterdam.
About 1631.

B 9
Self portrait, leaning forward, listening. Only state. Amsterdam.
About 1628.

B 10
Self portrait, frowning: bust. Second state of three. Haarlem.
In the first state signed and dated *RHL 1630*. The lines crossing the plate were burnished out in the third state.

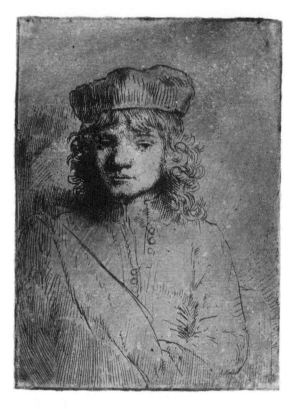

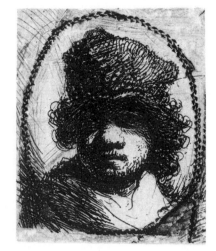

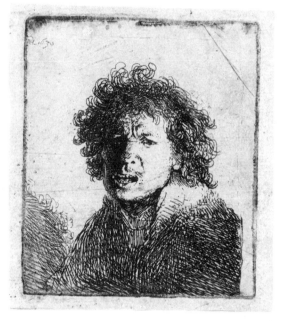

BI2
Self portrait in a fur cap, in an oval border: bust. Only state. Amsterdam.

About 1629. One of four surviving impressions, two of which are on larger paper than this one.

BII
The artist's son, Titus [1641-68]. Only state. Printed with surface tone. Amsterdam.

About 1656. Titus was the only child of Rembrandt and Saskia to outlive infancy, and he too died before his time. This plate was formerly considered a self portrait, and accordingly dated about 25 years earlier.

BI3
Self portrait open-mouthed, as if shouting: bust. Second state of three. Signed and dated *RHL 1630*. Amsterdam.

The diagonal scratch in the upper right was removed in the third state.

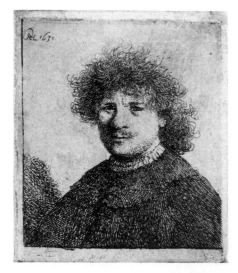

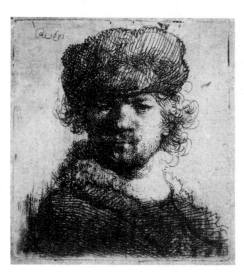

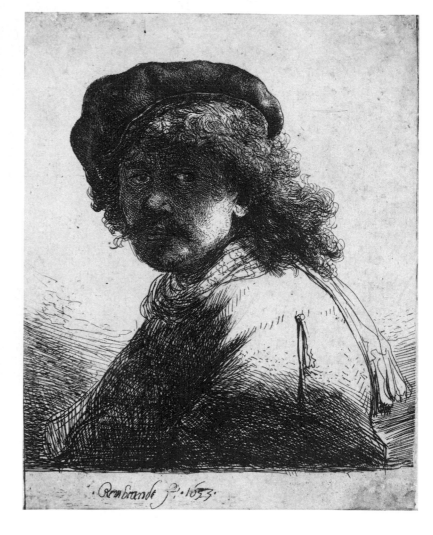

B 15
Self portrait in a cloak with a falling collar: bust. Second state of five. Signed and dated *RHL 1631*. Haarlem.
 The date was altered from 1630 to 1631.

B 16
Self portrait in a heavy fur cap: bust. Only state. Signed and dated *RHL 1631*. Haarlem.
 The top of the head with hair can be seen through the fur cap, indicating that the portrait was originally conceived bareheaded.

B 17
Self portrait in a cap and scarf with the face dark: bust. Second state of two. Signed and dated *Rembrandt f. 1633*. Haarlem.
 Signature lacking in the first state. Between the first and second states the artist's moustache gained the silhouetted twirl.

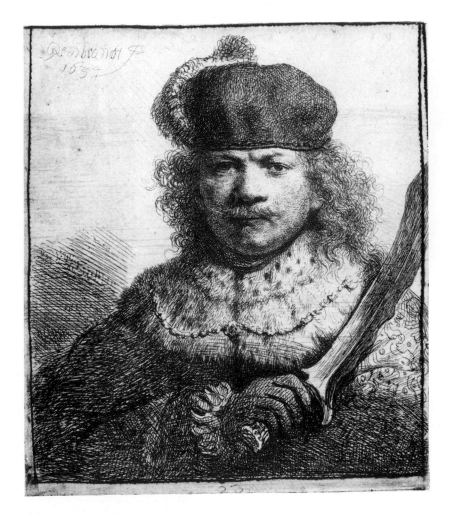

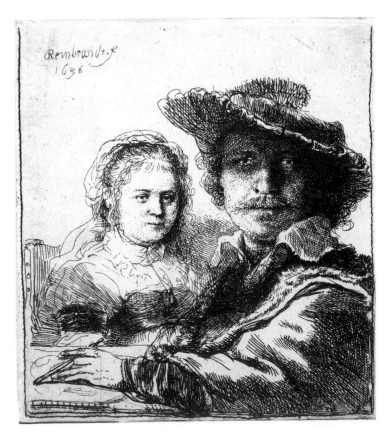

B 18
Self portrait with raised sabre.
With touches of burin. First
state of two. Signed and dated
Rembrandt f. 1634. Haarlem.

The penned *23* in the lower
margin is the etching's number
in Gersaint's catalogue (1751).

B 19
Self portrait with Saskia. Second
state of three. Signed and dated
Rembrandt f. 1636. Haarlem.

The portrait of Saskia
(see B 347) resembles that on
B 365 in reverse, reminding us
that here Rembrandt was seeing
Saskia in the mirror.

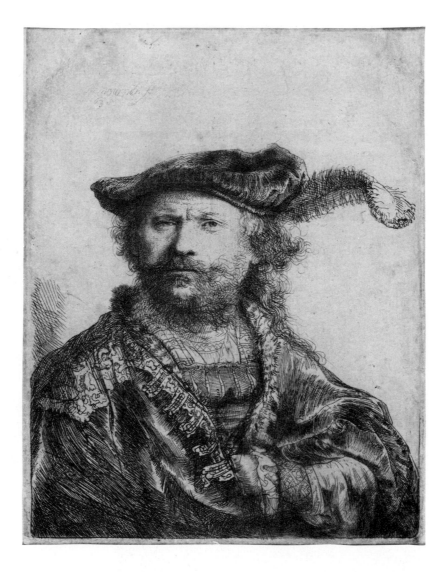

B 20
Self portrait in a velvet cap with
plume. Only state. Signed and
dated *Rembrandt f. 1638.*
Haarlem.

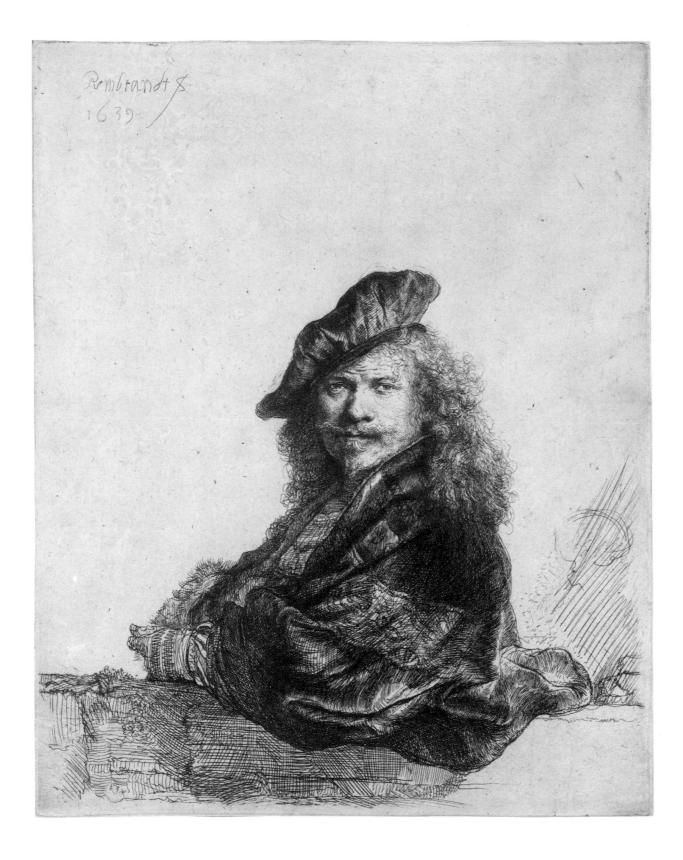

B 21
*Self portrait leaning on a stone
sill.* Second state of two. Signed
and dated *Rembrandt f. 1639.*
Haarlem.

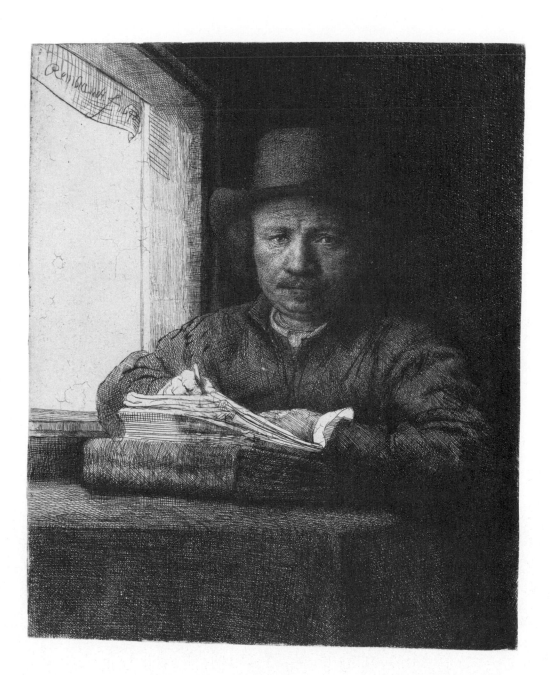

B 22
Self portrait drawing at a window.
With drypoint and burin.
Second state of five. Signed and
dated *Rembrandt f. 1648*.
Amsterdam.
 The first state lacks the
signature.

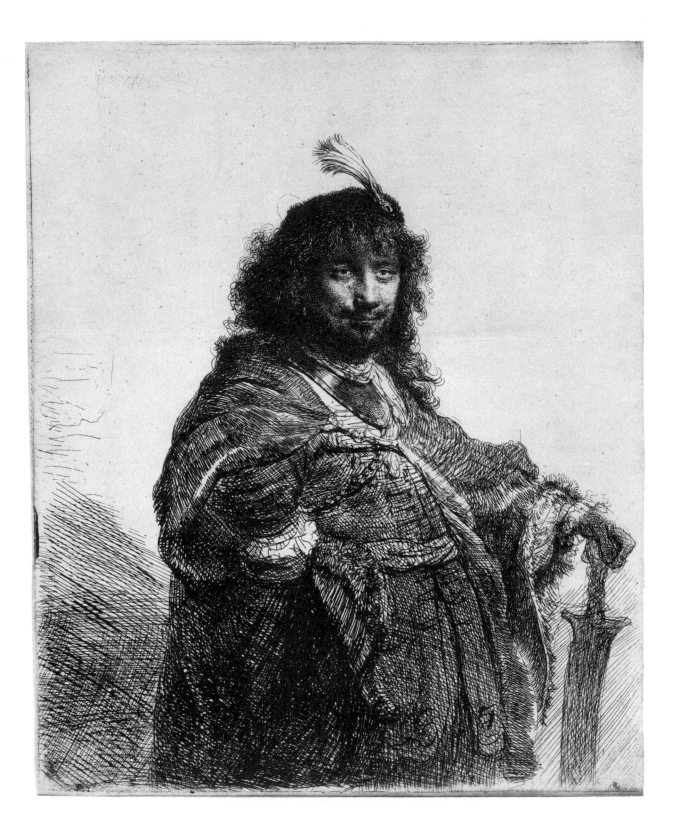

B 23
Self portrait [?] *with plumed cap
and lowered sabre*. First state of
three. Signed and dated
Rembrandt f. 1634. Amsterdam.
 Cut down to an oval in the
second state.

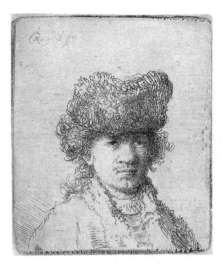

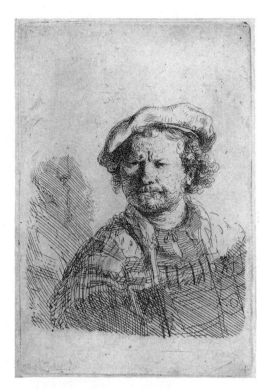

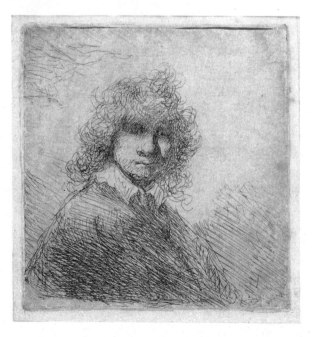

B 24
Self portrait in a fur cap: bust.
Fourth state of four. Signed and
dated *RHL 1630*, faintly.
Amsterdam.

B 26
*Self portrait in a flat cap and
embroidered dress.* Only state.
Signed *Rembrandt f.*, very
faintly. Haarlem.
About 1642.

B 27
*Self portrait bareheaded, with
high curly hair: head and bust.*
Only state. Haarlem.
 About 1628. One of the three
known impressions, cut down
from the full size of the plate.

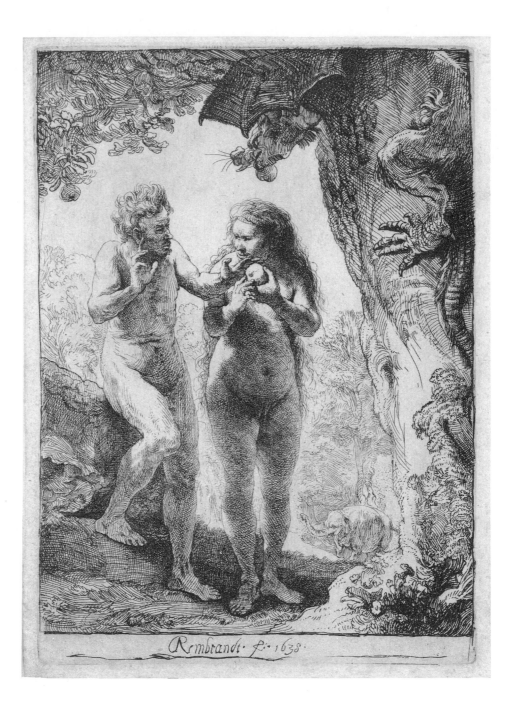

B 28
Adam and Eve. Second state of
two. Signed and dated
Rembrandt f. 1638. Haarlem.
 Genesis 3:6.

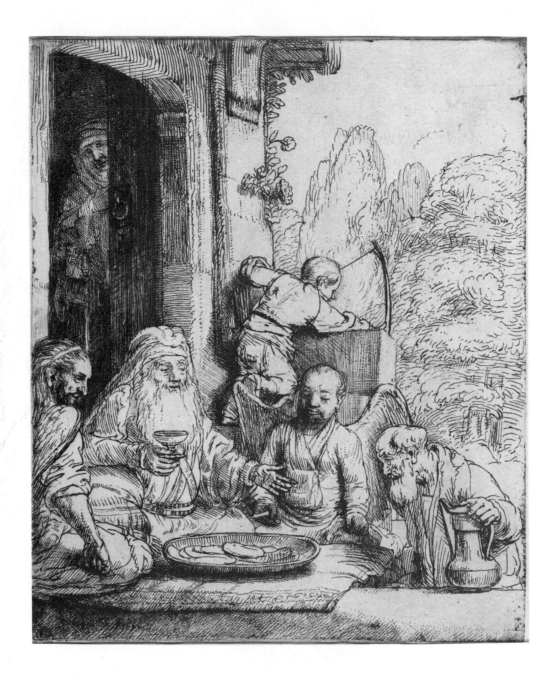

B 29
Abraham entertaining the angels.
With drypoint. Only state.
Signed and dated *Rembrandt f.*
1656. Haarlem.
 Genesis 18:1-15.

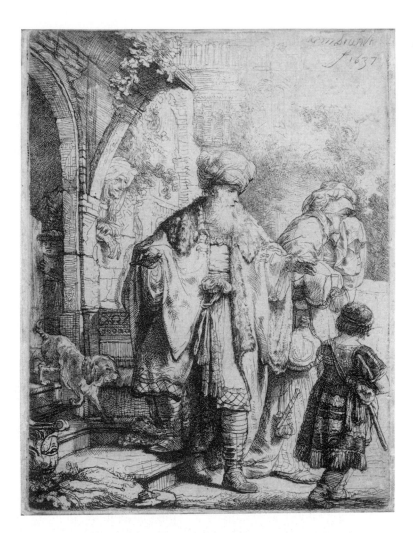

B 30
Abraham casting out Hagar and Ishmael. Only state. Signed and dated *Rembrandt f. 1637.* Haarlem.
 Genesis 21:14.

B 33
Jacob caressing Benjamin. First state of two. Signed *Rembrandt f.* Haarlem.
 About 1637. The traditional title, recently rejected, was *Abraham caressing Isaac.* Neither theme is taken directly from the Bible.

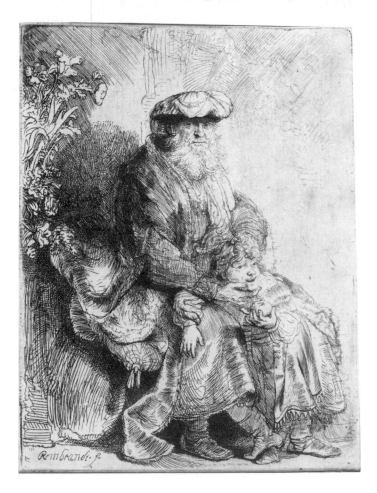

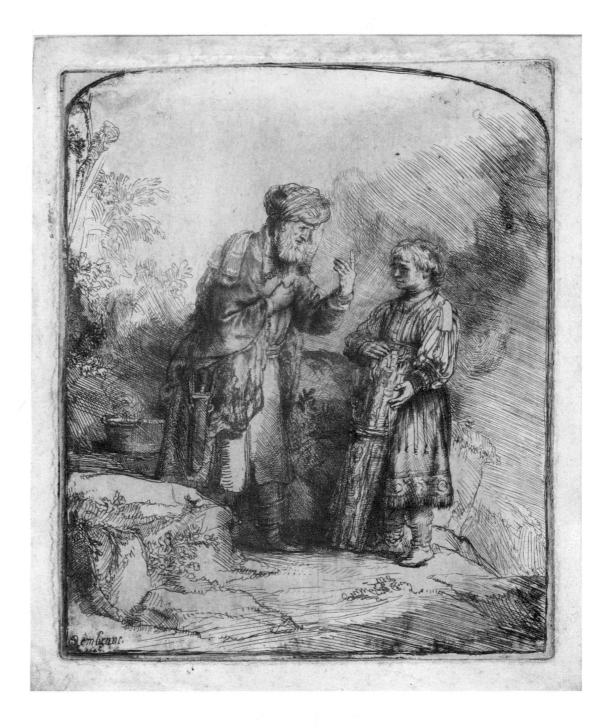

B 34
Abraham and Isaac. With
drypoint. Only state. Signed and
dated *Rembrant 1645*. Haarlem.
 Genesis 22:1-9.

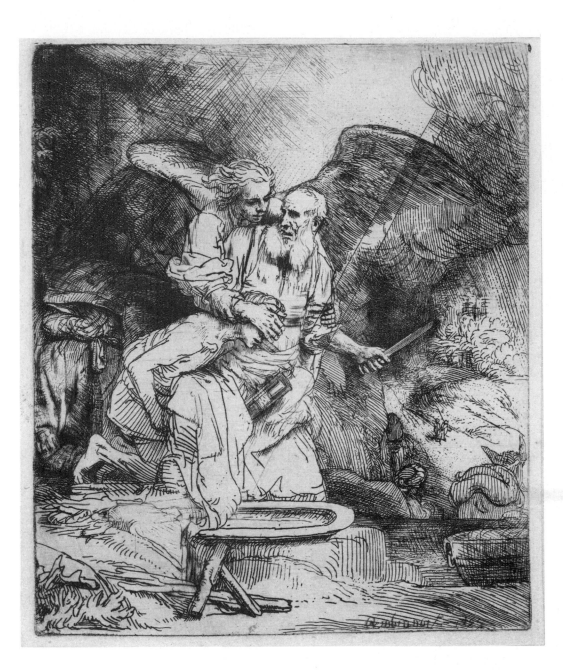

B 35
Abraham's sacrifice. With
drypoint. Only state. Signed and
dated *Rembrandt f. 1655*.
Haarlem.
　　Same text as B 34.

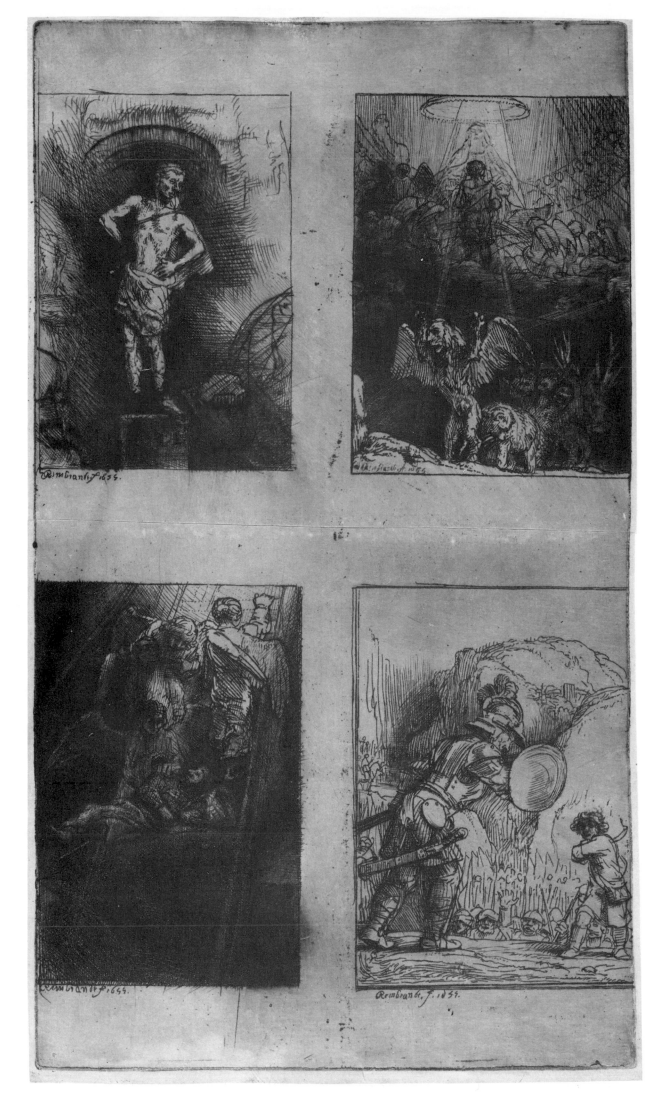

B 36
Four illustrations to a Spanish book. With burin and drypoint. Second state of three of the undivided plate. Signed and dated *Rembrandt f. 1655* on each of the four representations. Amsterdam.

Each of the themes depicts a stage in the history of the 'piedra gloriosa' of the title of the book: the glorious 'stone cut without hands.' [A] Destroying the statue seen by Nebuchadnezzar in his dream (Daniel 2:1-49); [B] serving Jacob as a pillow when he dreamt of the heavenly ladder (Genesis 28:11-15); [C] helping David kill Goliath (1 Samuel 17:49); [D] seen by Daniel in his apocalyptic dream of the four beasts (Daniel 7). The etchings were made as illustrations for a mystical book by the Sephardic rabbi Menasseh ben Israel (portrayed by Rembrandt 19 years earlier in B 269). Only four copies of the book with Rembrandt's illustrations have survived. The whole plate went through three states before being divided into its four components, three of which underwent further alterations afterwards.

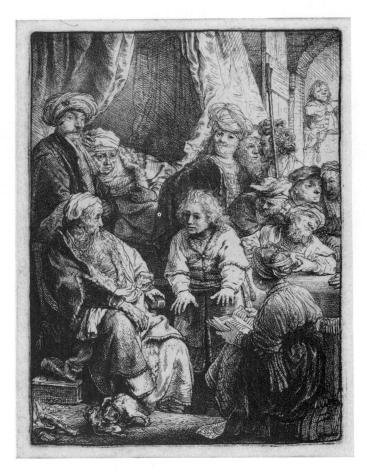

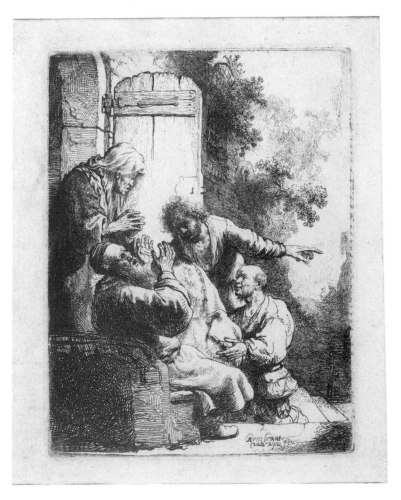

B 37
Joseph telling his dreams. Second
state of three. Signed and dated
Rembrant f. 1638. Haarlem.
 Genesis 37:1-11.

B 38
Joseph's coat brought to Jacob.
First state of two. Signed
Rembrant van Ryn fe.
Haarlem.
 About 1633. Genesis 37:31-34.
The only plate signed with the
artist's full name.

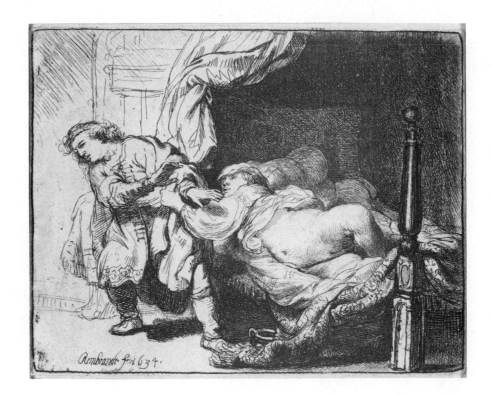

B 39
Joseph and Potiphar's wife.
First state of two. Signed and
dated *Rembrandt f. 1634.*
Haarlem.
 Genesis 39:7-12.

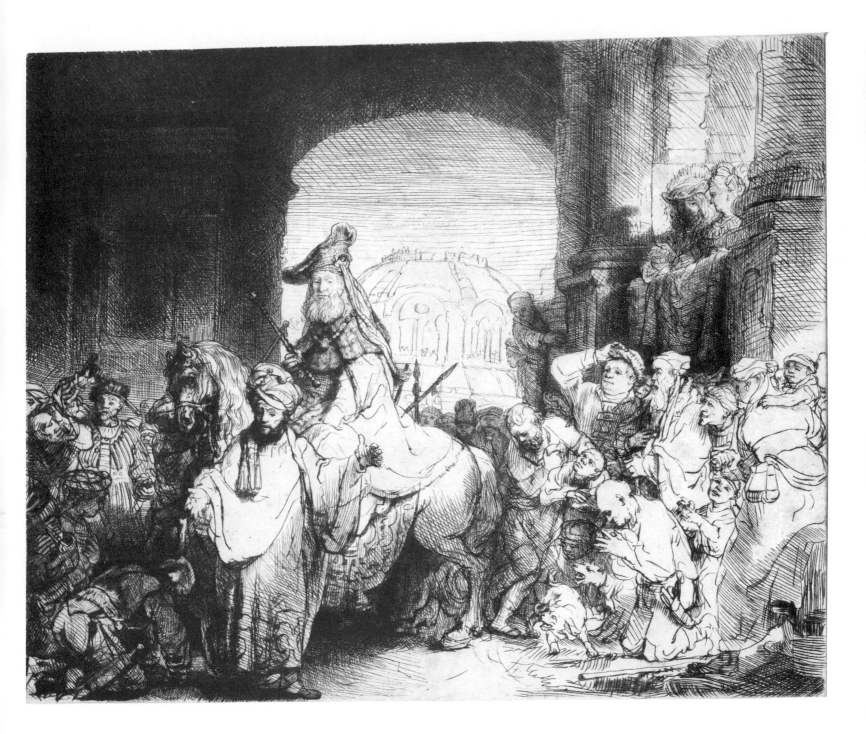

B 40
The triumph of Mordechai. With
drypoint. Only state. Haarlem.
About 1641. Esther 6.

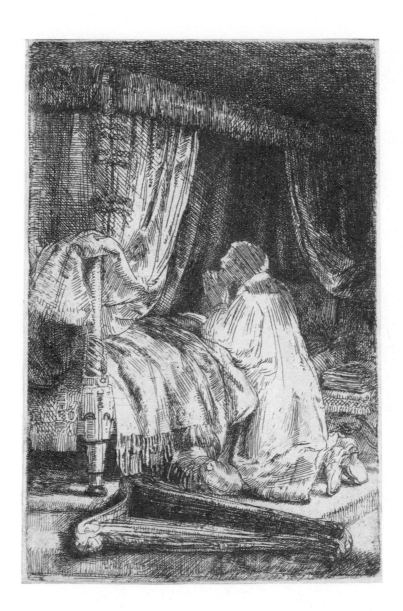

B 41
David in prayer. First state of
three. Signed and dated
Rembrandt f. 1652. Haarlem.
 Presumably from 2 Samuel 12.

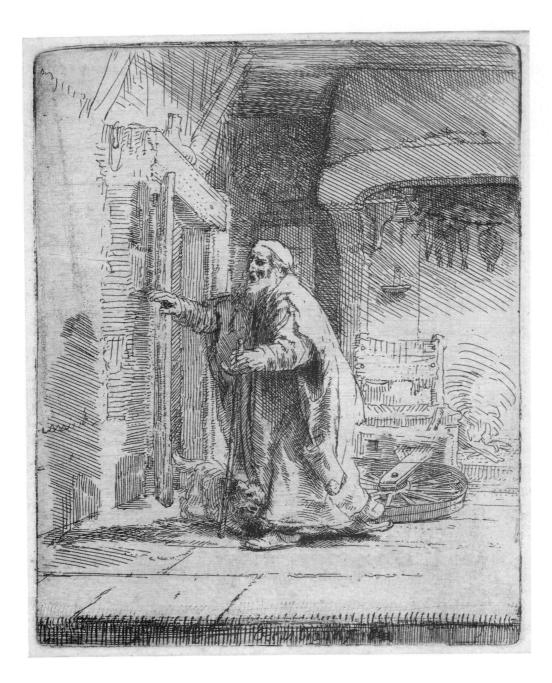

B 42
*The blindness of Tobit: the larger
plate*. With touches of drypoint.
First state of two. Signed and
dated twice, in the shadows of
the lower margin, *Rembrandt f.
1651*. Haarlem.
 Tobit 11:6-10.

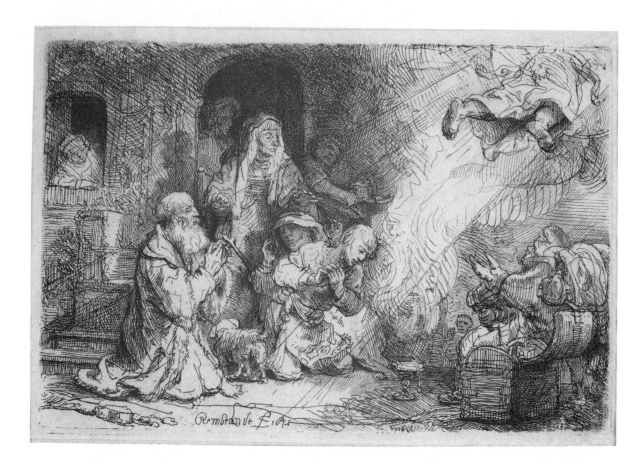

B 43
*The angel departing from the
family of Tobias.* With drypoint.
Third state of four. Signed and
dated *Rembrandt f. 1641.*
Haarlem.
 Tobit 12:16-22.

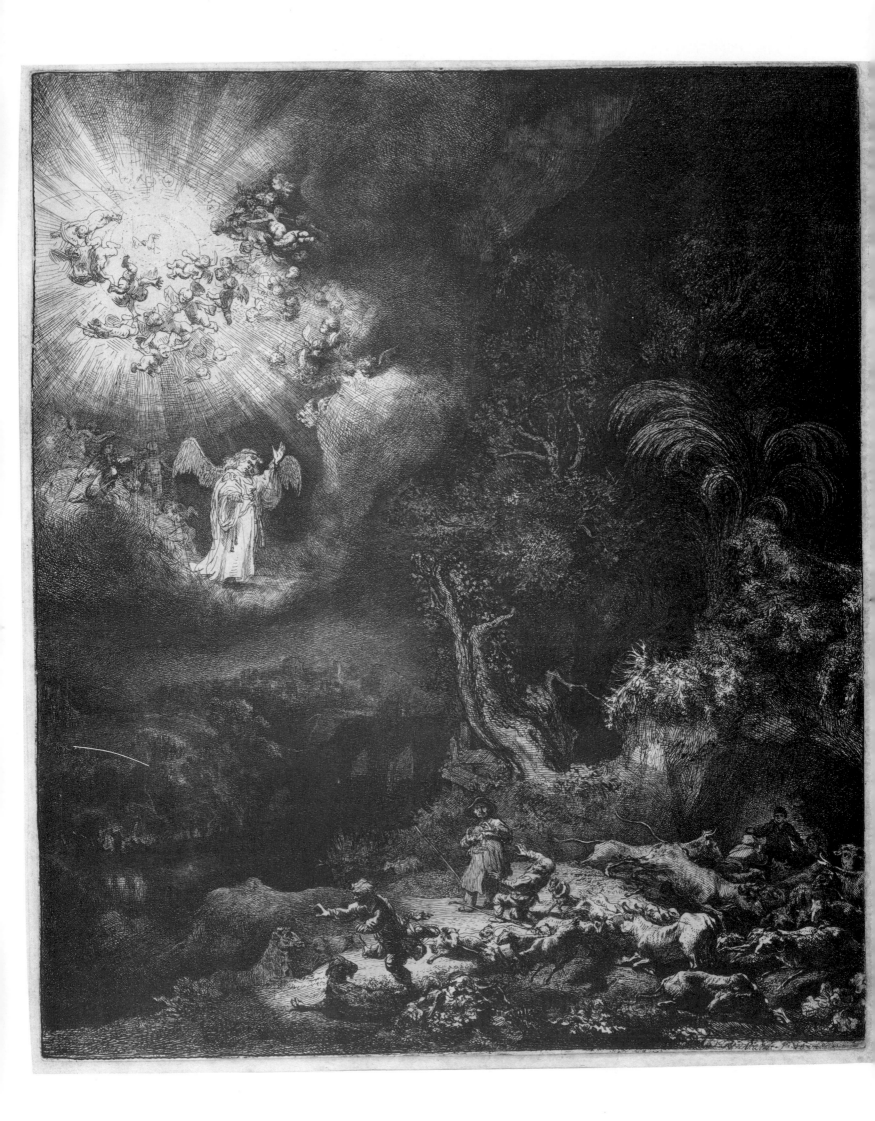

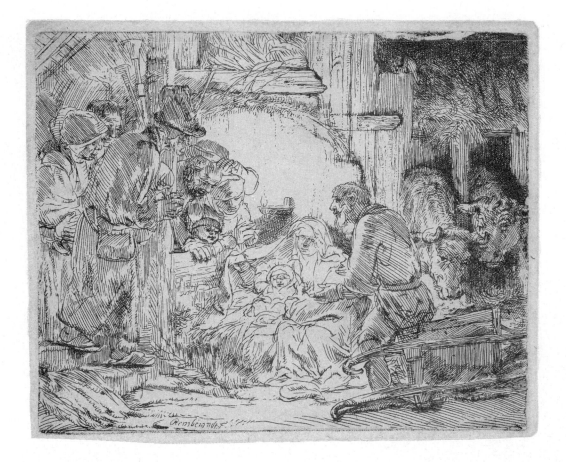

◀ B 44
*The angel appearing to the
shepherds.* With burin and
drypoint. Third state of three.
Signed and dated *Rembrandt f.
1634.* Haarlem.
 The first, unfinished state
lacks the signature and date.
Luke 2 : 8-14.

B 45
*The adoration of the shepherds:
with the lamp.* First state of two.
Signed *Rembrandt f.* Amsterdam.
 About 1654. Luke 2 : 15-16.

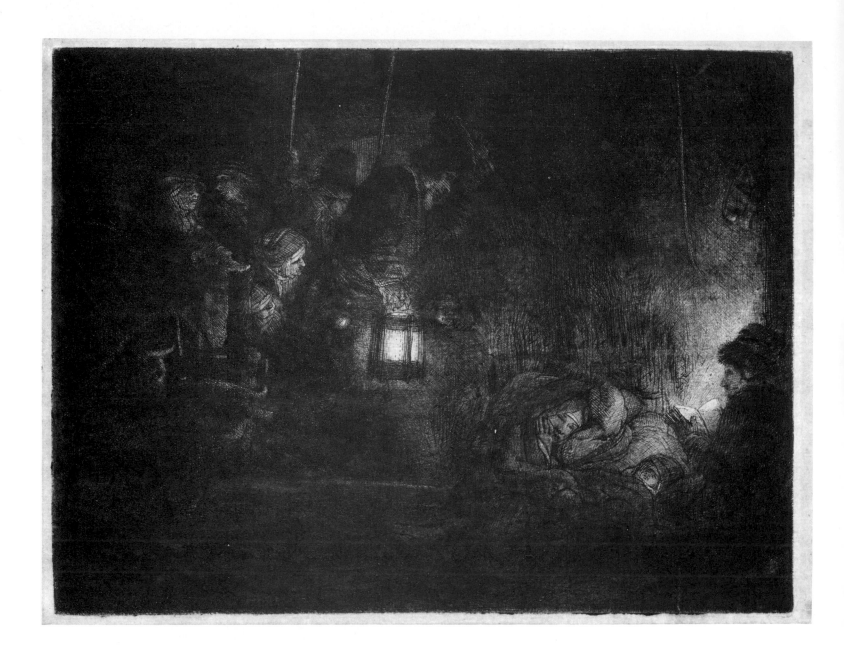

B 46
*The adoration of the shepherds:
a night piece.* With drypoint and
burin. Fifth state of eight.
Haarlem.
About 1652. Same text as
B 45.

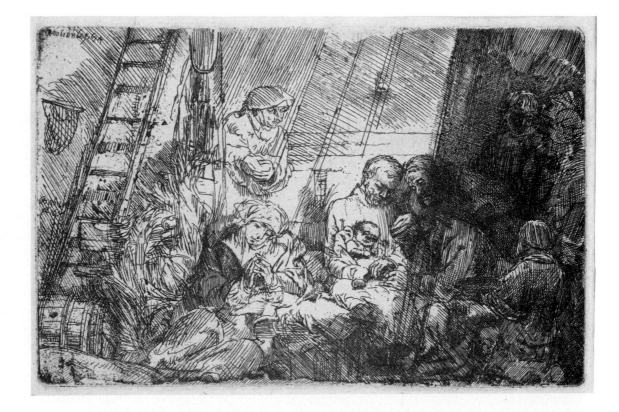

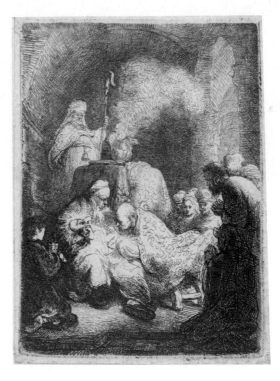

B 47
The circumcision in the stable.
First state of two. Signed and
dated twice *Rembrandt f. 1654.*
Haarlem.
 Luke 2:21.

B 48
The circumcision: the small plate.
With touches of drypoint. Only
state. Haarlem.
 About 1630. Same text as B 47.

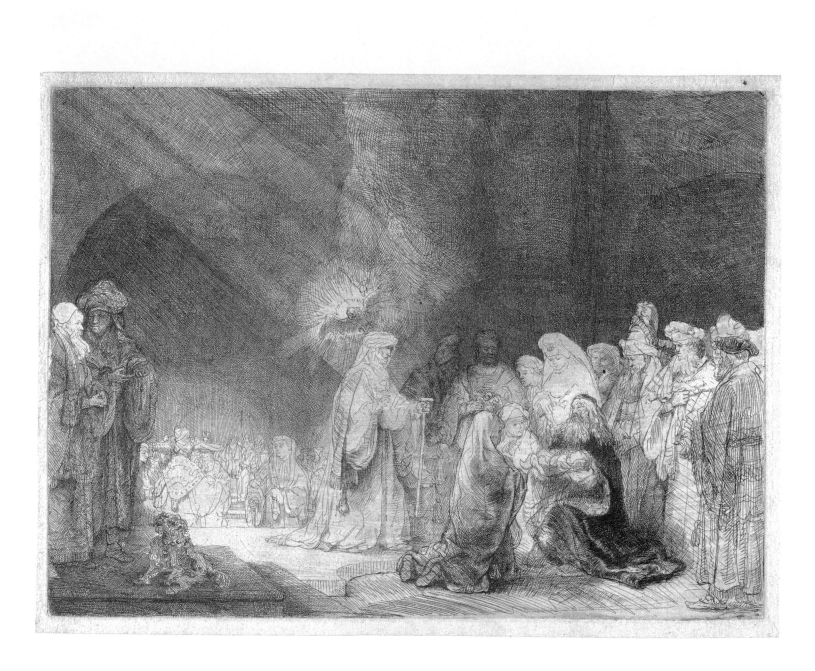

B 49
Simeon's hymn of praise [*The presentation in the Temple: oblong print*]. With drypoint. Second state of three. Amsterdam.

About 1639. Luke 2:22-38. The action depicted precedes the actual presentation.

This illustration is reduced. For a full-scale reproduction, see outsize sheets.

Original size 21.3 × 29 cm.

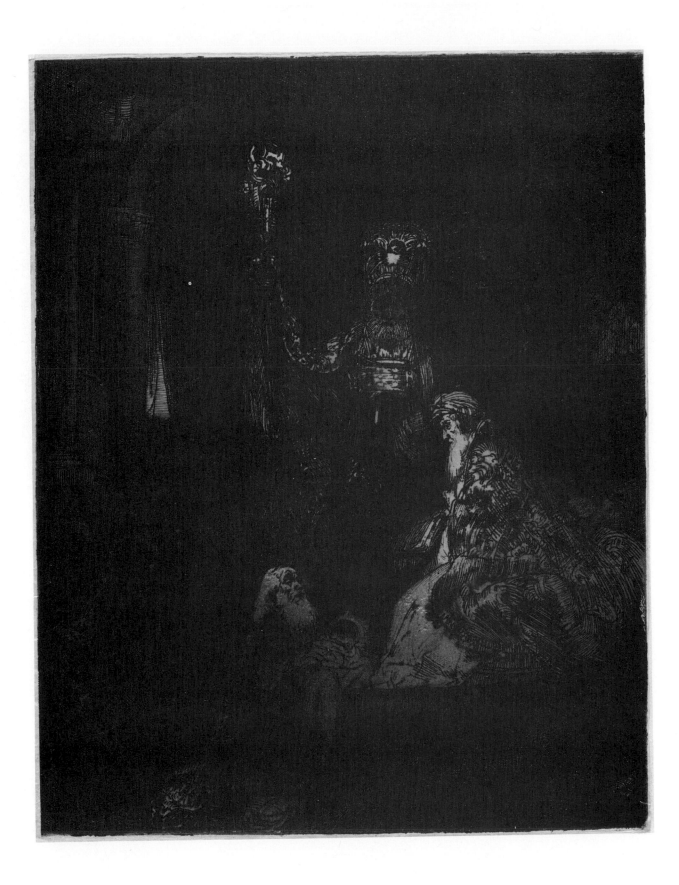

B 50
*The presentation in the Temple in
the dark manner.* With drypoint.
Only state. Printed with surface
tone on Japanese paper.
Haarlem.
 About 1654. Luke 2:39.

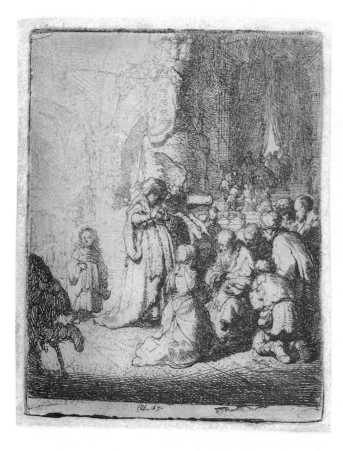

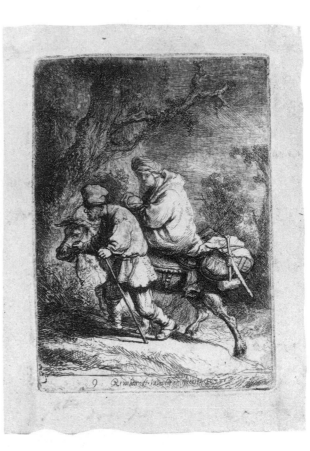

B 51

Simeon's hymn of praise [*The presentation in the Temple with the angel: the small plate*]. Second state of two. Signed and dated *RHL 1630*. Amsterdam.

Same text as B 49.
The first state has more blank space above.

B 52

The flight into Egypt: the small plate. First state of two. Signed and dated *Rembrandt inventor et fecit. 1633*. Amsterdam.

Matthew 2:13-15. Only in this plate and in B 90, of the same year, did Rembrandt identify himself by inscription as the draftsman and etcher of a plate.

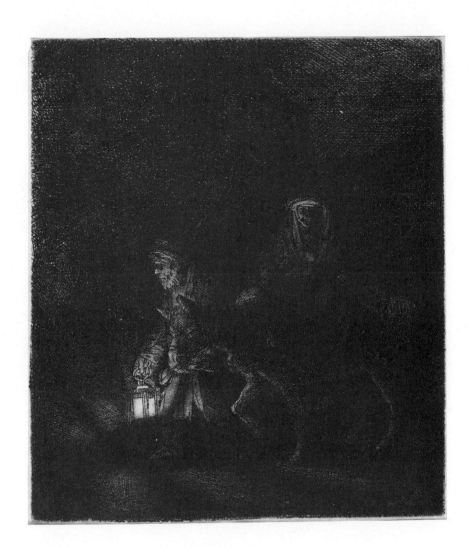

B 53
The flight into Egypt: a night piece. With burin and drypoint. Sixth state of six. Signed and dated *Rembrandt f. 1651* (invisible in the reproduction). Haarlem.

Same text as B 52.

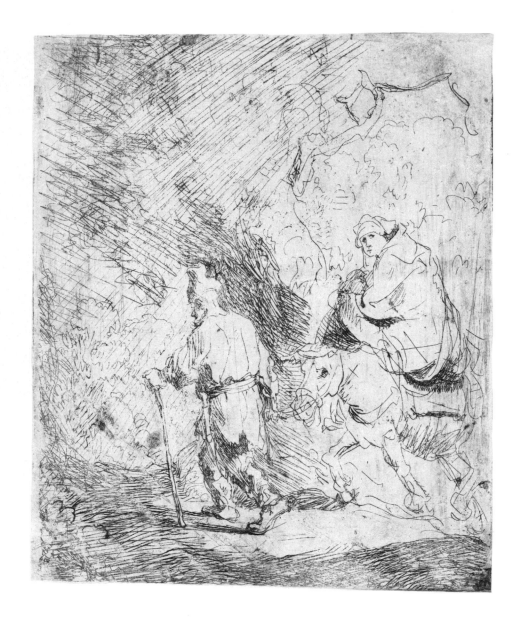

B 54
The flight into Egypt: a sketch.
First state of six. Amsterdam.
 About 1627. Same text as B 52.
After this state the plate was cut
down, and part of the copper
was used for the self portrait B 5.
One of the two surviving
impressions of the first state.

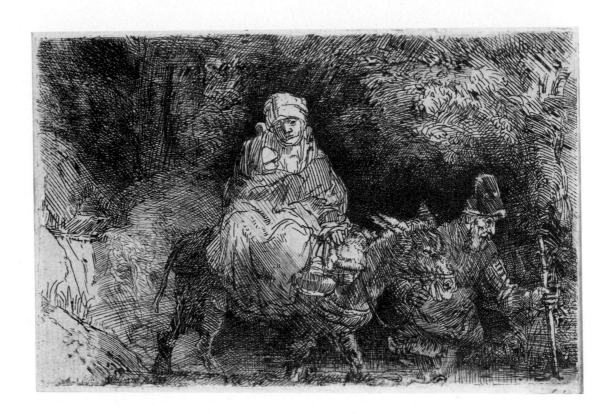

B 55
*The flight into Egypt: crossing a
brook*. With drypoint. Only
state. Signed and dated
Rembrandt f. 1654. Haarlem.
Same text as B 52.

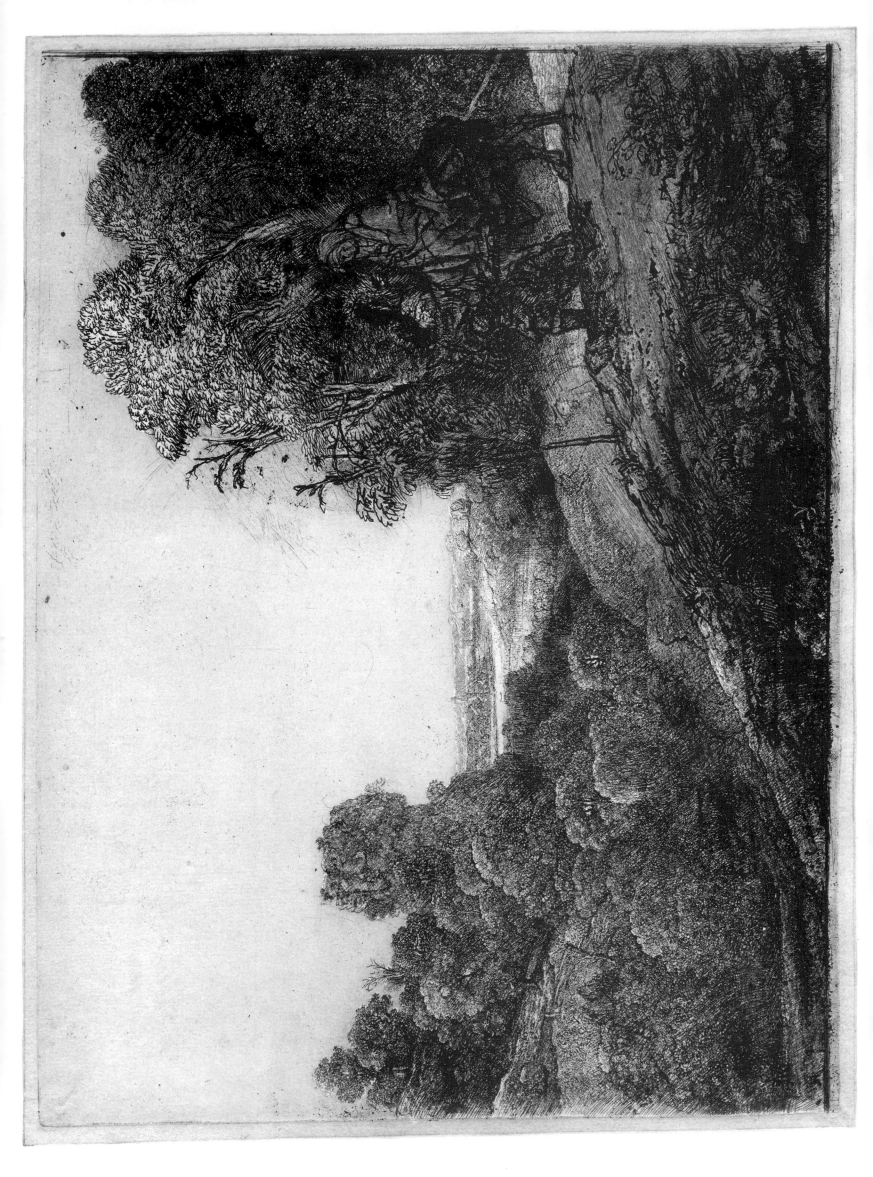

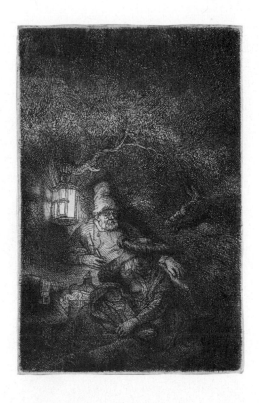

B 56
The flight into Egypt: altered from Seghers. With burin and drypoint. Fourth state of seven. Amsterdam.

About 1653. Same text as B 52. The first state, depicting Tobias and the angel, is entirely by Rembrandt's contemporary Hercules Seghers (1590-1640). The right half of the plate was burnished out and redone by Rembrandt as a *Flight into Egypt*, with smaller figures.

B 57
The rest on the flight: a night piece. With drypoint. Fourth state of four. Haarlem.

About 1644. This and the following two etchings depict an apocryphal subject with a long iconographical tradition.

B 58
The rest on the flight: lightly etched. With touches of drypoint. Only state. Signed and dated *Rembrandt f. 1645.* Haarlem.

See comment under B 57.

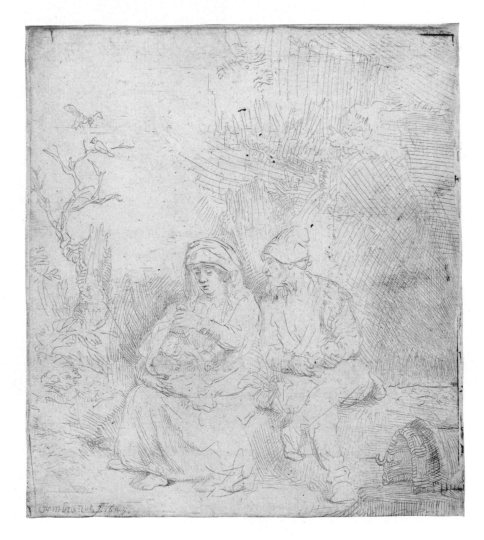

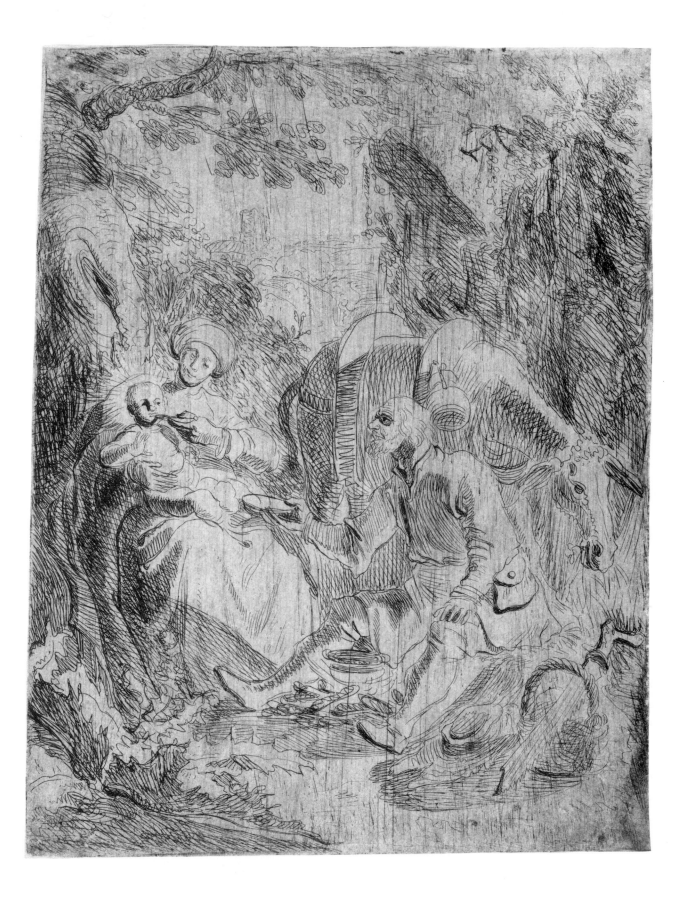

B 59
The rest on the flight into Egypt.
Only state. Amsterdam.
About 1626. See comment
under B 57. One of three
surviving impressions. Among
the earliest etchings, with s 398.
Both have the same rawness as
the paintings of that period.

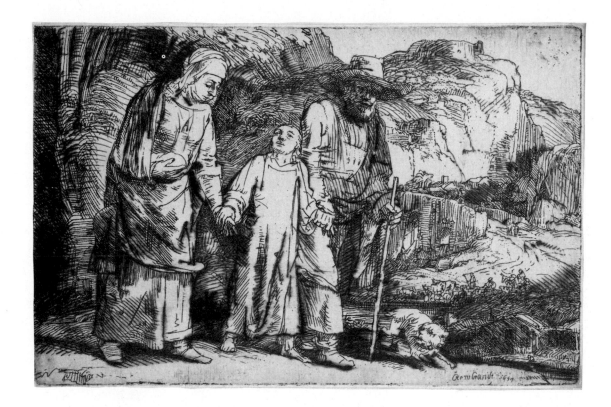

B 60
*Christ returning from the Temple
with his parents.* With drypoint.
Only state. Signed and dated
Rembrandt f. 1654. Haarlem.
 Luke 2:41-52.

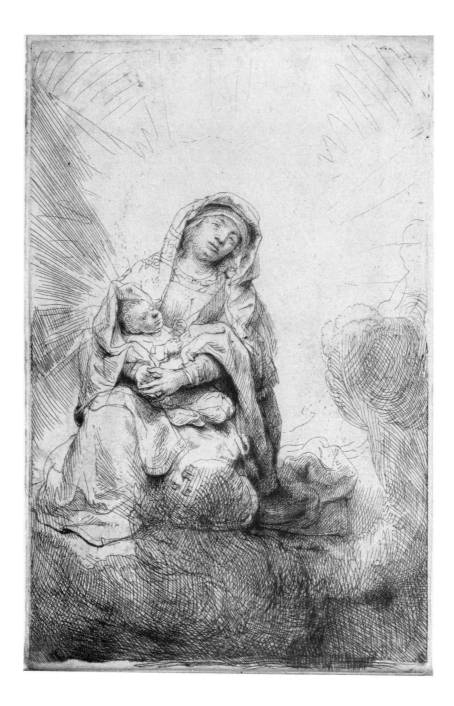

B 61
Virgin and child in the clouds.
With drypoint. Only state.
Signed and dated *Rembrandt f.*
1641, in the dark clouds.
Amsterdam.

This Catholic theme is unique
in Dutch 17th-century art.
The upside-down head near the
Virgin's left knee has been
variously interpreted as a
leftover from an earlier use of
the plate, a reflection of the
Virgin's face in the clouds, and a
false start on the Virgin's face,
after which the artist turned the
plate around and began again.

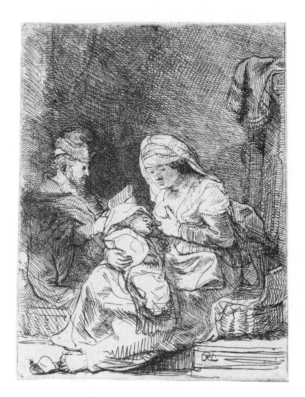

B 62
The holy family. Only state.
Signed *RHL*. Amsterdam.
 About 1632. Neither this
etching nor the following one
depicts a specific passage in the
Bible.

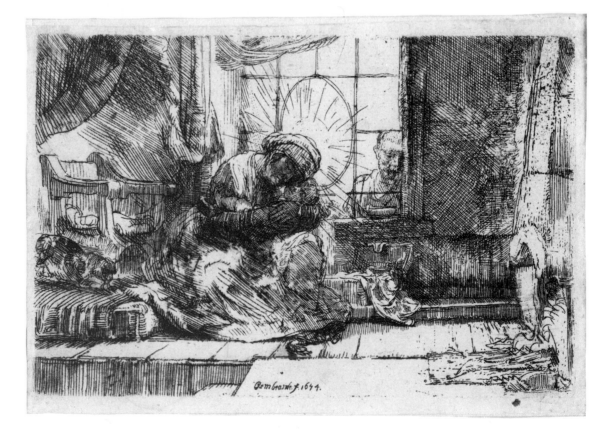

B 63
*The Virgin and child with the
cat and snake*. Second state of
two (with burin). Signed and
dated *Rembrandt f. 1654*.
Haarlem.
 See comment under B 62.

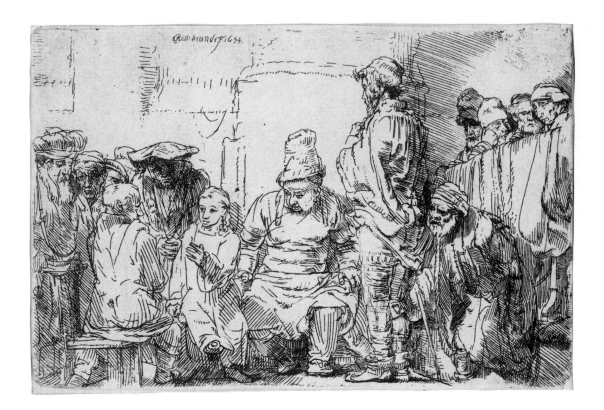

B 64
*Christ seated disputing with the
doctors*. Only state. Signed and
dated *Rembrandt f. 1654*.
Haarlem.
 Luke 2:41-52.

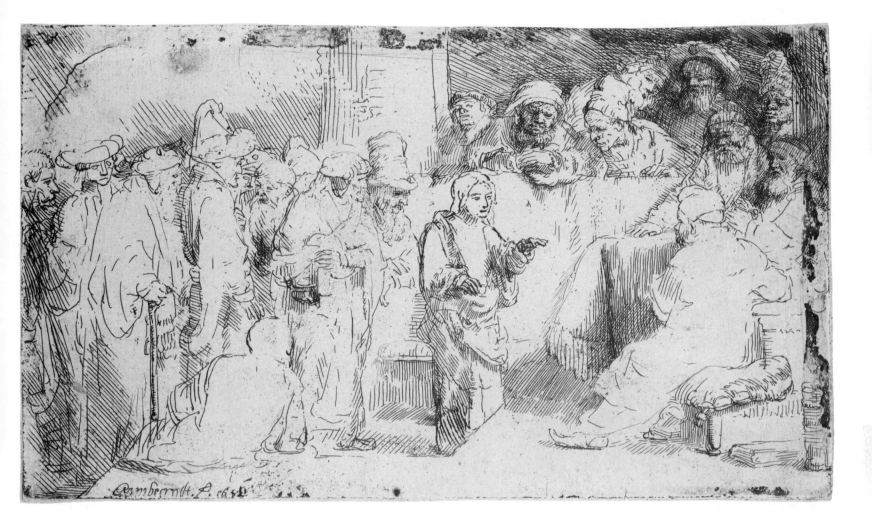

B 65
*Christ disputing with the doctors:
a sketch.* With drypoint. First
state of three. Signed and dated
Rembrandt f. 1652. Amsterdam.
 Same text as B 64. The date is
smudged by false biting – an area
of the plate etched although the
artist did not intend it to be.

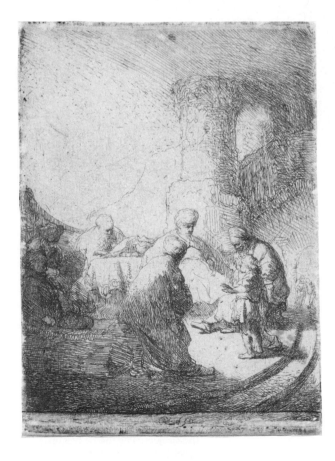

B 66
*Christ disputing with the doctors:
small plate.* Second state of
three. Signed and dated
RHL 1630. Amsterdam.
 Same text as B 64. In the third
state the plate was cut down on
three sides, removing the
monogram and dating.

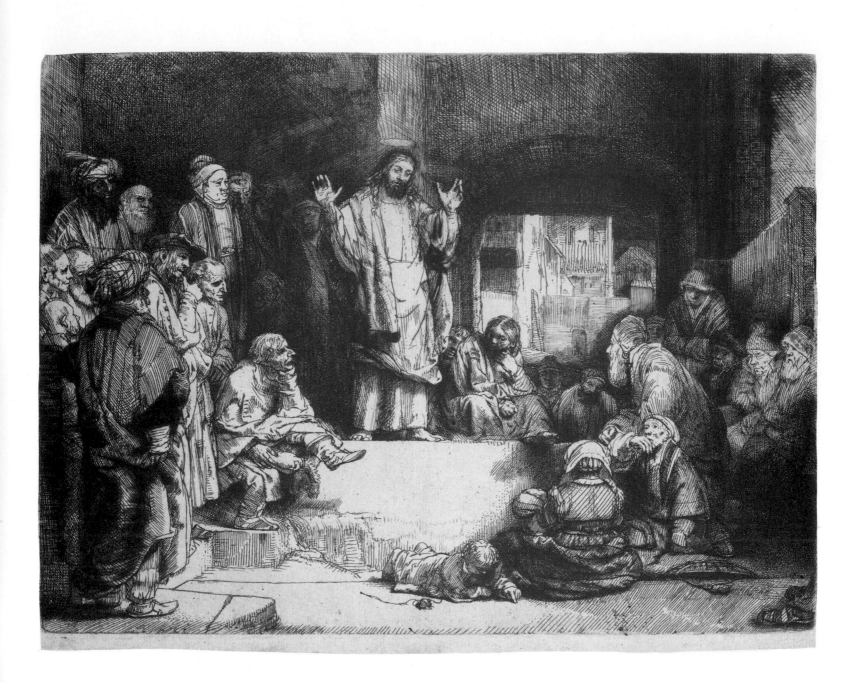

B 67
Christ preaching ['*La petite tombe*']. With burin and drypoint. Only state. Amsterdam.

About 1652. The traditional title (The small tomb) is based on an 18th-century misreading of the subject. The theme has no specific scriptural nor iconographic precedent. The same is true of B 74.

▶ B 68
The tribute money. First state of two. Haarlem.

About 1635. Matthew 22: 15-22.

▶ B 69
Christ driving the moneychangers from the Temple. First state of two. Signed and dated *Rembrandt f. 1635*. Haarlem. John 2:13-17.

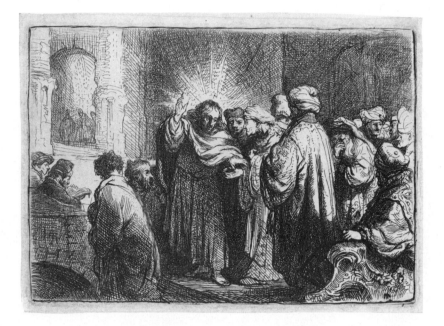

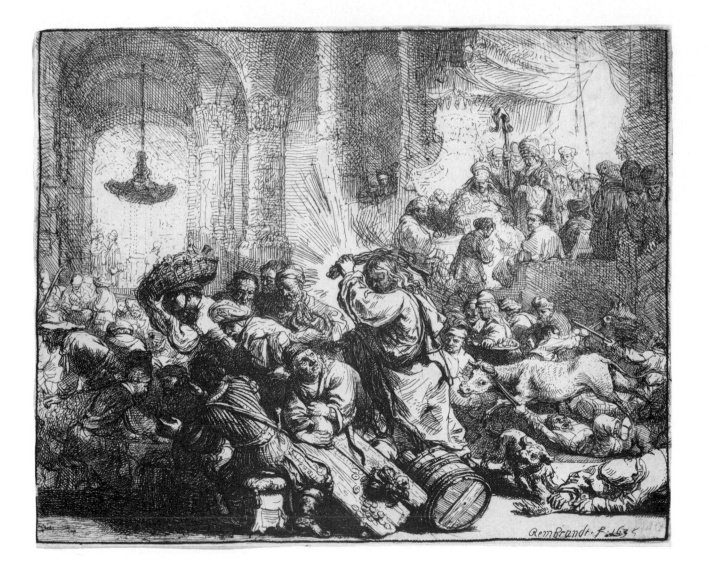

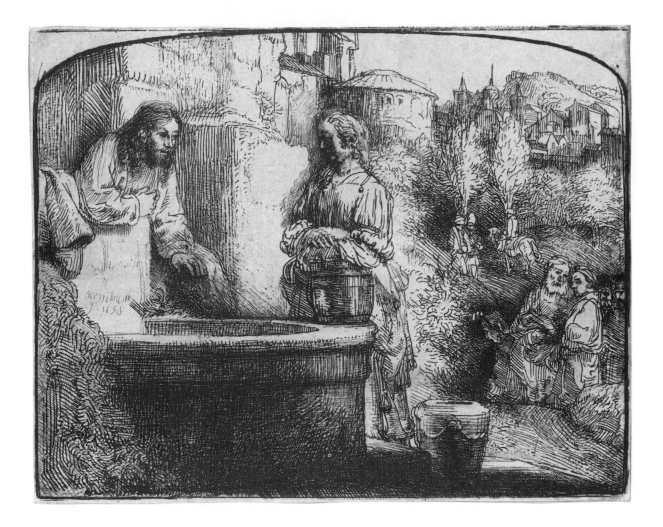

B 70
*Christic and the woman of Samaria:
an arched print*. With drypoint.
Third state of three. Signed and
dated *Rembrandt f. 1658.*
Haarlem.
John 4:5-42. Dated 1657 in
the first, incomplete state.

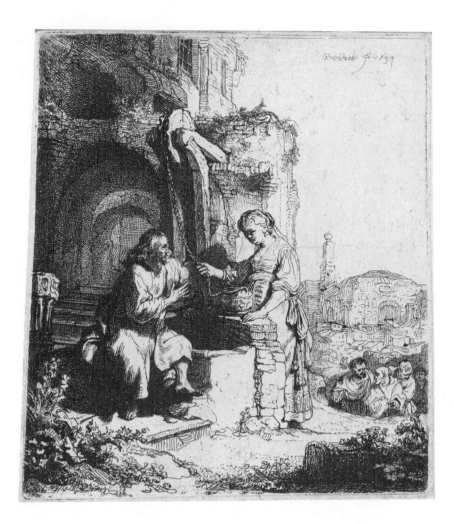

B 71
*Christic and the woman of
Samaria: among ruins.* First
state of two. Signed and dated
Rembrandt f. 1634. Haarlem.
 Same text as B 70.

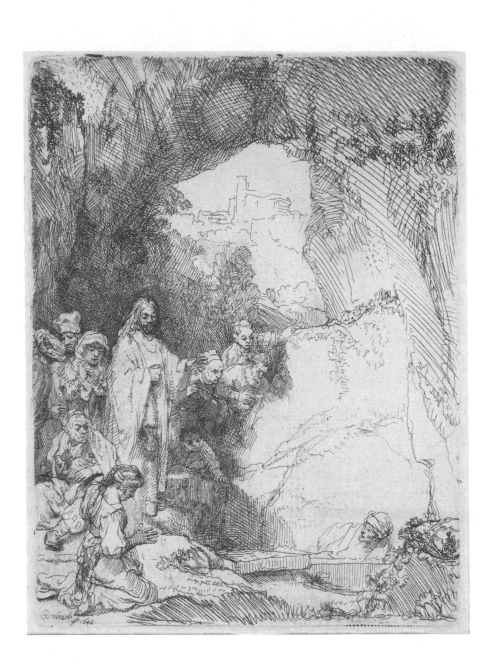

B 72
*The raising of Lazarus: the
small plate.* First state of two.
Signed and dated *Rembrandt f.
1642.* Haarlem.
John 11:1-44.

▶ B 73
*The raising of Lazarus: the
larger plate.* With burin.
Eighth state of ten. Signed
RHL van Ryn f. Amsterdam.
About 1630. The same text as
B 72. The only occurrence of
this form of signature, which
would read fully: Rembrandus
Hermanni Leidensis van Rijn
fecit.
*This illustration is reduced. For
a full-scale reproduction, see
outsize sheets.*
Original size 36.6× 25.8 cm.

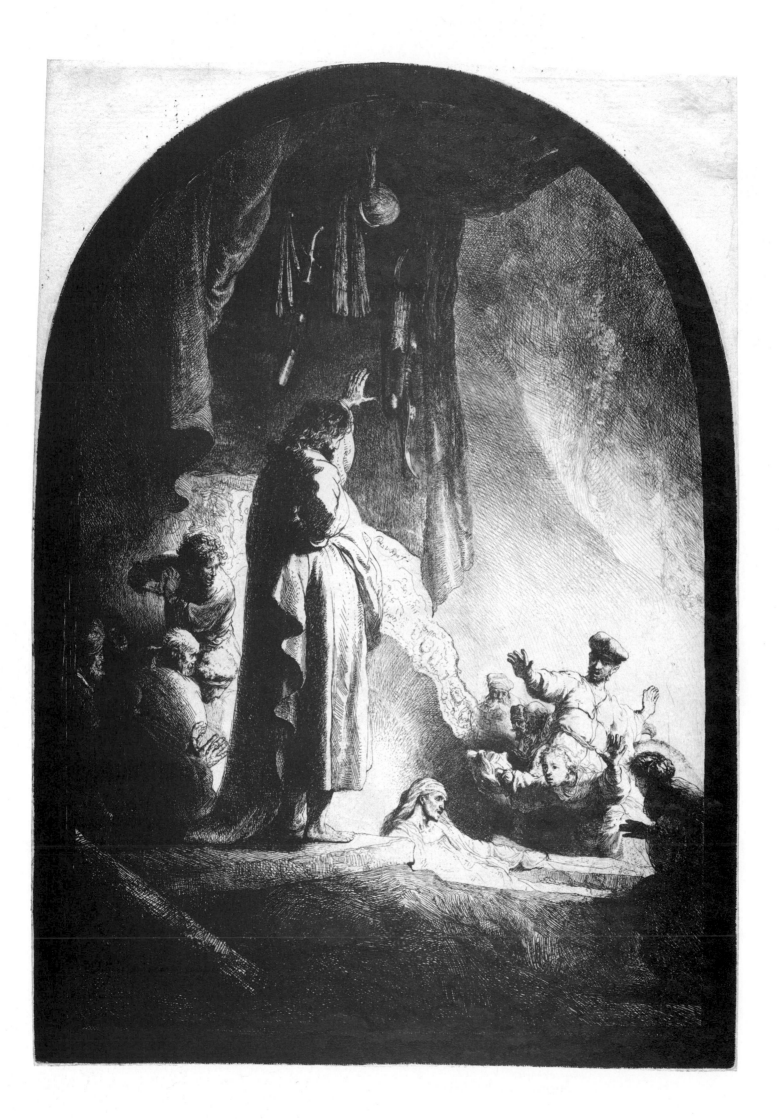

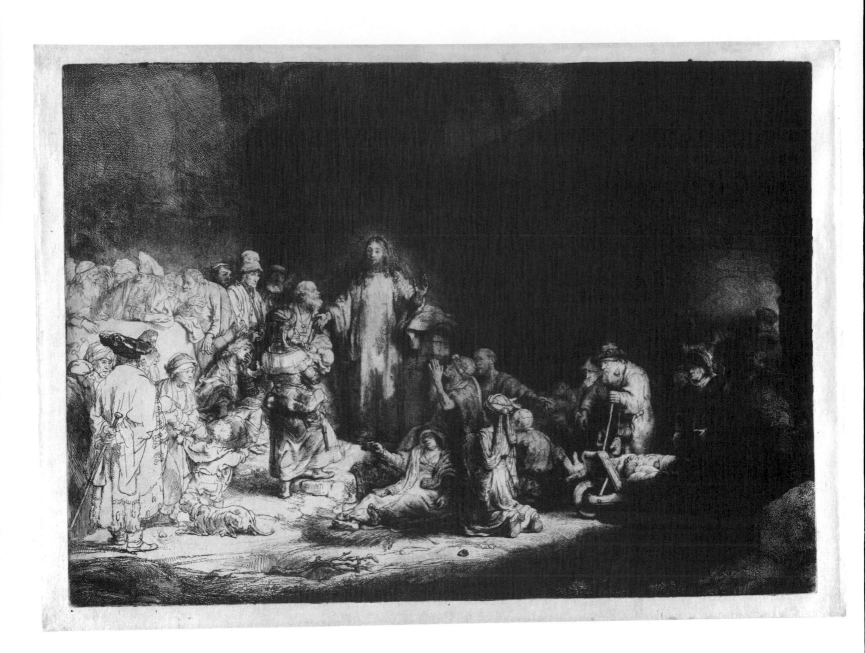

B 74
Christ preaching ['*The hundred-guilder print*']. With drypoint and burin. Second state of two. Amsterdam.

About 1643-49. The main themes of Matthew 19 are telescoped by Rembrandt into a single scene, unprecedented in earlier iconography. Cf. B 67. The traditional title refers to the unusually high price the print was said to have fetched in the 17th century.

This illustration is reduced. For a full-scale reproduction, see outsize sheets.

Original size 27.8 × 38.8 cm.

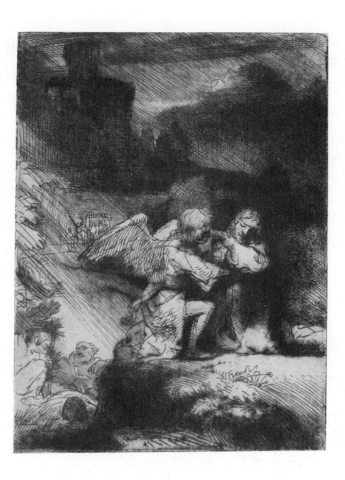

B 75
The agony in the garden. With
drypoint. Only state. Signed and
dated *Rembrandt f. 165-* (last
digit missing). An early
impression printed on Japanese
paper. Amsterdam.

About 1657. Luke 22:39-46.

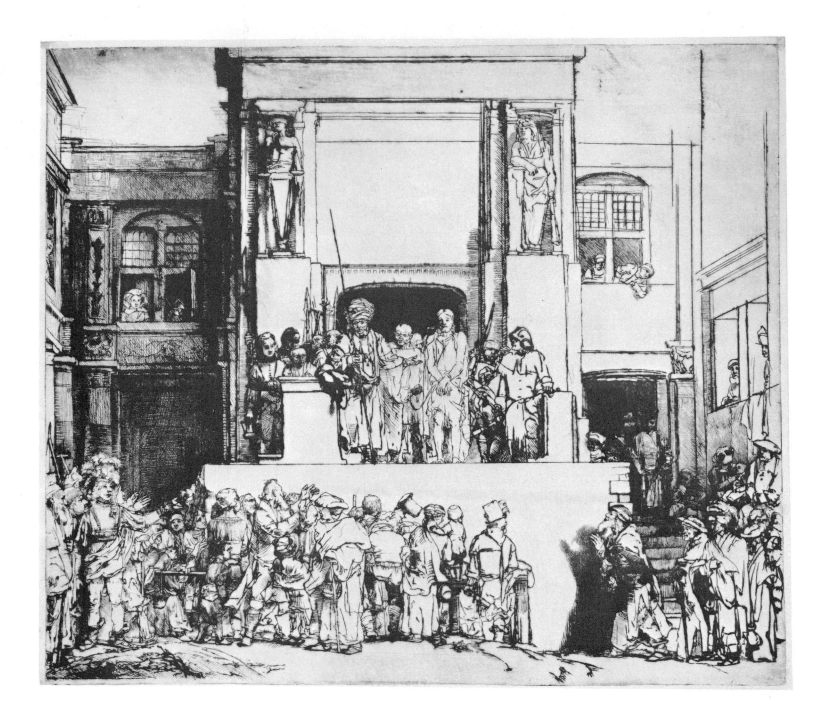

B 76
Christ presented to the people:
the oblong plate. Drypoint only.
Third state of eight. Printed on
Japanese paper. Amsterdam.
 Matthew 27:15-26. See
following number.
 This illustration is reduced. For
a full-scale reproduction, see
outsize sheets.
 Original size 38.3×45.5 cm.

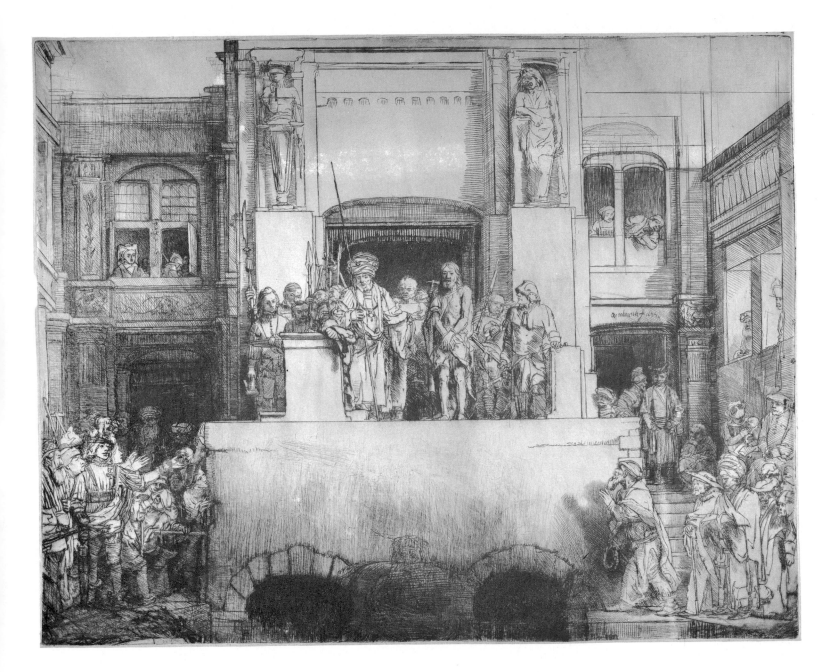

The same plate, in the seventh
state. Signed and dated
Rembrandt f. 1655. Printed on
Japanese paper. Amsterdam.
 The signature was added in
this state. The removal of the
foreground figures had occurred
in the sixth state, and the
trimming of the upper margin in
the fourth.
 *This illustration is reduced. For
a full-scale reproduction of the
third state, see outsize sheets.*
 Original size 35.8 × 45.5 cm.

▶ B 77
Christ before Pilate: larger plate.
Second state of five. Signed and
dated *Rembrandt f. 1636 cum
privile*. Amsterdam.
Signed and dated 1635 in the
first, unfinished state. John
19:1-16. Only in this plate and in
B 81 (II) of 1633–his two largest
etchings–did Rembrandt claim
the 'privilege' of copyright.
*This illustration is reduced. For
a full-scale reproduction, see
outsize sheets.*
Original size 54.9×44.7 cm.

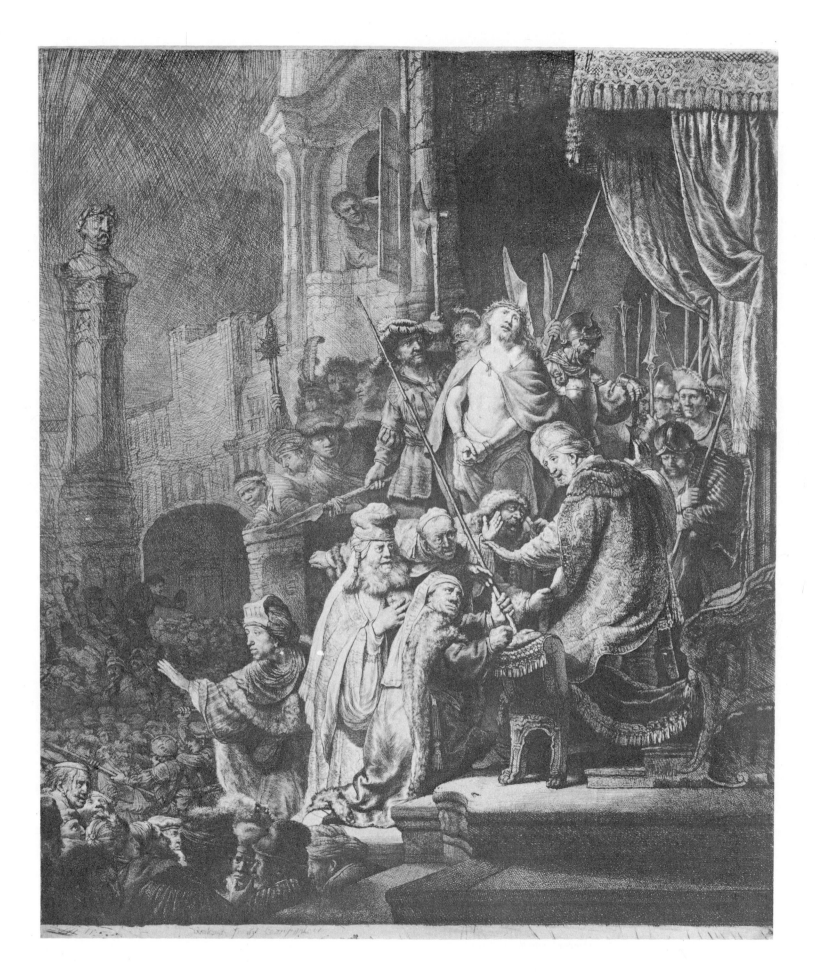

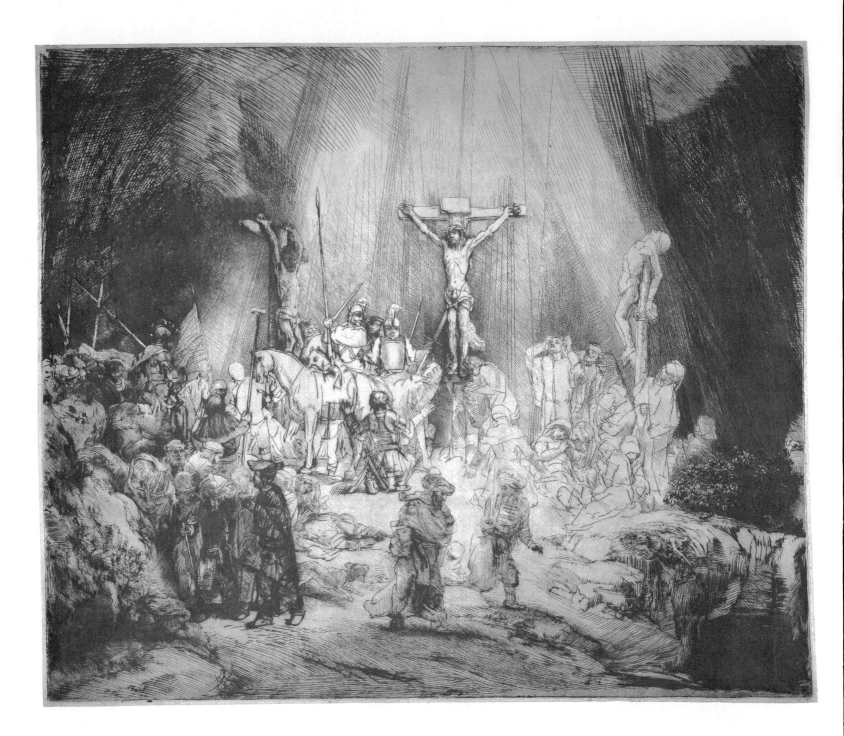

B 78
Christ crucified between the two thieves ['*The three crosses*'].
Drypoint and burin only. First state of five. Amsterdam.
 The third state is signed and dated *Rembrandt f. 1653.*
Matthew 27:33-56.
 This illustration is reduced. For a full-scale reproduction of the fourth state, see outsize sheets.
 Original size 38.5×45 cm.

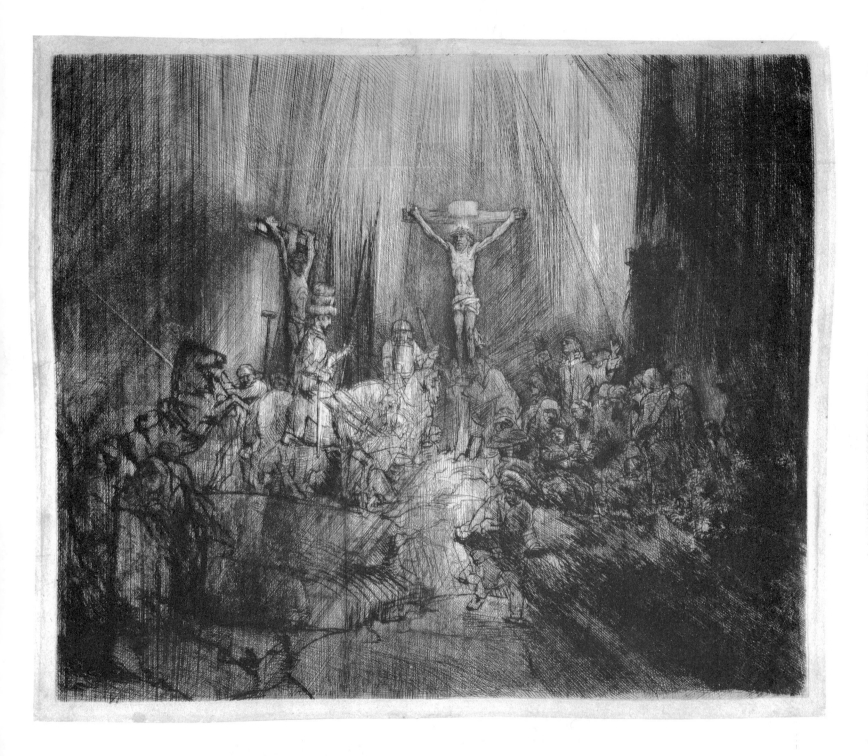

The same plate, in the fourth
state. This is the state in which
the total transformation of the
plate took place. Amsterdam.
 *This illustration is reduced. For
a full-scale reproduction, see
outsize sheets.*
 Original size 38.5 × 45 cm.

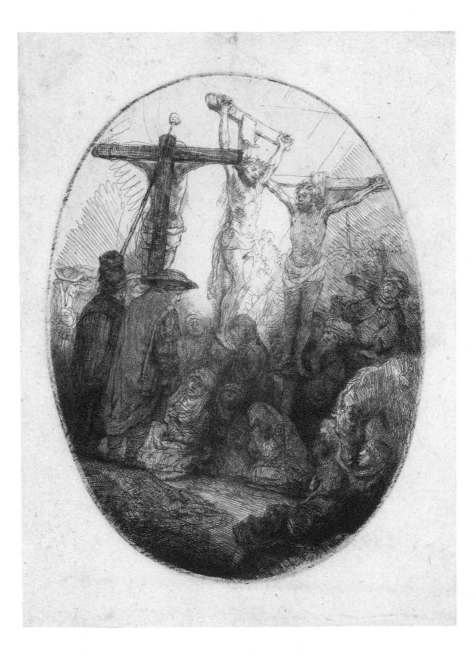

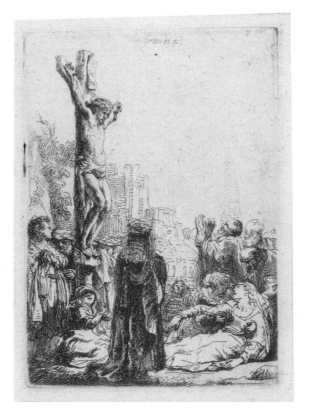

B 79
Christ crucified between the two thieves: an oval plate. With drypoint. First state of two. Haarlem.

About 1641. Same text as B 78.

B 80
The crucifixion: small plate. Only state. Signed *Rembrandt f.* Haarlem.

About 1635. Same text as B 78.

▶ B 81 (11)
The descent from the cross: the second plate. With burin. Second state of five. Signed and dated *Rembrandt f. cum pryvl⁰ 1633.* Amsterdam.

John 19:38-42. Based on Rembrandt's painting for Stadholder Frederick Henry. An earlier version of this huge plate was a failure and had to be discarded. See comment under B 77.

This illustration is reduced. For a full-scale reproduction, see outsize sheets.

Original size 53×41 cm.

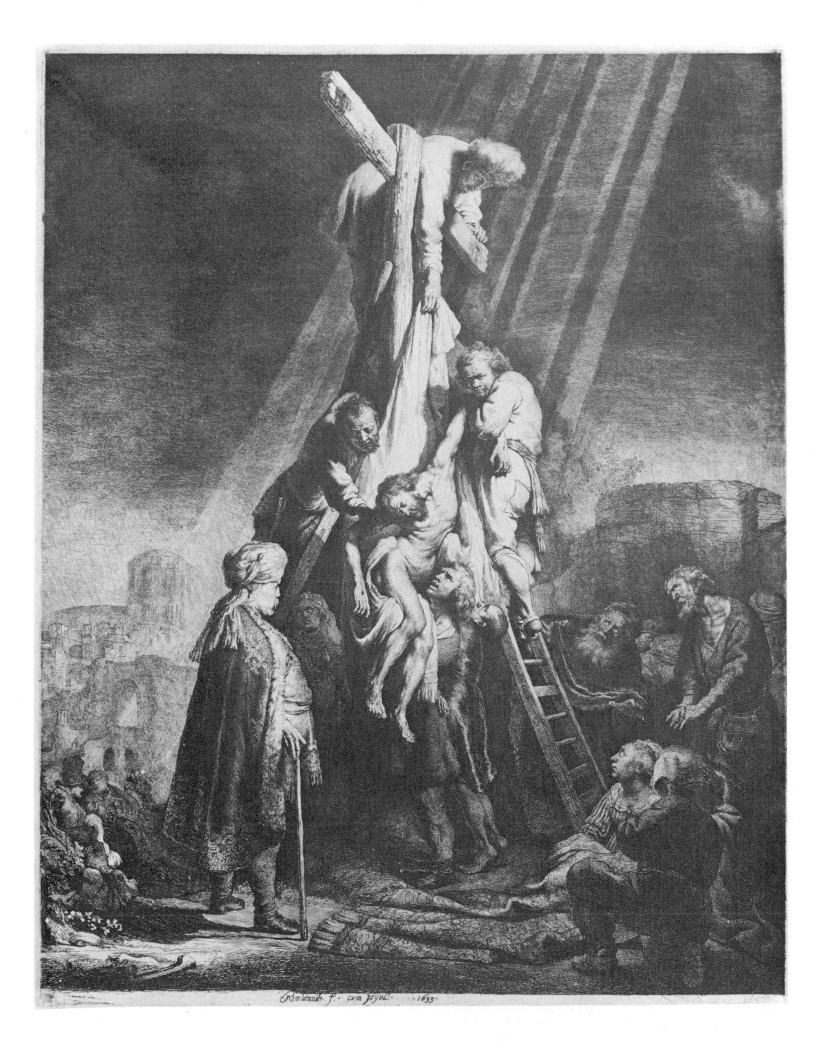

Rembrandt. f. cvm privl. 1633.

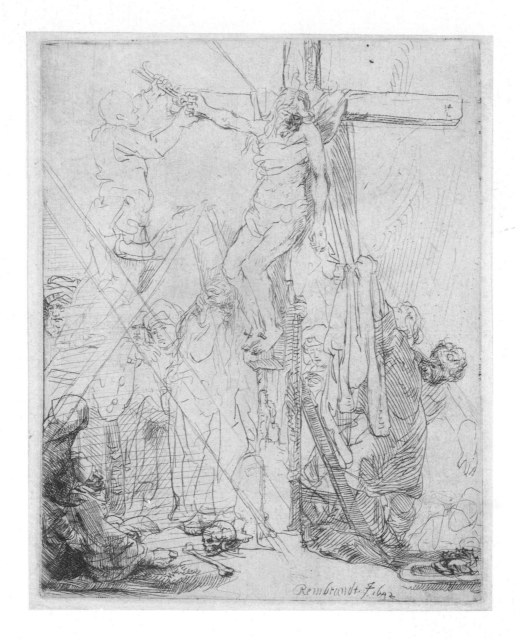

B 82
The descent from the cross: a
sketch. With drypoint. Only
state. Signed and dated
Rembrandt f. 1642. Haarlem.
Same text as B 81.

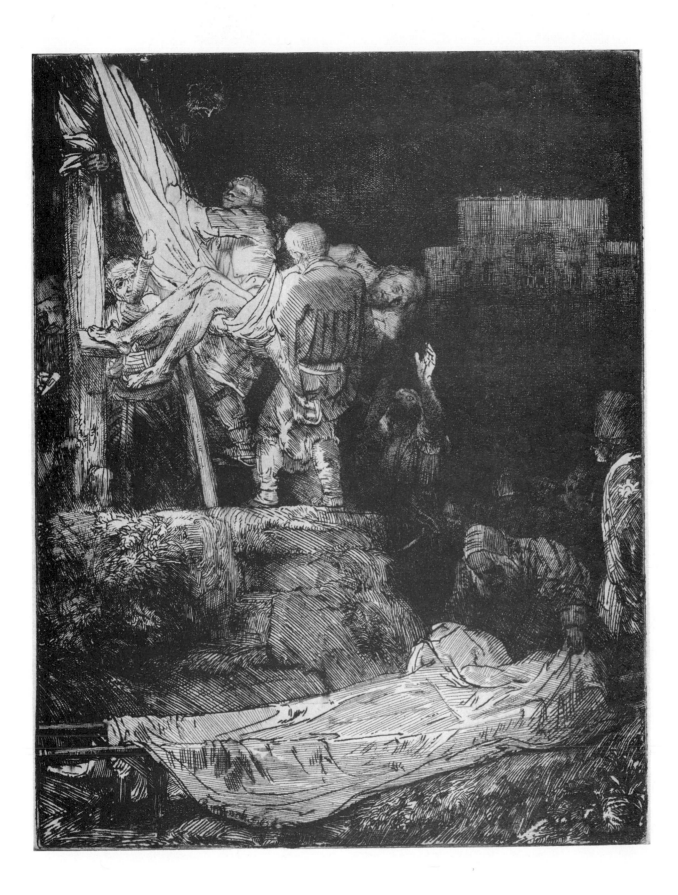

B 83
The descent from the cross by torchlight. With drypoint. Only state. Signed and dated *Rembrandt f. 1654.* Haarlem. Same text as B 81.

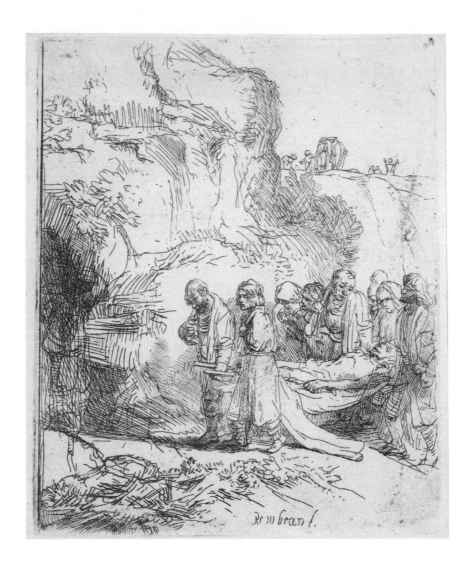

B 84
Christ carried to the tomb. With
touches of drypoint. Only state.
Signed *Rembrant*. Haarlem.
 About 1645. Matthew
27:59-61.

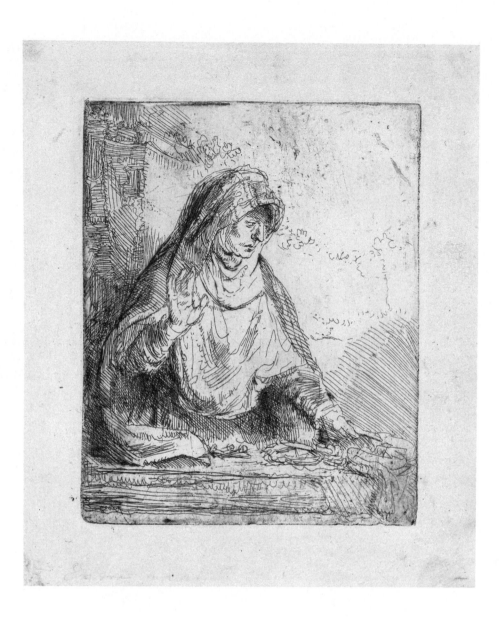

B 85
*The Virgin with the instruments
of the passion.* With drypoint.
Only state. Amsterdam.
 About 1652. Not a subject
with a specific biblical reference.

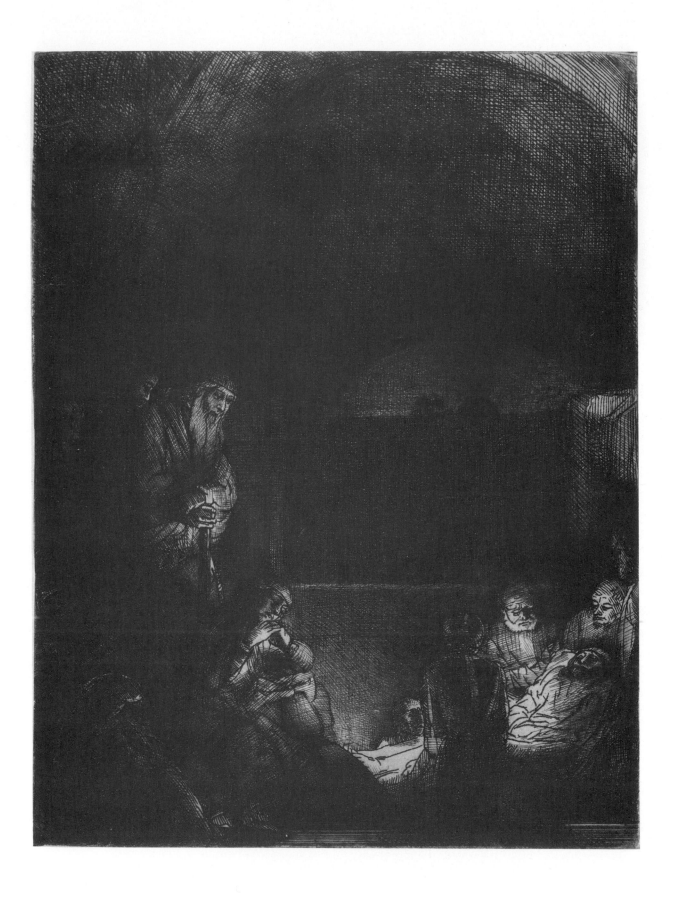

B 86
The entombment. With drypoint
and burin. Third state of four.
Haarlem.
 About 1654. Same text as B 84.

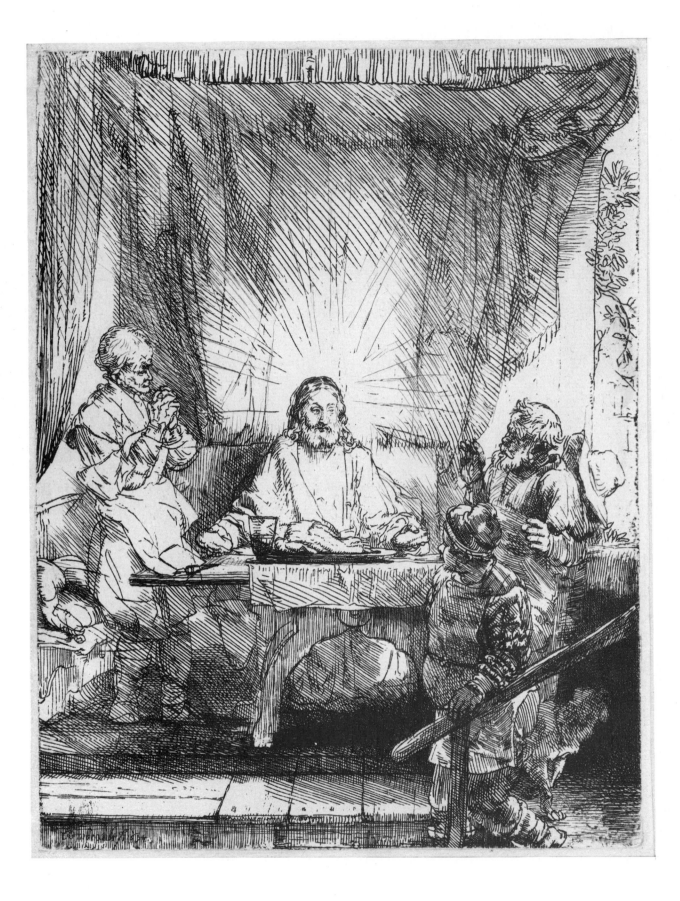

B 87
*Christ at Emmaus: the larger
plate.* With burin and drypoint.
Third state of three. Signed and
dated *Rembrandt f. 1654.*
Haarlem.
 Luke 24:13-31.

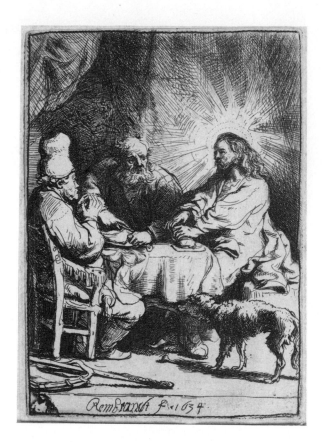

B 88
Christt at Emmaus: the smaller plate. With touches of drypoint.
Only state. Signed and dated
Rembrandt f. 1634. Haarlem.
 Same text as B 87.

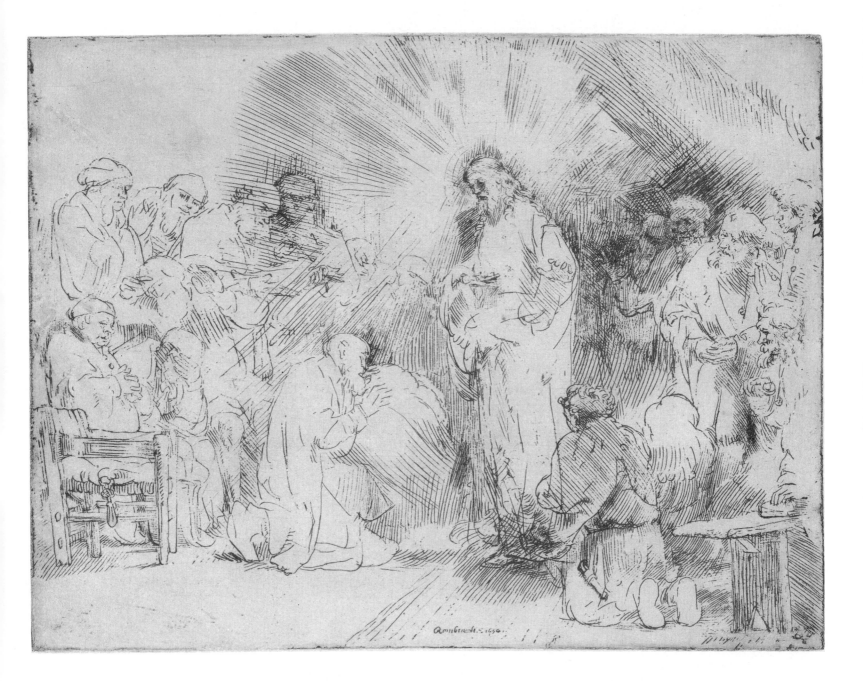

B 89
Christ appearing to the apostles.
Only state. Signed and dáted
Rembrandt f. 1656. Amsterdam.
John 20:19-29.

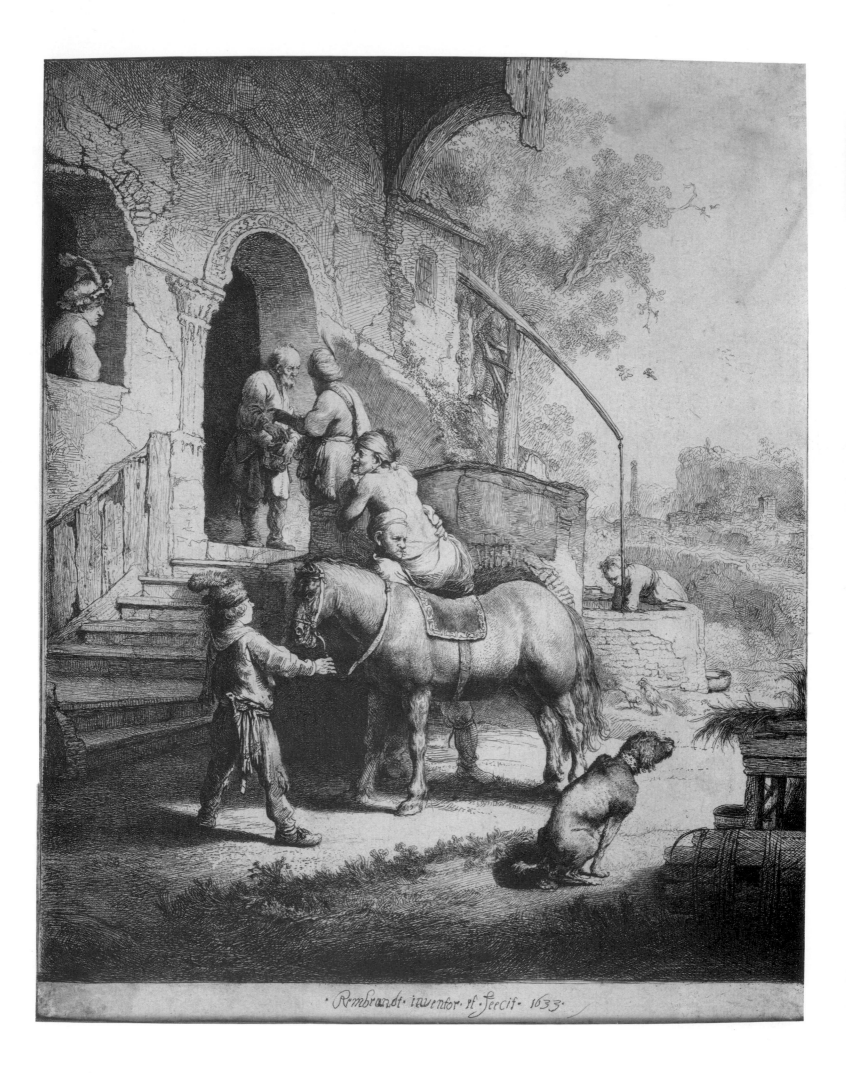

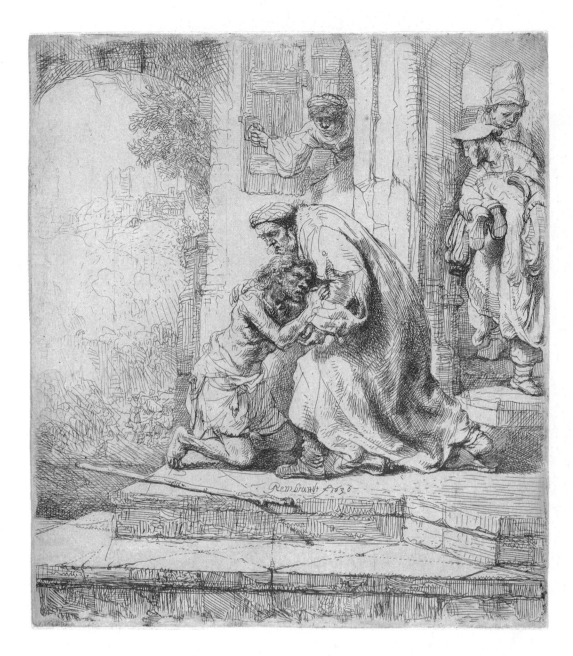

◄ B 90

The good Samaritan. With burin.
Fourth state of four. Signed and
dated *Rembrandt inventor et
Feecit. 1633.* Amsterdam.

Luke 10:30-35. The signature
appears for the first in this state.
See comment under B 52.

B 91
The return of the prodigal son.
Only state. Signed and dated
Rembrandt f. 1636. Amsterdam.
Luke 15:11-32.

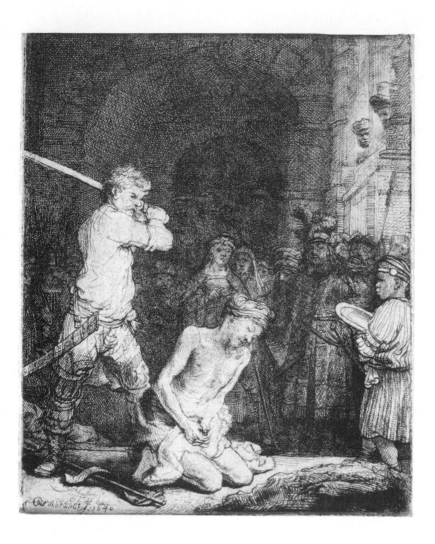

B 92
*The beheading of John the
Baptist*. With drypoint. First
state of two. Signed and dated
Rembrandt f. 1640. Amsterdam.
Matthew 14:3-11.

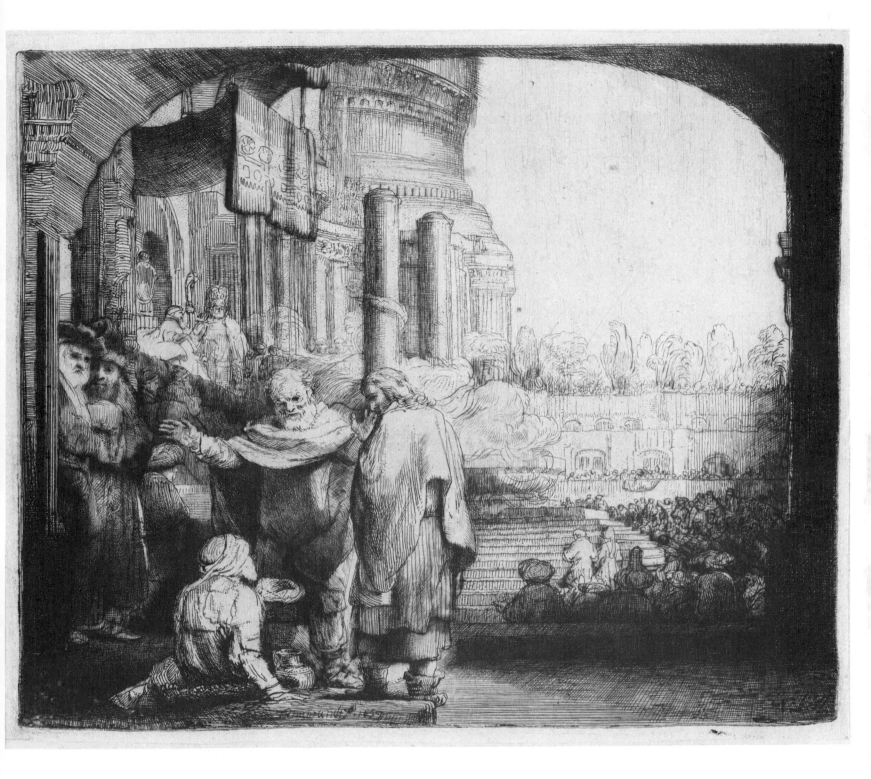

B 94
*Peter and John healing the cripple
at the gate of the Temple.* With
drypoint and burin. Second
state of four. Signed and dated
Rembrandt f. 1659. Haarlem.
Acts 3:1-8.

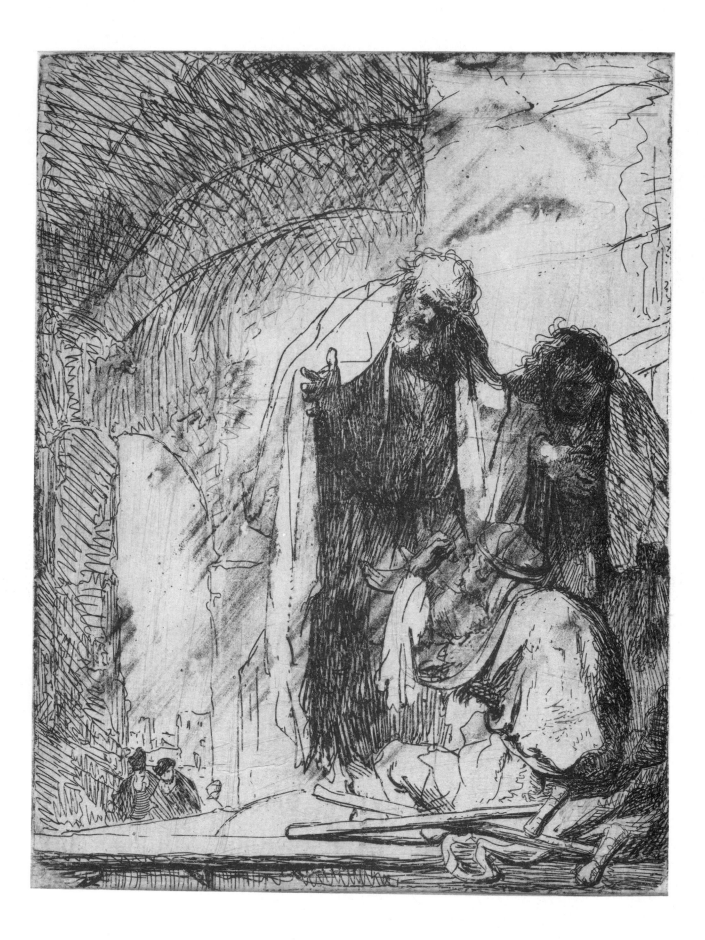

B 95
*Peter and John at the gate of the
Temple: roughly etched.* Only
state. Amsterdam.
About 1629. Same text as B 94.

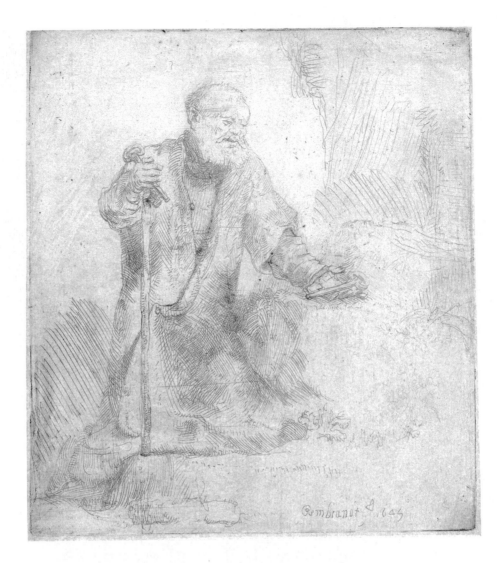

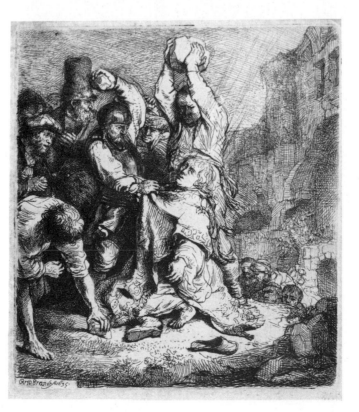

B 96
St. Peter in penitence. Only state.
Signed and dated *Rembrandt f.*
1645. Amsterdam.
 Matthew 26:75.

B 97
The stoning of St. Stephen. First
state of two. Signed and dated
Rembrandt f. 1635. Haarlem.
 Acts 7:58-60.

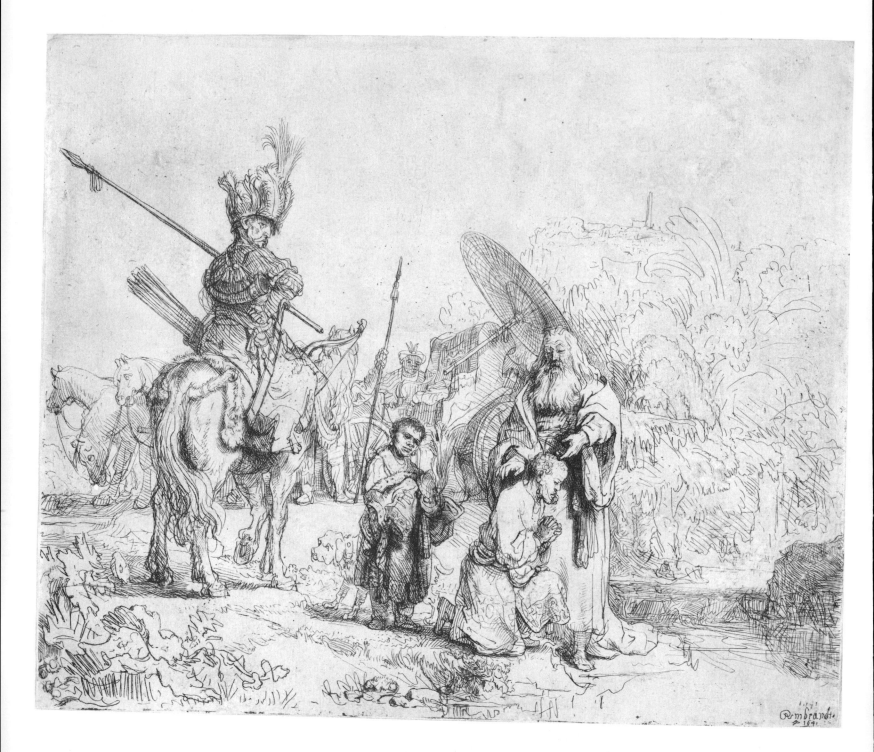

B 98
The baptism of the eunuch.
Second state of two. Signed and
dated *Rembrandt f. 1641.*
Haarlem.
Acts 89:26-39.

► B 99
The death of the Virgin. With
drypoint. First state of three.
Signed and dated *Rembrandt f.
1639.* Amsterdam.
An apocryphal theme with a
long iconographic tradition.
*This illustration is reduced. For
a full-scale reproduction, see
outsize sheets.*
Original size 40.9×31.5 cm.

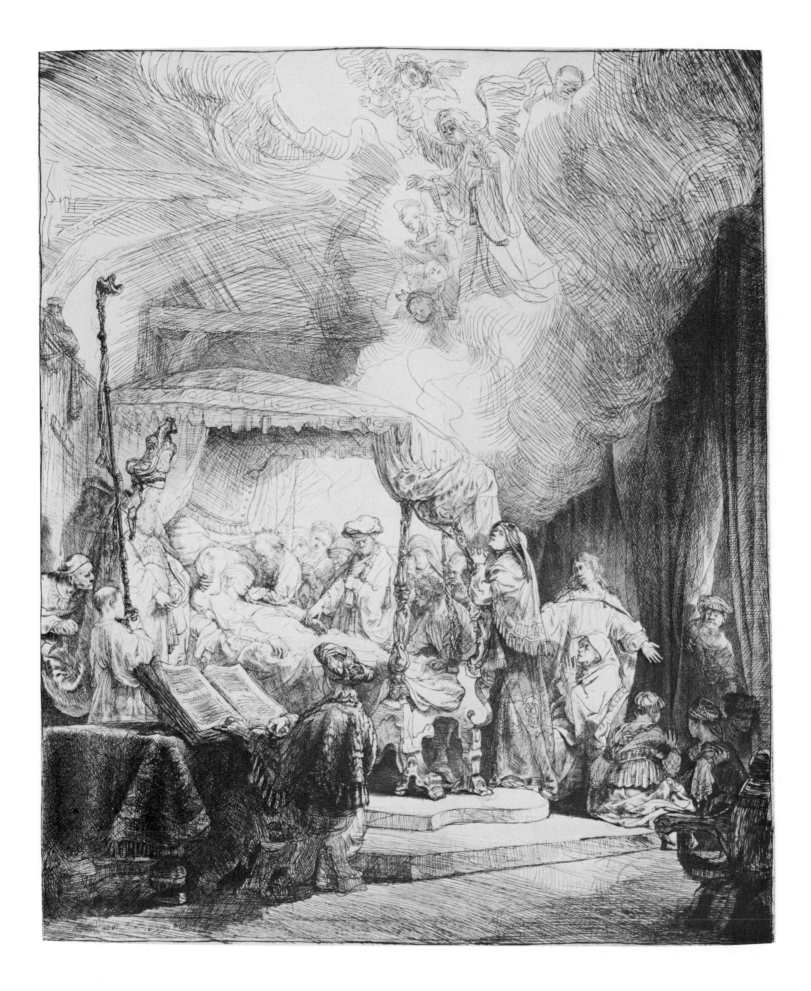

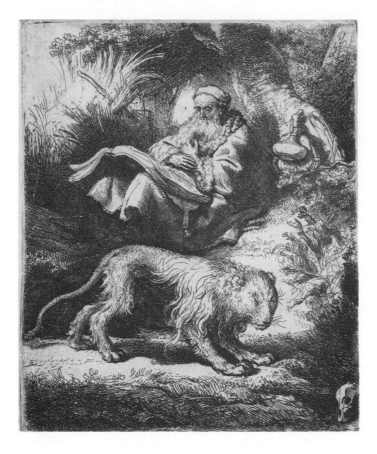

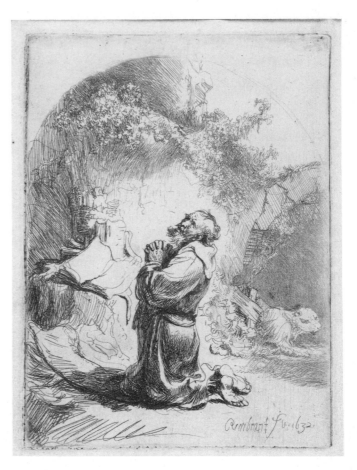

B 100

St. Jerome reading. Only state.
Signed and dated *Rembrandt f.*
1634, in the shadows at the
lower left. Haarlem.

B 101

St. Jerome praying: arched print.
First state of three. Signed and
dated *Rembrandt ft. 1632.*
Haarlem.

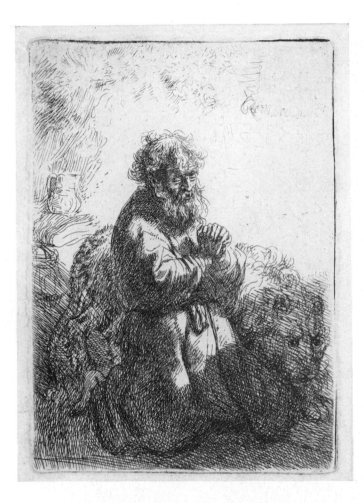

B 102
St. Jerome kneeling in prayer,
looking down. Only state. Signed
and dated *Rembrandt f. 1635,*
faintly. Haarlem.

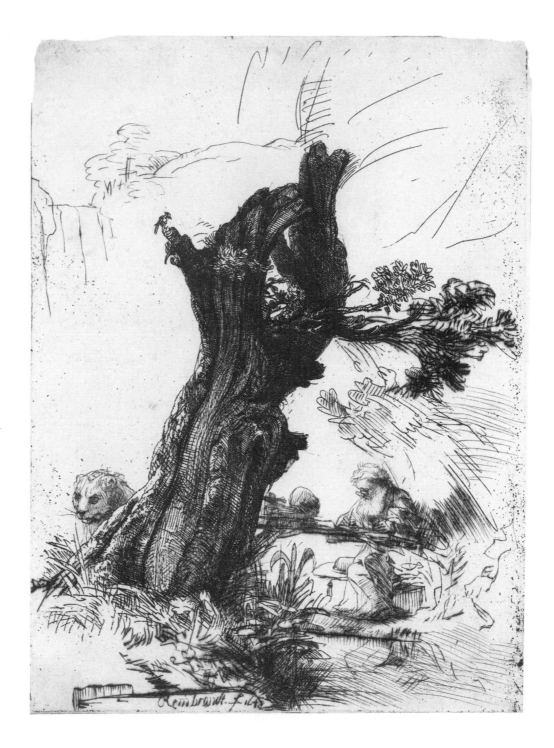

B 103
*St. Jerome beside a pollard
willow.* With drypoint. Second
state of two. Signed and dated
Rembrandt f. 1648. Haarlem.
Signature lacking in first state.

▶ B 104
*St. Jerome reading in an Italian
lanascape.* With burin and
drypoint. Second state of two.
Haarlem.
About 1654.

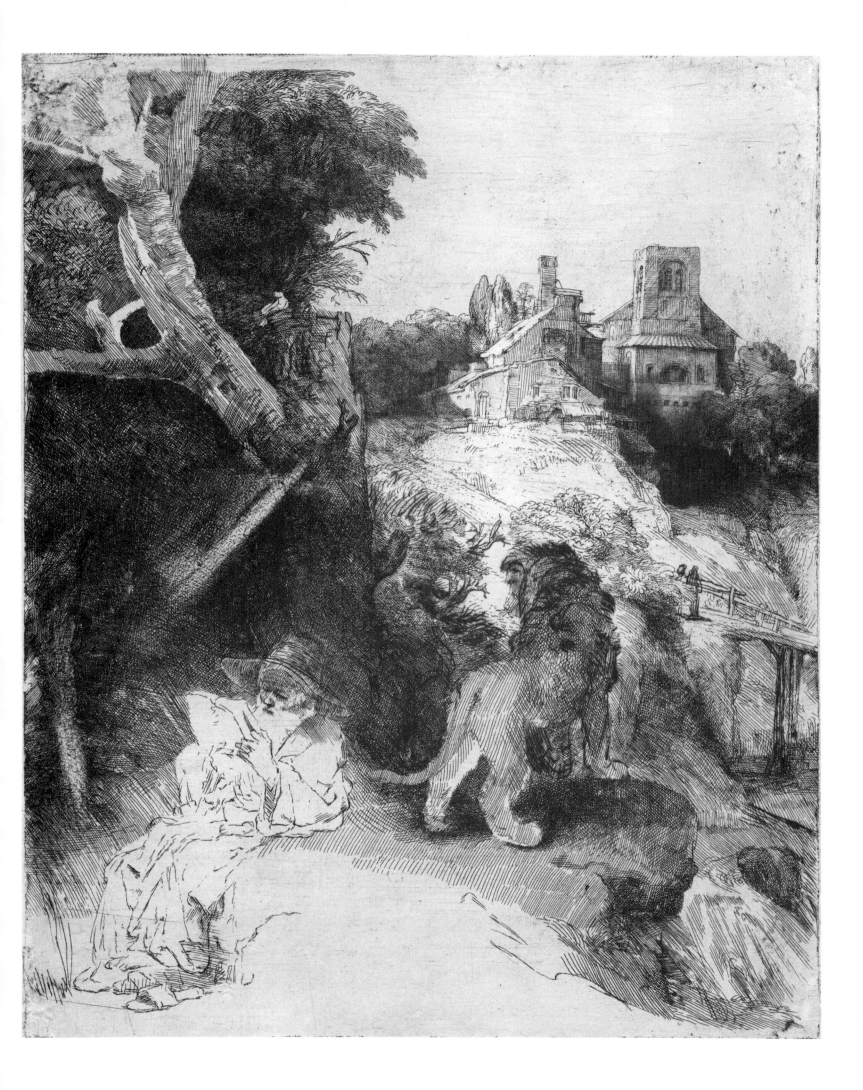

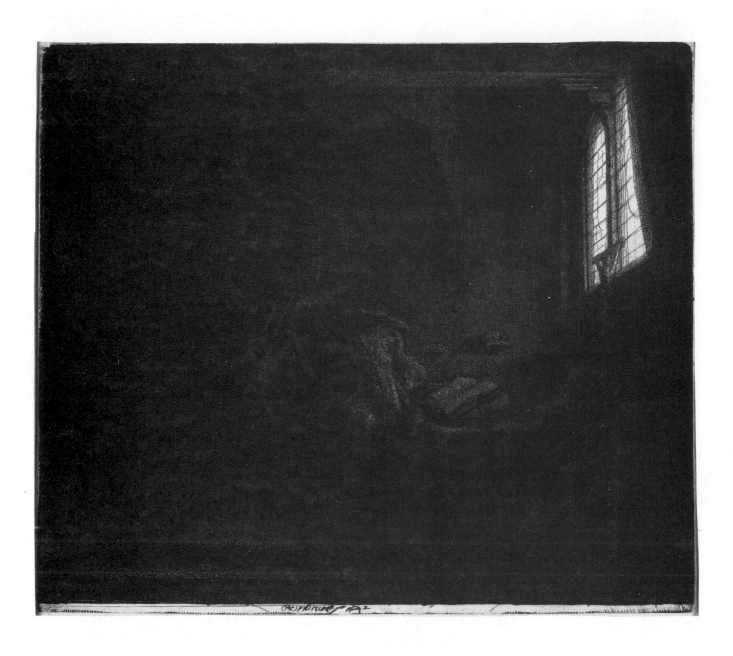

B 105
St. Jerome in a dark chamber.
First state of two. Signed and
dated *Rembrandt f. 1642.*
Amsterdam.

▶ B 106
St. Jerome kneeling: a large plate.
Only state. Amsterdam.
 About 1629. One of the two
surviving impressions.
 *This illustration is reduced. For
a full-scale reproduction, see
outsize sheets.*
 Original size 38.9× 33.2 cm.

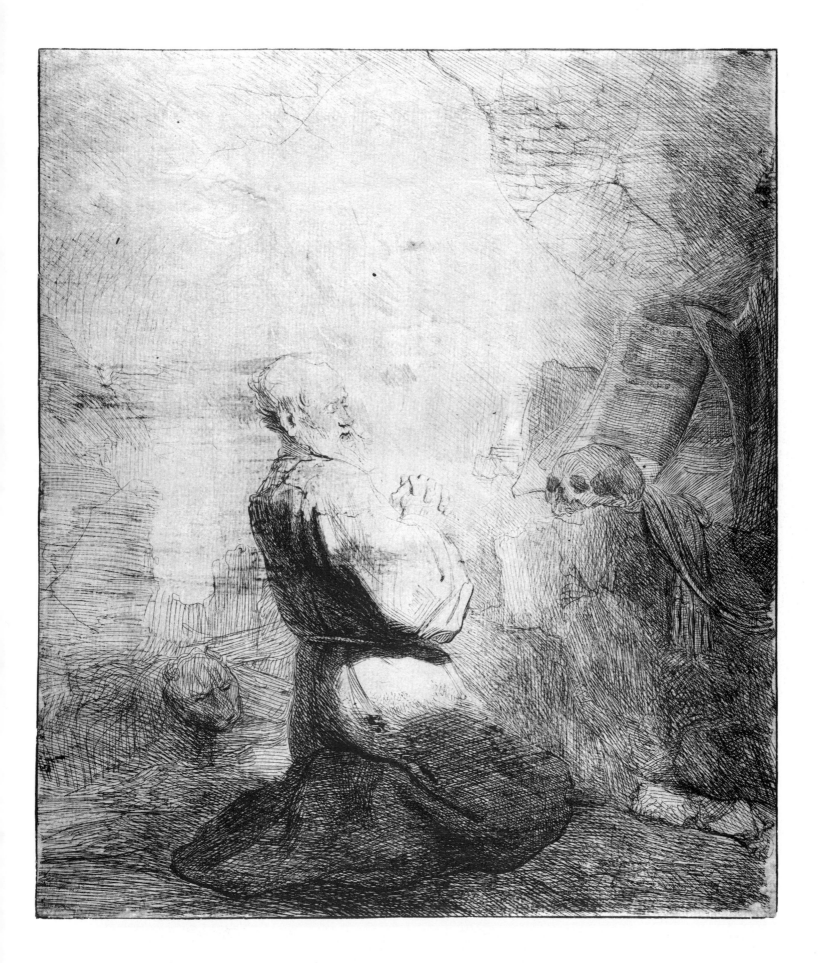

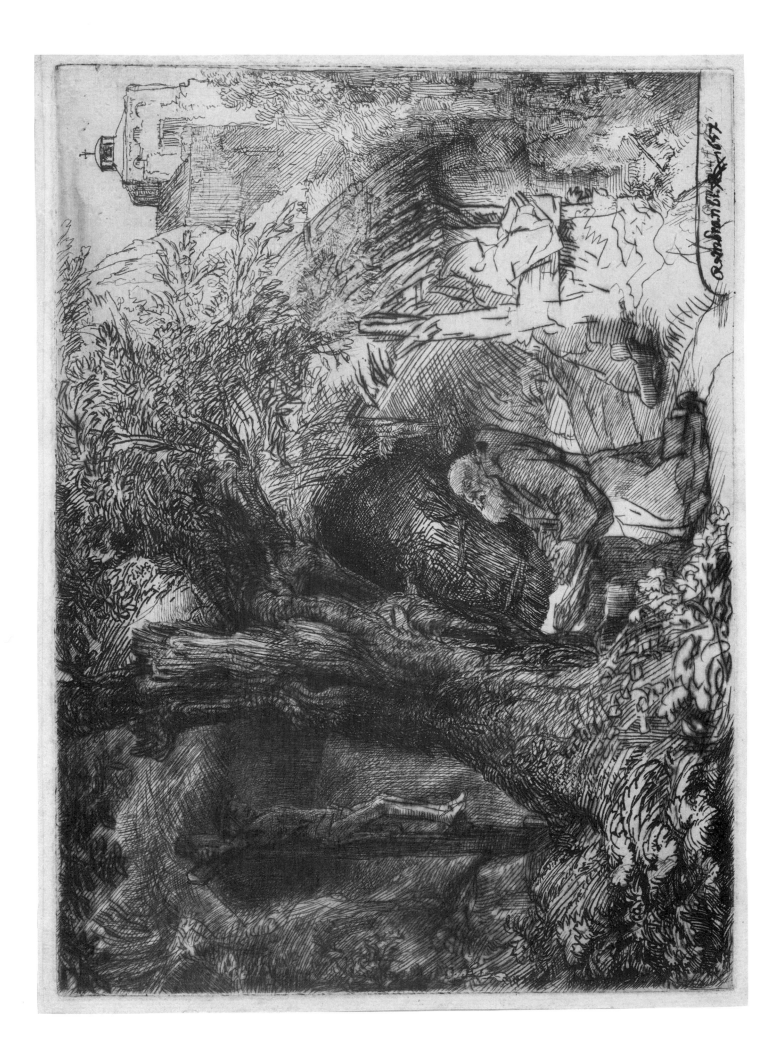

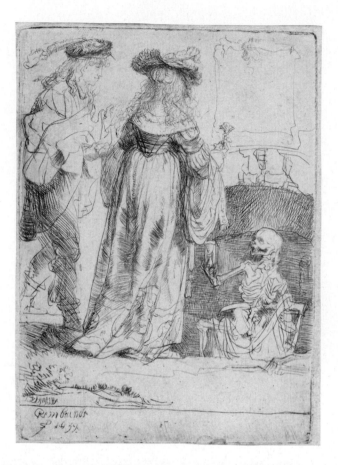

◄ B 107
*St. Francis beneath a tree
praying.* Drypoint. Second state
of two (with etching). Signed and
dated twice *Rembrandt f. 1657.*
Printed on Japanese paper.
Haarlem.

B 109
*Death appearing to a wedded
couple from an open grave.* Only
state. Signed and dated
Rembrandt f. 1639. Haarlem.

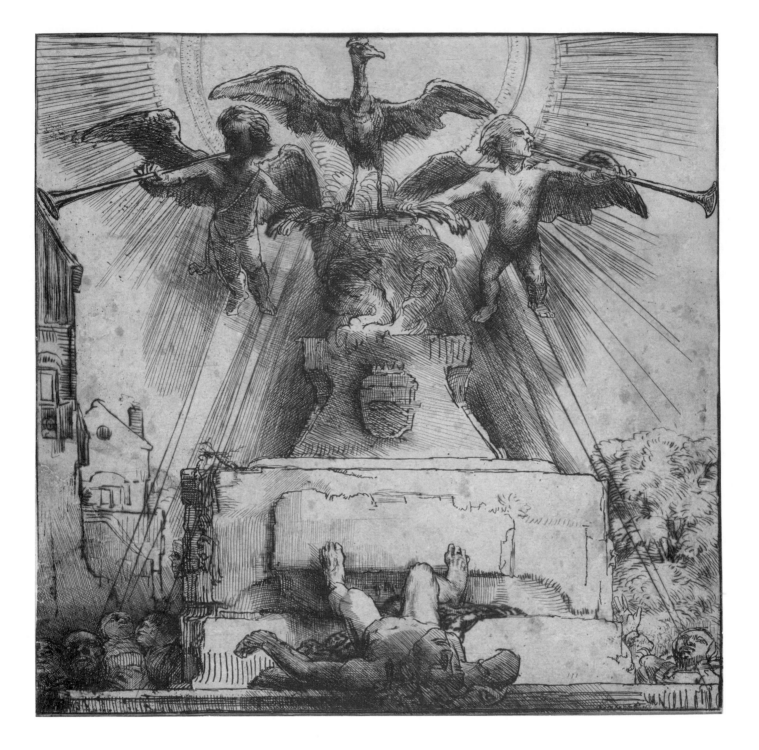

B 110

The phoenix or the statue overthrown. With drypoint. Only state. Signed and dated *Rembrandt f. 1658*, in the shadows in the lower center. Haarlem.

The specific reference of the subject has not yet been conclusively identified.

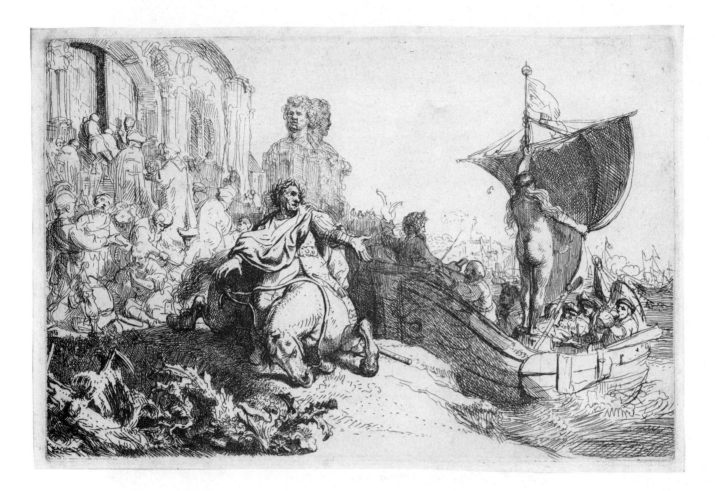

B III
The ship of fortune. Second state
of two. Signed and dated
Rembrandt f. 1633. Haarlem.

In this state the signature is
partly burnished out. Served as
an illustration for a book on the
history of navigation by
E. Herckmans, *Der zee-vaert lof*
(In praise of sailing), Amsterdam
1634.

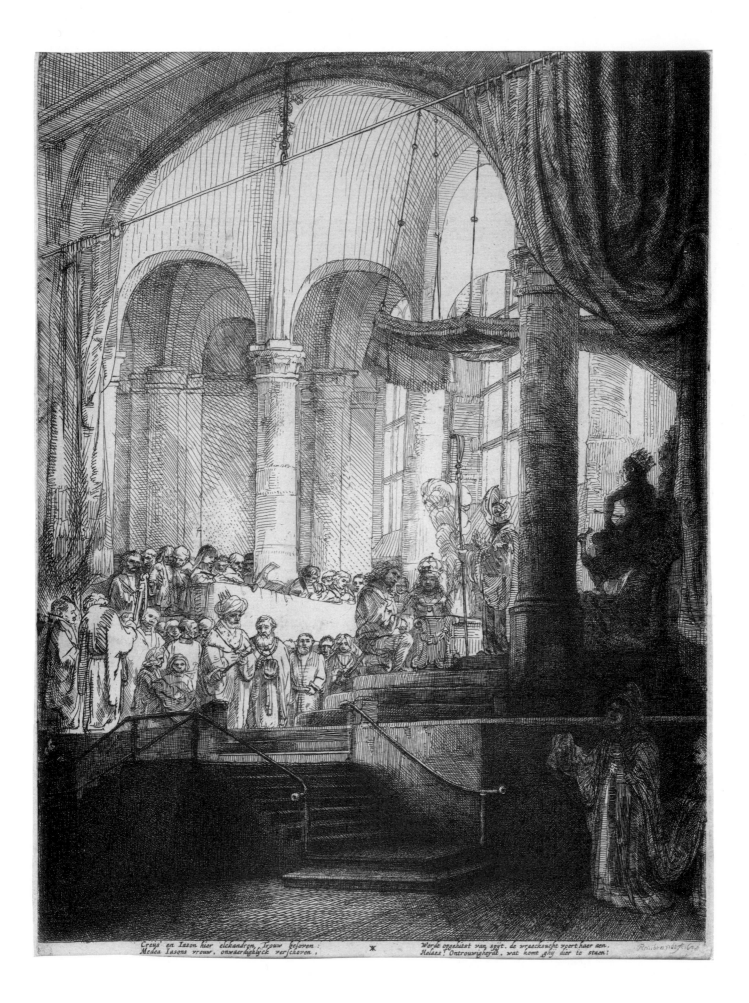

Creüs en Iason hier elckandren, Trouw beloven:
Medea Iasons vrouw, onwaerdighlyck verschoven,

Werdt opgehitst van spyt, de wraecksucht ycert haer aen.
Helaes! Ontrouwigheydt, wat komt ghy dier te staen!

Rembrandt f. 1648

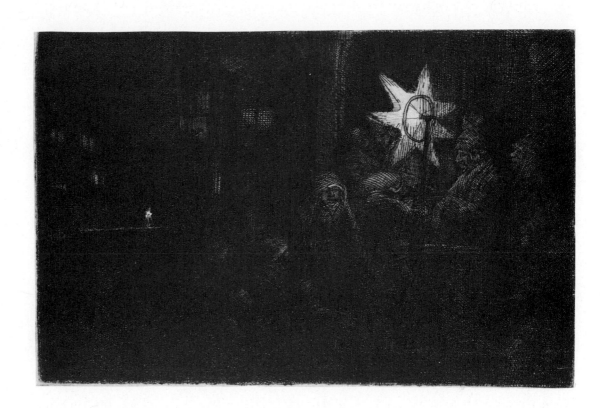

◀ B112
Medea: or the marriage of Jason and Creusa. With touches of drypoint. Fourth state of five. Signed and dated *Rembrandt f. 1648*. Haarlem.

Served as an illustration to the printed version of Jan Six's play *Medea*, published in 1648. This is the state in which the signature and verses appear.

B113
The star of the kings: a night piece. Only state. Haarlem.

About 1651. The subject shows how Dutch children celebrated the feast of Epiphany in the 17th century.

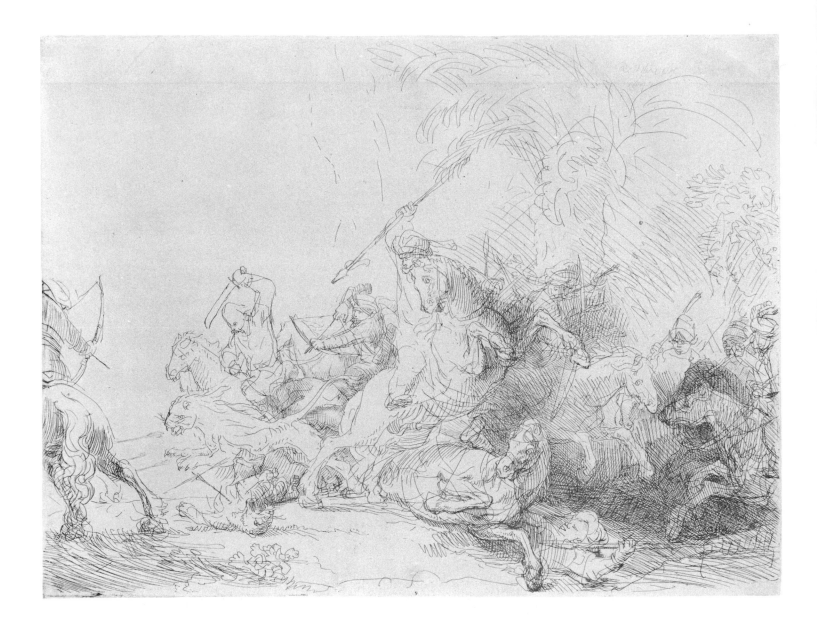

B 114
The large lion hunt. Second state
of two. Signed and dated
Rembrandt f. 1641. Paris,
Rothschild collection.
*This illustration is reduced. For
a full-scale reproduction, see
outsize sheets.*
Original size 22.4×30 cm.

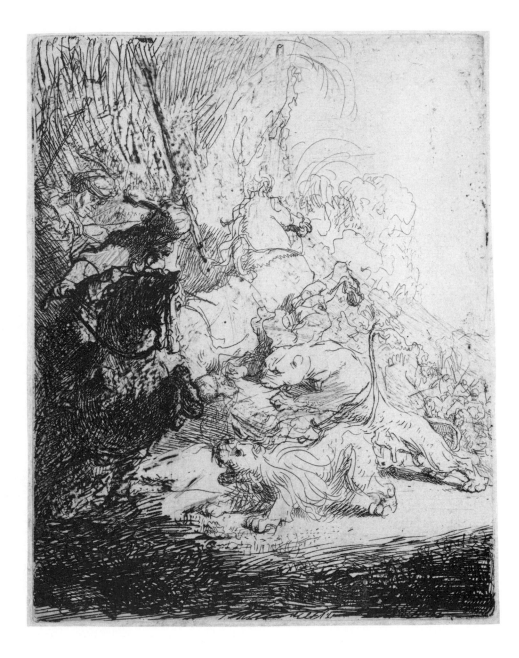

B 115
*The small lion hunt: with two
lions.* Only state. Haarlem.
About 1629.

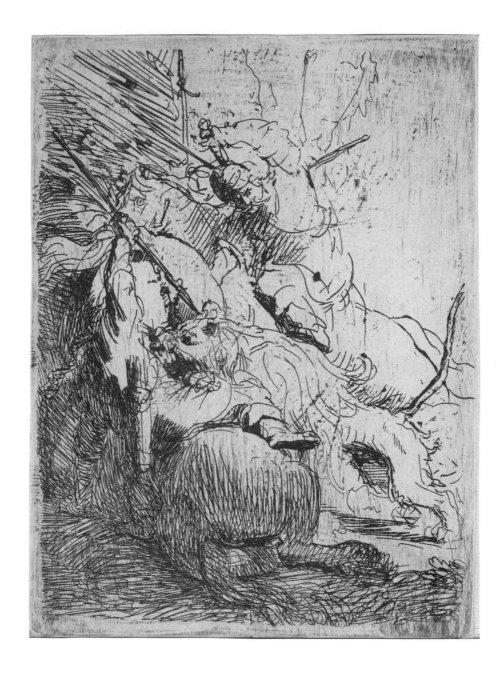

B116
*The small lion hunt: with one
lion.* Only state. Haarlem.
About 1629.

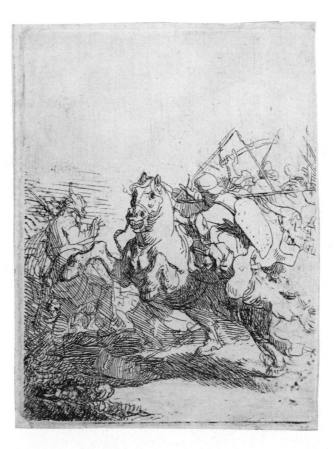

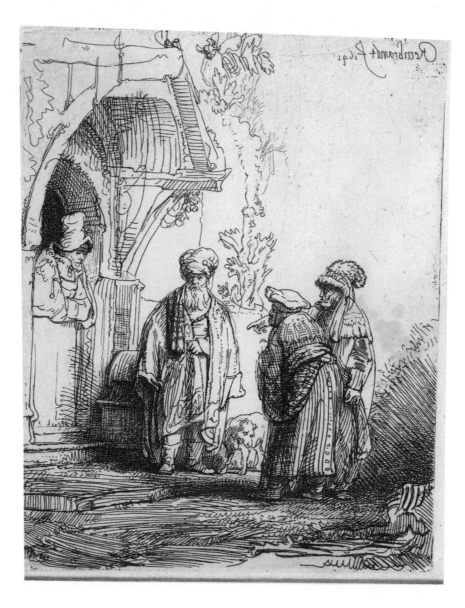

B117
A cavalry fight. Second state of two. Haarlem.
 About 1632.

B118
Three oriental figures [*Jacob and Laban?*]. Second state of two. Signed and dated *Rembrandt f. 1641*, in reverse. Haarlem.
 Perhaps Genesis 30:25-34.

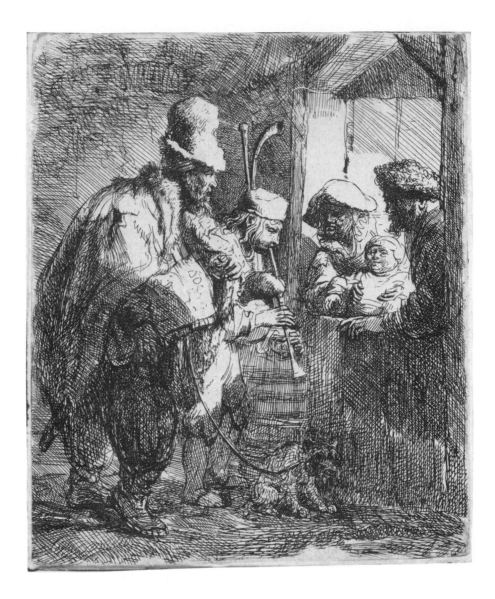

B 119
The strolling musicians. First
state of two. Haarlem.
 About 1635.

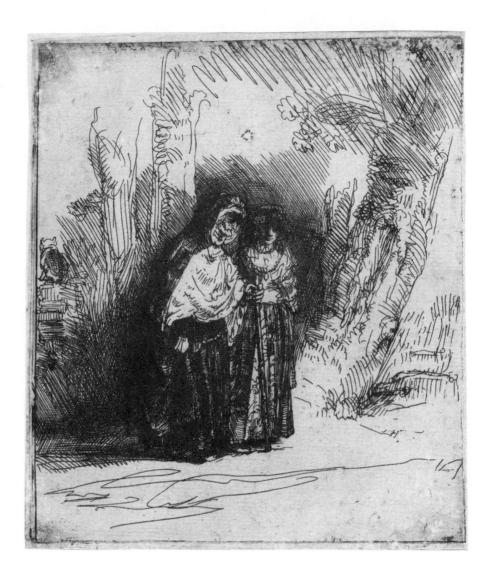

B 120
The Spanish gypsy 'Preciosa.'
Only state. Haarlem.
 About 1642. The subject is
thought to derive indirectly from
Cervantes' play *Preciosa*.

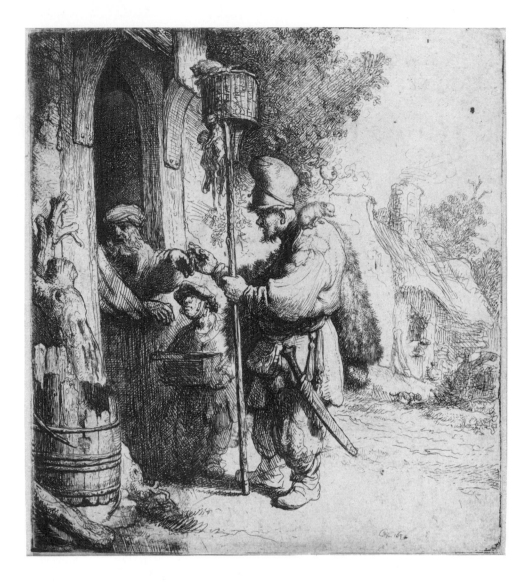

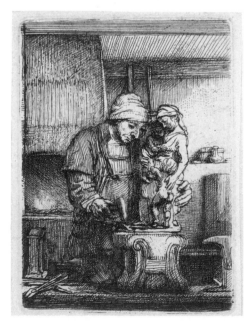

B121
The rat-poison peddler [*The rat catcher*]. Third state of three. Signed and dated *RHL 1632*. Haarlem.

B123
The goldsmith. With drypoint. First state of two. Signed and dated *Rembrandt f. 1655*, in the shadows in the lower center. Haarlem.

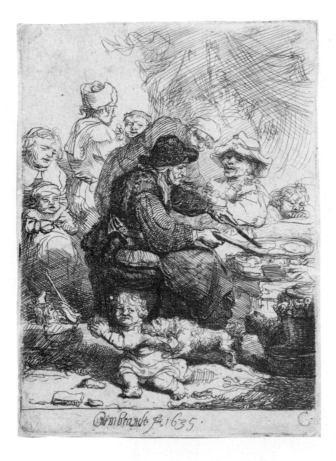

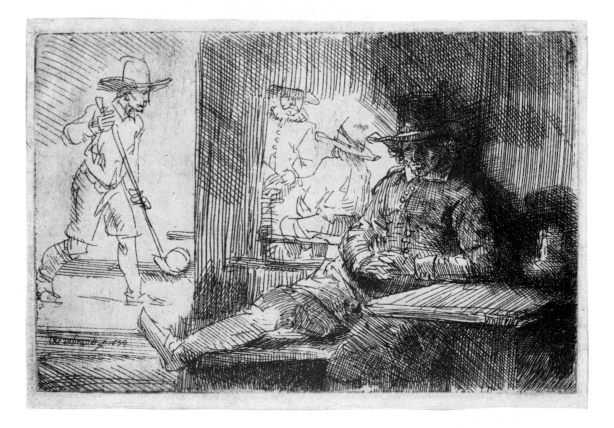

B124
The pancake woman. Second state of three. Signed and dated *Rembrandt f. 1635.* Haarlem.

B125
The golf player. First state of two. Signed and dated *Rembrandt f. 1654.* Haarlem.

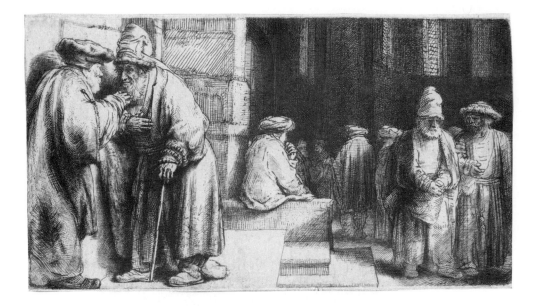

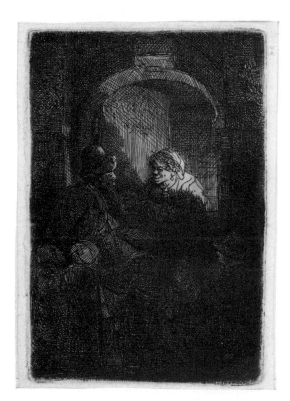

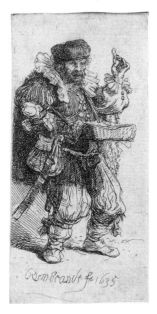

B126
Pharisees in the Temple [*Jews in the synagogue*]. With drypoint. Second state of three. Signed and dated *Rembrandt f. 1648.* Haarlem.

The former reading of the subject as a scene from Rembrandt's Amsterdam cannot be correct, since there were only house synagogues in the city during the artist's lifetime.

B128
Woman at a door hatch talking to a man and children ['*The schoolmaster*']. Only state. Signed and dated *Rembrandt f. 1641.* Haarlem.

B129
The quacksalver. Only state. Signed and dated *Rembrandt f. 1635.* Haarlem.

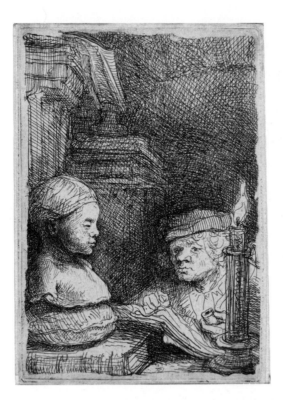

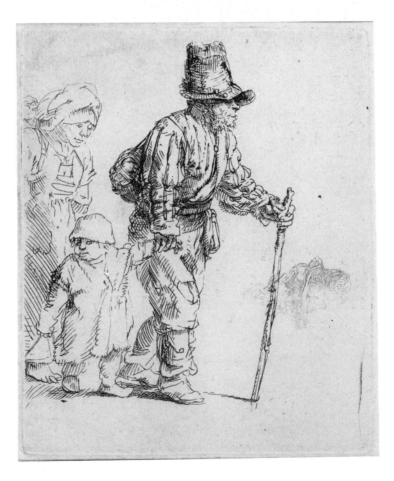

B130
Man drawing from a cast. First
state of three. Haarlem.
About 1641.

B131
Peasant family on the tramp.
Second state of two. Haarlem.
About 1652.

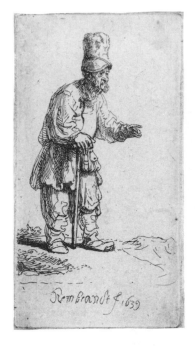

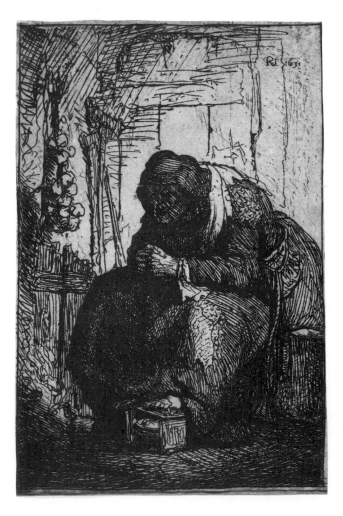

B 133
*A peasant in a high cap, standing
leaning on a stick*. Only state.
Signed and dated *Rembrandt f.
1639*. Haarlem.

B 134
*Old woman seated in a cottage
with a string of onions on the wall*.
Second state of three. Signed and
dated (by Rembrandt?) *Rt. 1631*.
Haarlem.

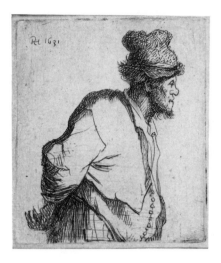

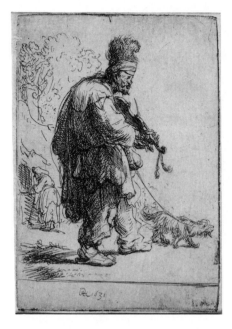

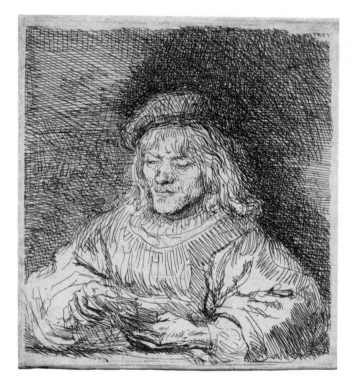

B135
Peasant with his hands behind his back. With burin. Fourth state of five. Signed and dated *RHL 1631.* Haarlem.

B136
The card player. First state of two. Signed and dated *Rembrandt f. 1641.* Amsterdam.

B138
The blind fiddler. First state of three. Signed and dated *RHL 1631.* Haarlem.

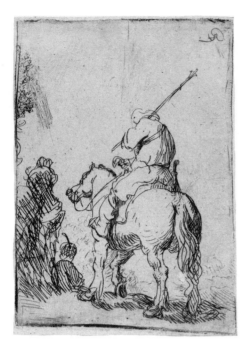

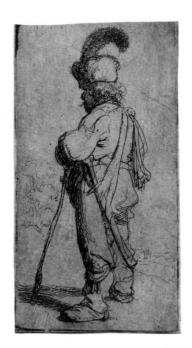

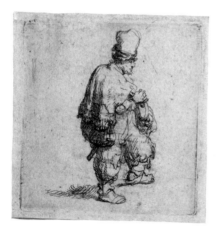

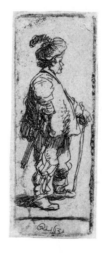

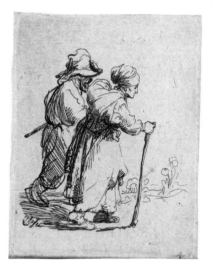

B 141
Polander leaning on a stick.
Third state of six. Haarlem.
About 1632. In this state the
patch of landscape between the
stick and the leg has been
burnished out.

B 139
Turbaned soldier on horseback.
Only state. Signed *RHL*, in
reverse. Amsterdam.
About 1632.

B 140
The barrel-organ player
[*Polander standing with arms
folded*]. Only state. Haarlem.
About 1631.

B 142
*A polander standing with his
stick: right profile.* Only state.
Signed and dated *RHL 1631*.
Amsterdam.

B 144
Two tramps, a man and a woman.
Only state. Haarlem.
About 1634.

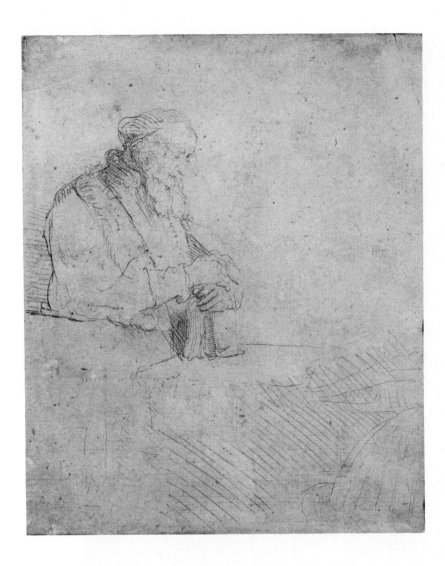

B 147
*Old man in meditation, leaning
on a book.* Second state of two.
Haarlem.
About 1645.

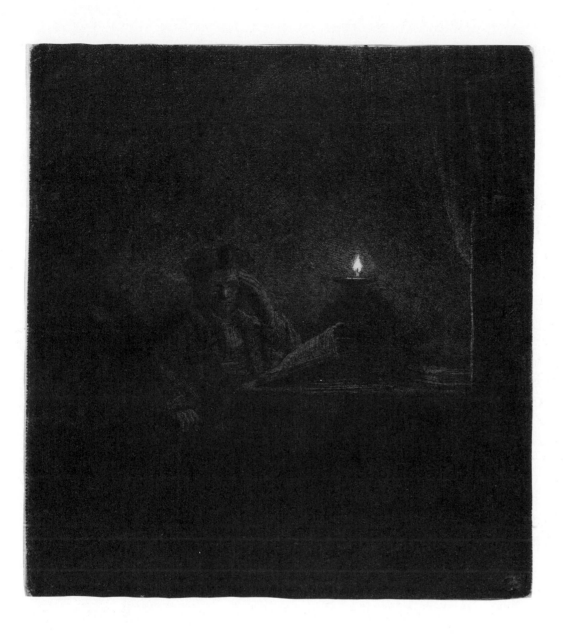

B 148
Student at a table by candlelight.
Only state. Signed *Rembrandt*,
in the lower right, barely visibly.
Haarlem.
 About 1642.

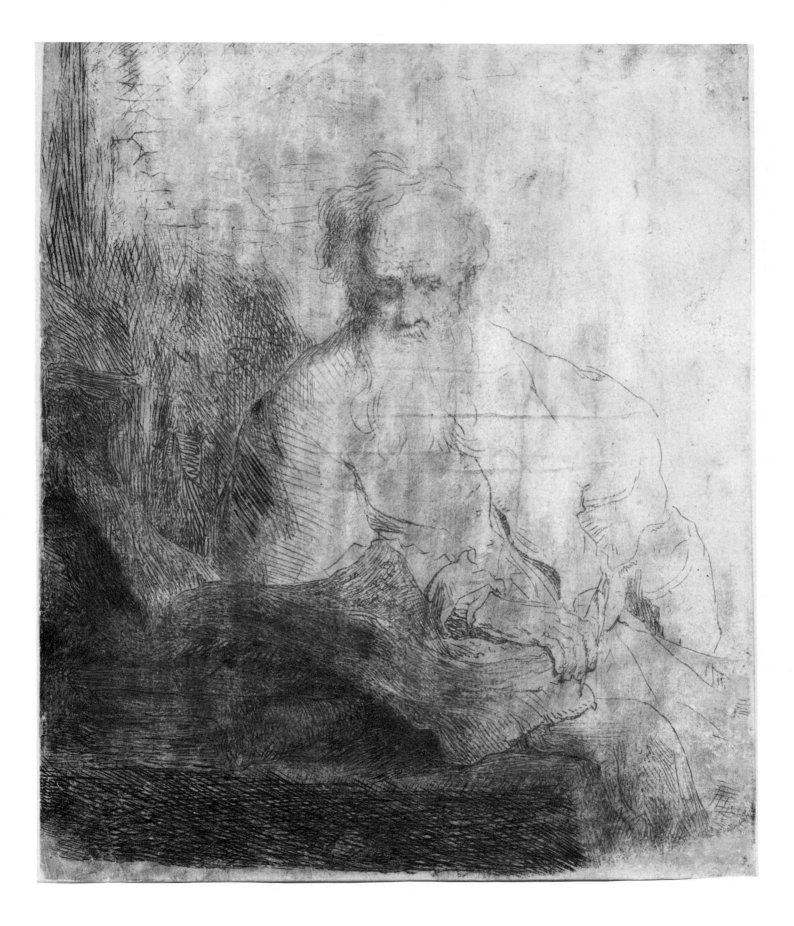

B 149
St. Paul in meditation. Only
state. Haarlem.
 About 1629. One of the four
known impressions. The uneven
appearance is due to partial
inking.

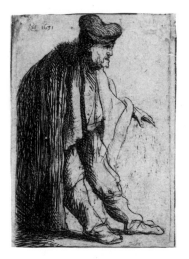

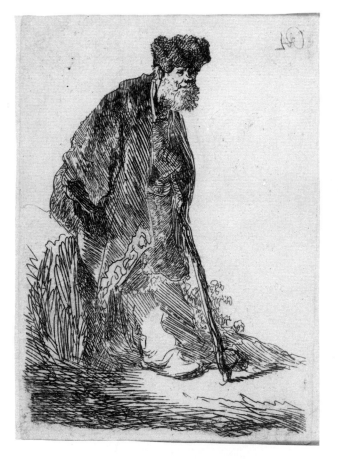

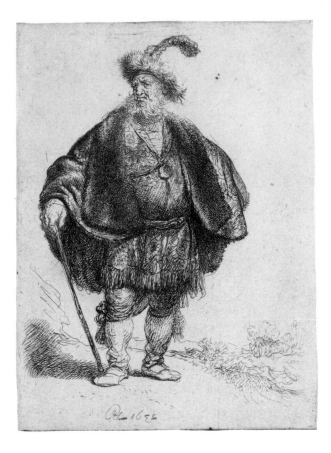

B 150
*Beggar with his left hand
extended*. Fourth state of four.
Signed and dated *RHL 1631*.
Haarlem.
 The first state lacks the
signature.

B 151
*Man in a coat and fur cap leaning
against a bank*. Second state of
three. Signed *RHL*, in reverse.
Haarlem.
 About 1630.

B 152
The Persian. Only state. Signed
and dated *RHL 1632*. Haarlem.

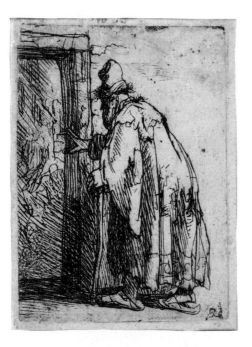

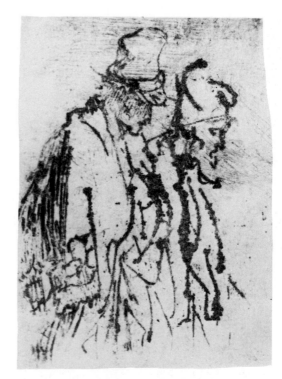

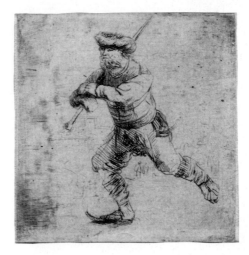

B154
*Two beggars tramping towards
the right*. First state of two.
Vienna.
 About 1631. Unique
impression. The second state is
probably not by Rembrandt.
 Reproduced from a photograph.

B153
The blindness of Tobit: a sketch.
Second state of five. Haarlem.
 About 1629. Same text as B 42.
The plate was cut down after
the first state, which was less
finished as a composition.
Bartsch did not recognize the
biblical subject matter.

B156
The skater. With drypoint. Only
state. Haarlem.
 About 1639.

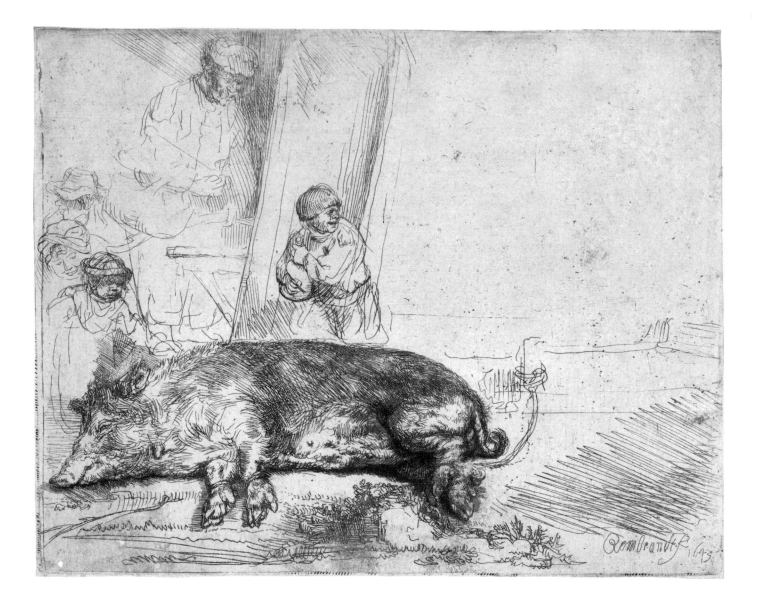

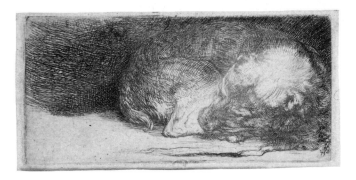

B 157
The hog. With drypoint. First
state of two. Signed and dated
Rembrandt f. 1643. Haarlem.

B 158
Sleeping puppy. With drypoint.
Third state of three. Haarlem.

About 1640. The earlier states
are larger, with a lot of empty
space below and to the left of the
dog.

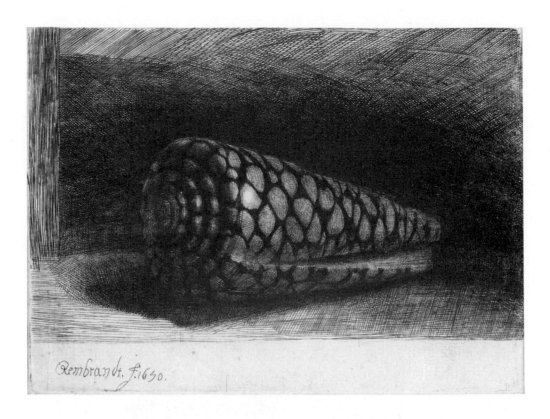

B 159
The shell [*Conus Marmoreus*].
With drypoint and burin.
Second state of three. Signed
and dated *Rembrandt f. 1650*.
Haarlem.

This is the only Rembrandt
etching that could be called a
still life.

B 160
*Old man in a long cloak sitting in
an armchair*. Only state.
Amsterdam.

About 1630. One of three
surviving impressions.

B 162
*Beggar in a high cap, standing
and leaning on a stick.* Only
state. Haarlem.
About 1629.

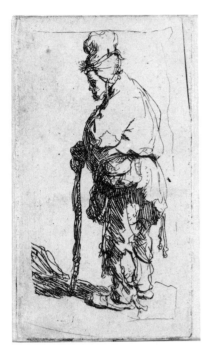

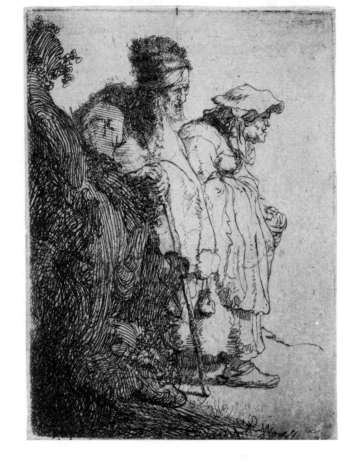

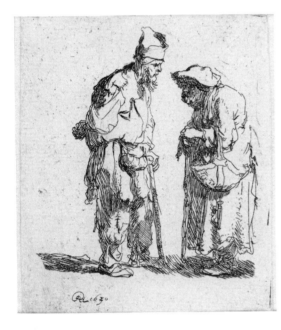

B 163
Beggar leaning on a stick, facing left. Only state. Haarlem.
About 1630.

B 164
Beggar man and beggar woman conversing. Only state. Signed and dated *RHL 1630*. Haarlem.
The *3* of the dating was originally a *2*.

B 165
Beggar man and woman behind a bank. Fourth state of nine (with drypoint). Signed *RHL*. Amsterdam.
About 1630. This plate, relatively more detailed and ambitious than most others of its kind, went through a series of tortured changes in etching, drypoint and burin.

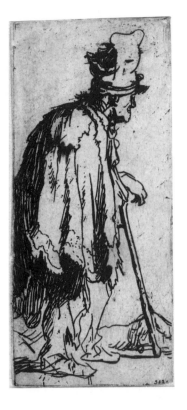

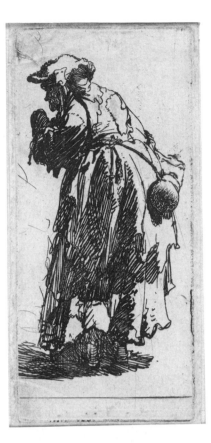

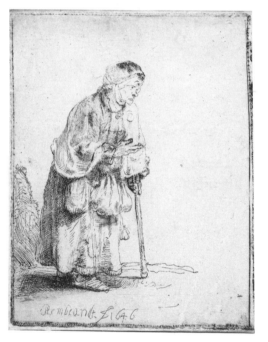

◀ B 168
Old beggar woman with a gourd.
Second state of two. Haarlem.
About 1629. The plate was cut
down slightly after the first state.

◀ B 170
Beggar woman leaning on a stick.
With drypoint. Only state.
Signed and dated
Rembrandt f. 1646. Haarlem.

▶ B 171
The leper ['*Lazarus Klep*']. Third
state of seven. Signed and dated
RHL 1631. Haarlem.

▶ B 172
*Ragged peasant with his hands
behind him, holding a stick.* With
touches of drypoint. Fourth
state of six. Haarlem.
About 1630.

B 166
*Beggar with a crippled hand
leaning on a stick.* First state of
five. Haarlem.
About 1629.

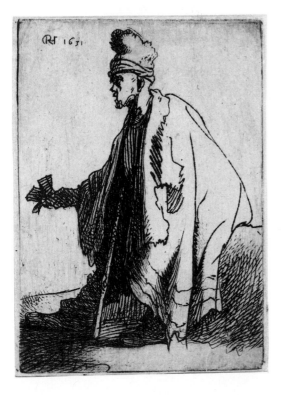

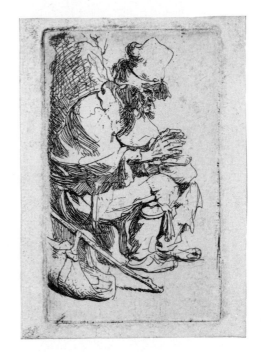

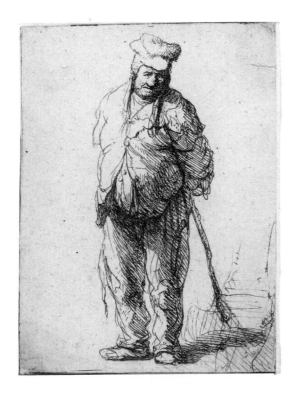

B173
Beggar seated warming his hands
at a chafing dish. Second state
of two. Haarlem.
About 1630.

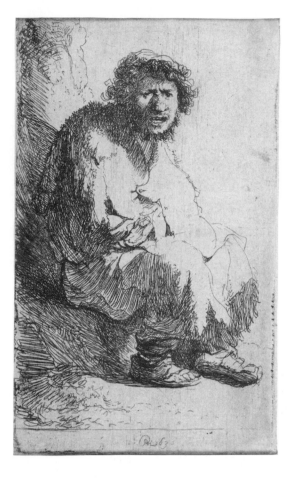

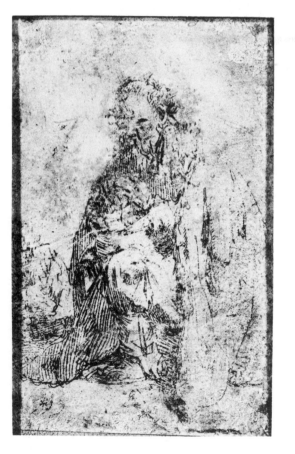

B174
Beggar seated on a bank. Only
state. Signed and dated *RHL
1630*. Haarlem.
 Probably a self portrait.

B175
Seated beggar and his dog. First
state of two. Paris.
 About 1629. Unique
impression. The second state,
inscribed *RL 1631*, is not by
Rembrandt.
 Reproduced from a photograph.

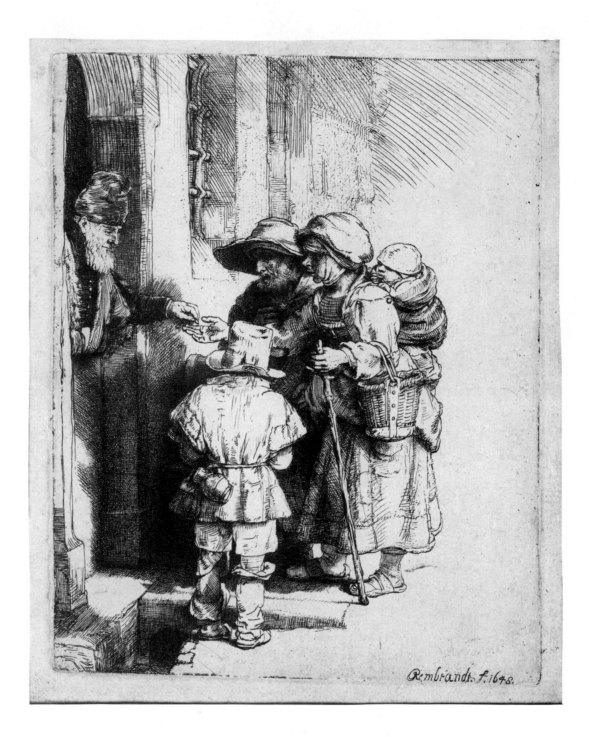

B176
*Beggars receiving alms at the
door of a house.* With burin and
drypoint. First state of three.
Signed and dated *Rembrandt f.
1648*. Haarlem.

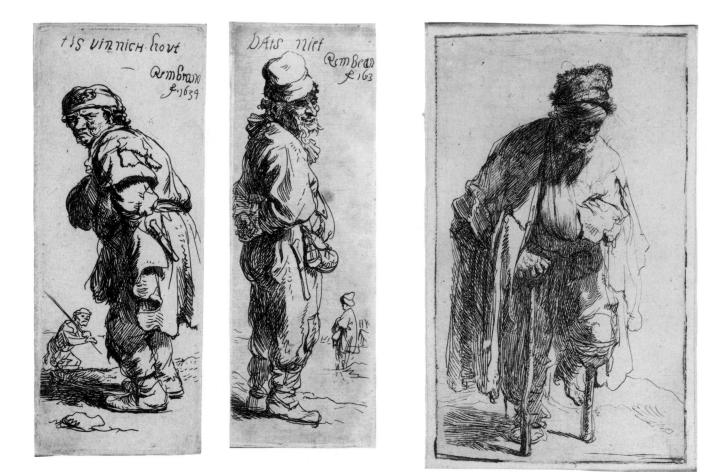

B 182
Two studies of beggars. Only
impression of the only state.
Paris.
About 1629.
Reproduced from a photograph.

B 178
A peasant replying 'Dats niet.'
Only state. Signed and dated
Rembran f. 163- (the last digit,
presumably a *4*, is missing).
Haarlem.

The exchange between the two
peasants – forming the only true
companion pieces among
Rembrandt's etchings – can be
freely translated as 'Damned
cold.' 'Call that cold?'

B 177
*A peasant calling out 'Tis
vinnich kout.'* Only state. Signed
and dated *Rembrandt f. 1634.*
Haarlem.

See comment under B 178.

B 179
Beggar with a wooden leg. First
state of two. Haarlem.
About 1630.

B 183
Beggar man and woman. Only
state. With surface tone.
Amsterdam.
About 1628. One of the two
known impressions.

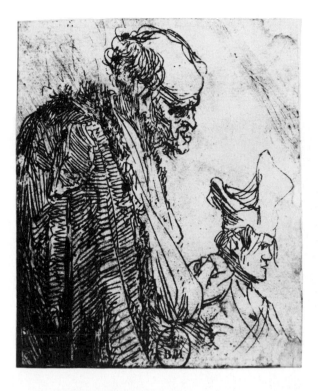

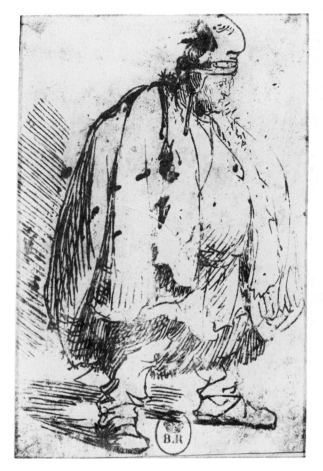

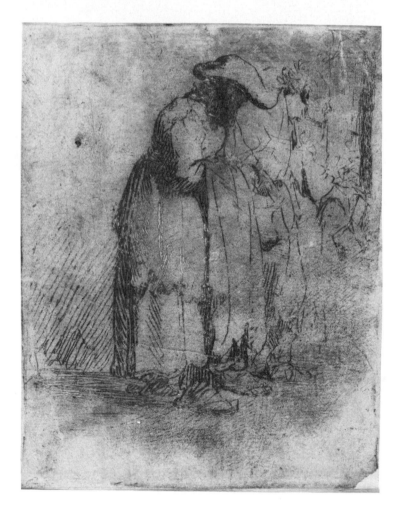

B 184
A stout man in a large cloak.
Only impression of the only
state. Paris.
 About 1628.
 Reproduced from a photograph.

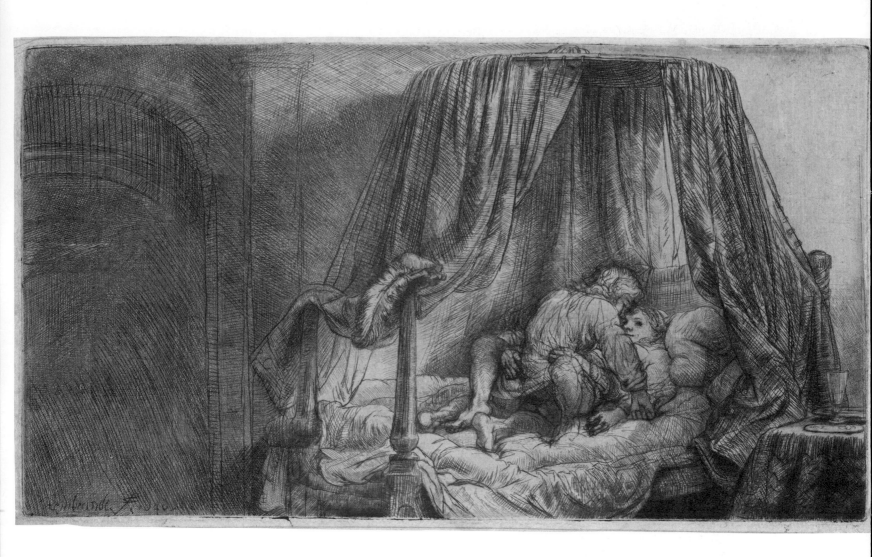

B 186
'*Ledikant*' *or* '*Lit à la française.*'
With burin and drypoint.
Fourth state of five. Signed and
dated *Rembrandt f. 1646*. With B 187
surface tone. Haarlem. *The monk in the cornfield.* With
 The woman has two left arms. drypoint. Only state. Haarlem.
 About 1646.

B 188
The flute player [*L'espiègle*].
With drypoint. Third state of
four. Signed and dated
Rembrandt f. 1642. Amsterdam.
 The signature and date are
lacking in the first state. The face
in the trees was burnished out in
the fifth state. The semi-erotic
subject, identified for a long time
as Till Eulenspiegel, is now a
matter of dispute.

B 189
The sleeping herdsman. With
burin. Only state. Haarlem.
 About 1644.

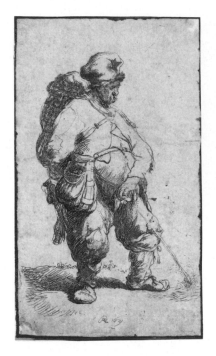

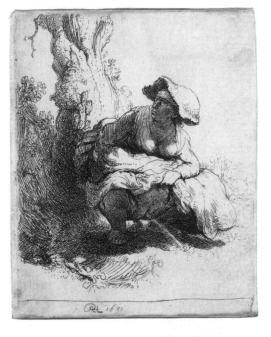

B 190
A man making water. Only state.
Signed and dated *RHL 1631*.
Haarlem.

B 190 and B 191, like the erotic
subjects B 186 and B 187, were
treasured for their daring by
collectors, and rejected as
Rembrandts, for the same
reason, by some scholars.

B 191
A woman making water. Only
state. Signed and dated
RHL 1631. Haarlem.

▶ B 192
The artist drawing from the
model. With drypoint and burin.
Second state of two. Amsterdam.
About 1639. No more finished
state than this has ever turned up.

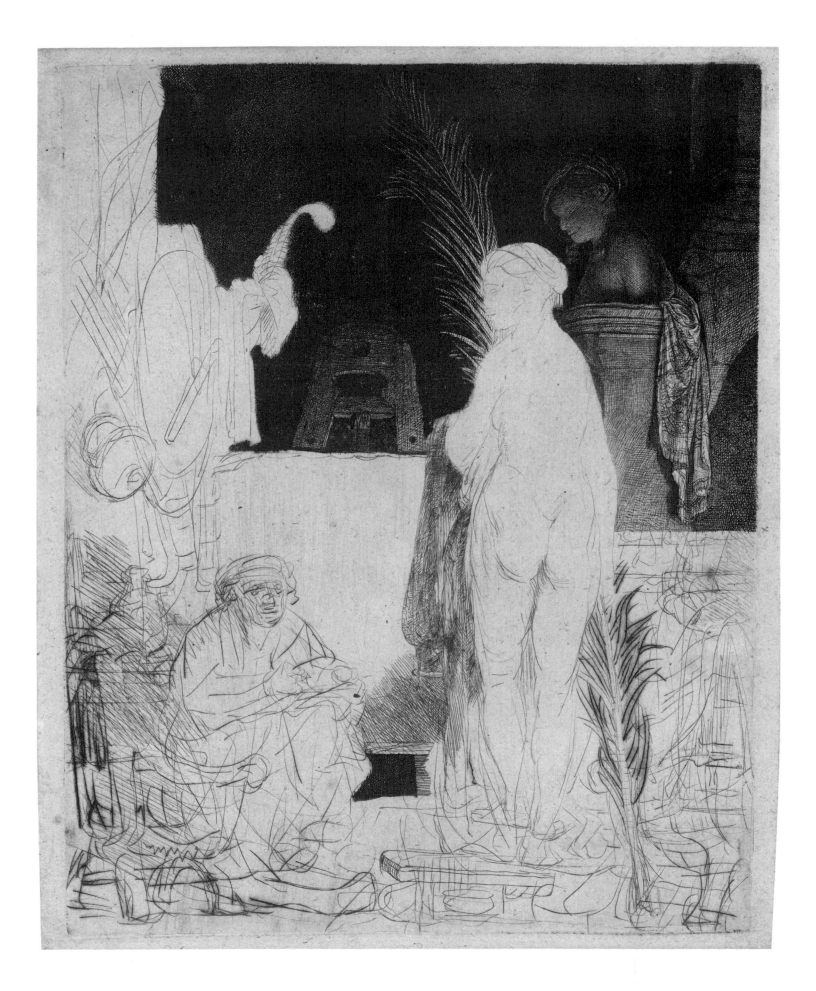

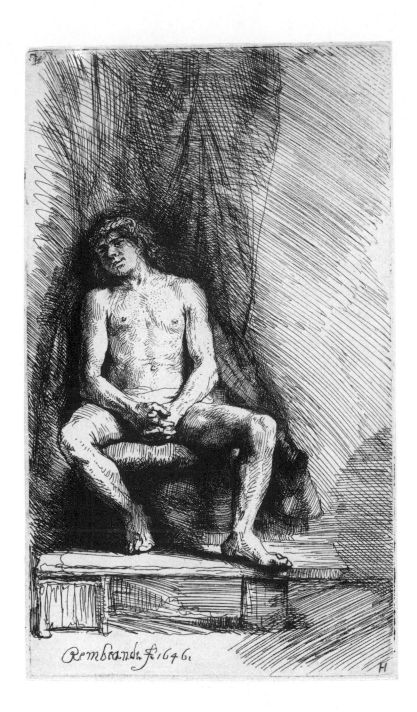

B193
Nude man seated before a curtain.
First state of two. Signed and
dated *Rembrandt f. 1646.*
Amsterdam.

The *H* in the lower right was
added by a later collector with
the pen.

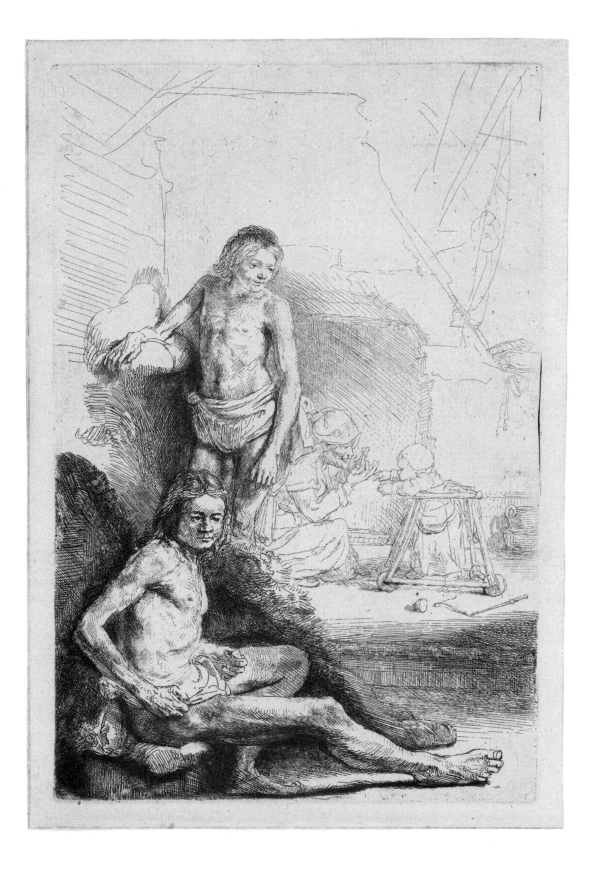

B 194
A young man seated and standing
[*The walking trainer*]. Second
state of three. Amsterdam.
 About 1646.

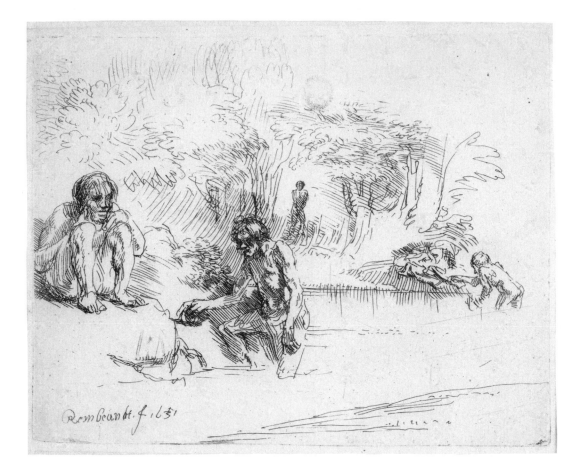

B195
The bathers. First state of two.
Signed and dated *Rembrandt f.*
1651. Haarlem.
 The *5* in the dating was
changed in drypoint from a *3*.

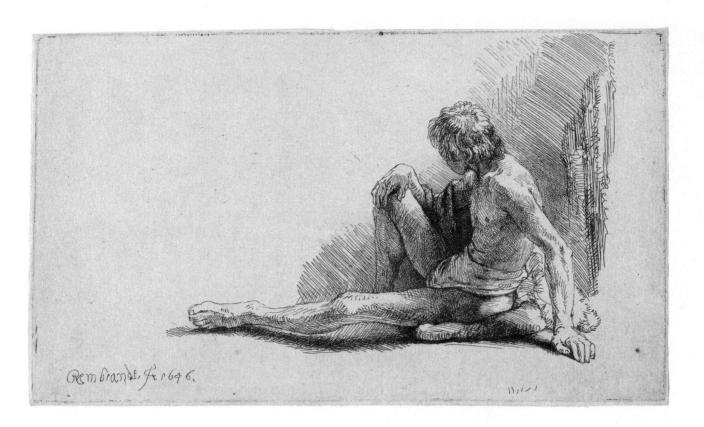

B 196
*Nude man seated on the ground
with one leg extended.* Second
state of two. Signed and dated
Rembrandt f. 1646. Amsterdam.

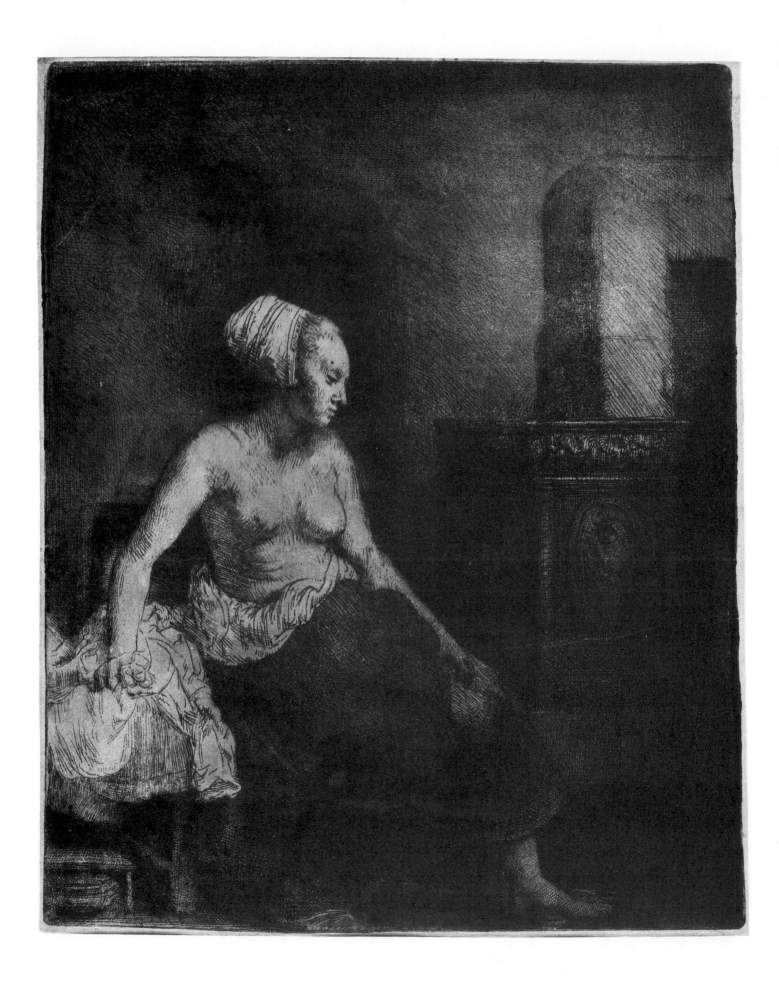

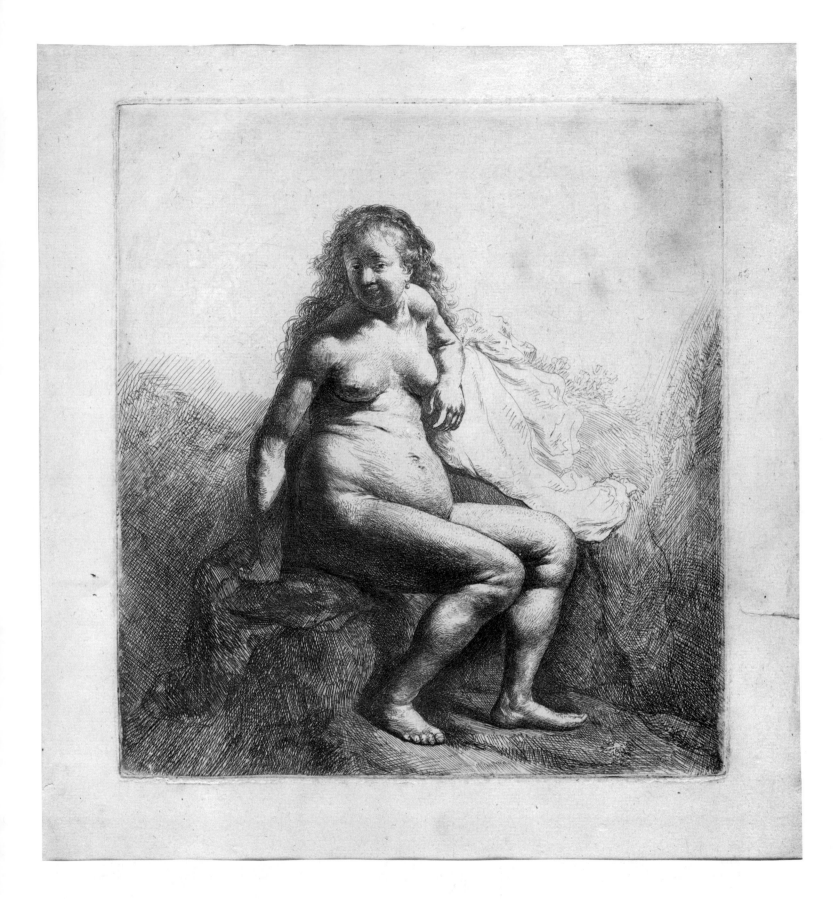

◄ B 197
*Woman sitting half dressed
beside a stove.* With burin and
drypoint. First state of seven.
Printed with surface tone on
Japanese paper. Signed and
dated *Rembrandt f. 1658.*
Amsterdam.

 The white lines across the
stove and in the upper left are
creases that arose during the
printing of this otherwise
excellent impression.

B 198
Naked woman seated on a mound.
Second state of two. Signed
RHL, very faintly, in the upper
left. Haarlem.
 About 1631.

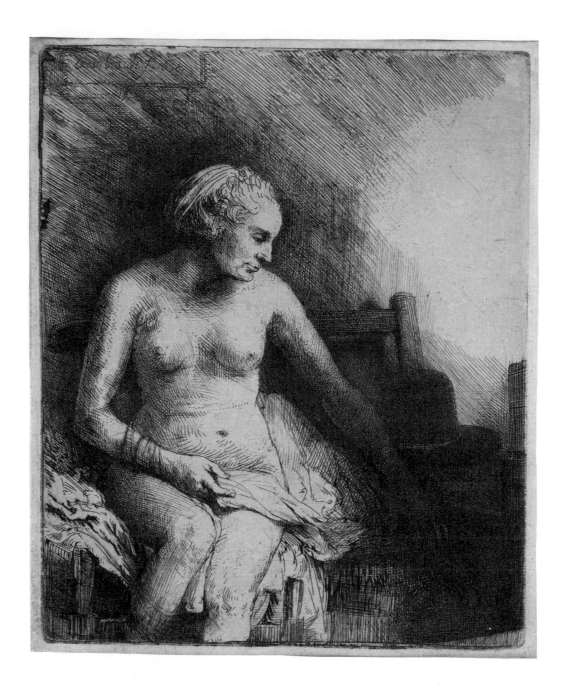

B 199
*Seated naked woman with a hat
beside her* [*Woman at the bath*].
With drypoint. Second state of
two. Signed and dated
Rembrandt f. 1658. Haarlem.
 The smudge in the left margin
is due to a fault in the plate and
is present in all impressions.

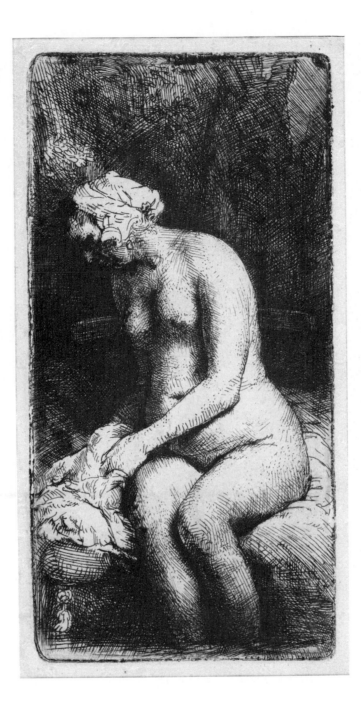

B 200
Seated naked woman ['*Woman
bathing her feet at a brook*'].
Only state. Signed and dated
Rembrandt f. 1658. Haarlem.

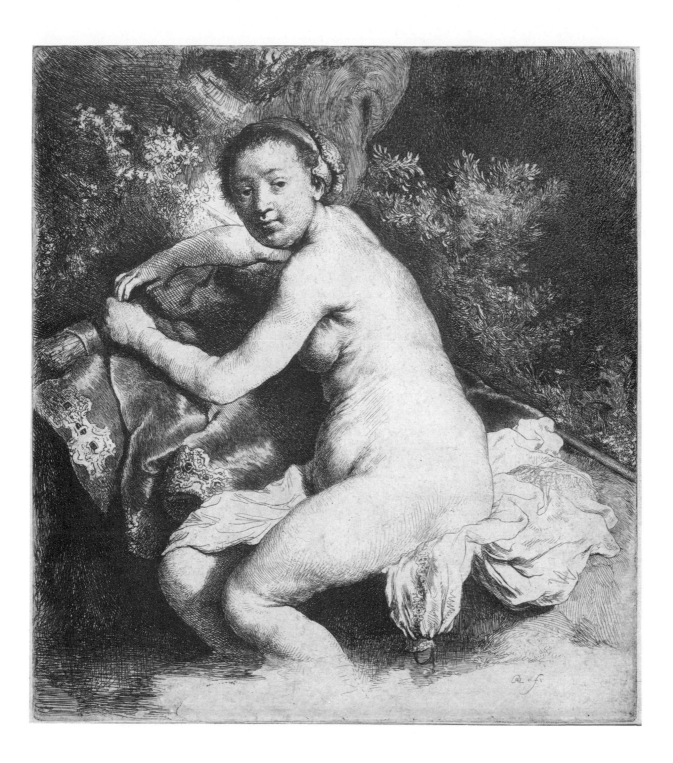

B 201
Diana at the bath. Only state.
Signed *RHL f*. Haarlem.
About 1631.

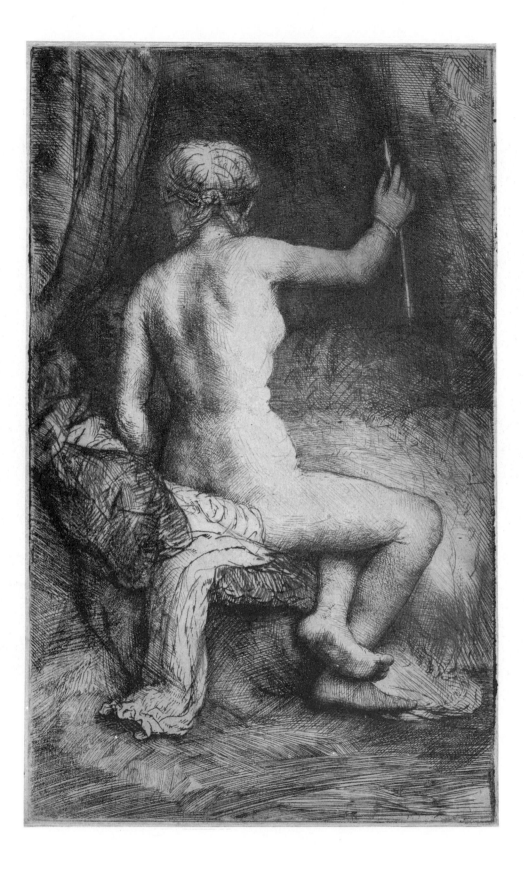

B 202

Woman with the arrow [*Venus and Cupid?*]. With drypoint and burin. Second state of three. Signed and dated *Rembrandt f. 1661*. Printed with surface tone. Haarlem.

No completely convincing explanation of the motif has yet been advanced.

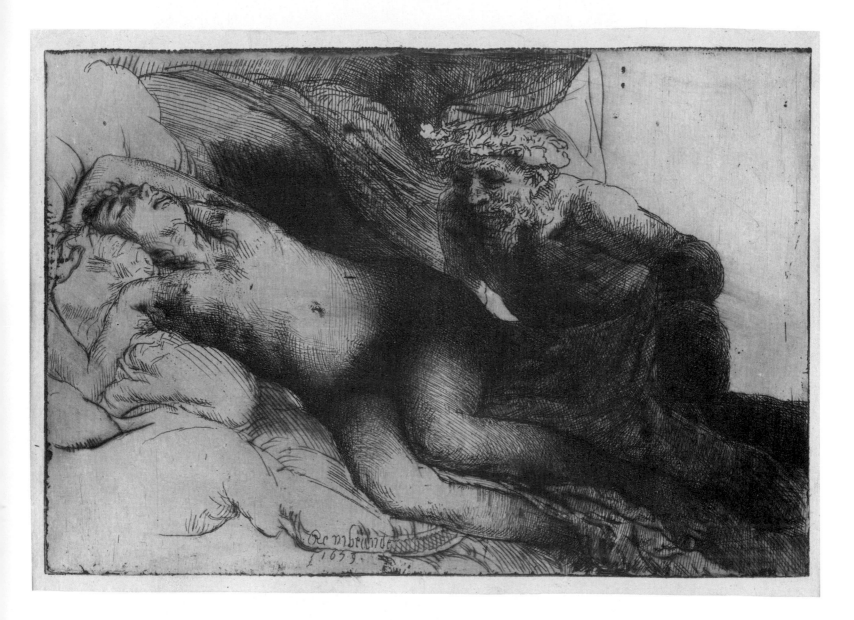

B 203
*Jupiter and Antiope: the larger
plate.* With burin and drypoint.
First state of two. Signed and
dated *Rembrandt f. 1659.*
Amsterdam.

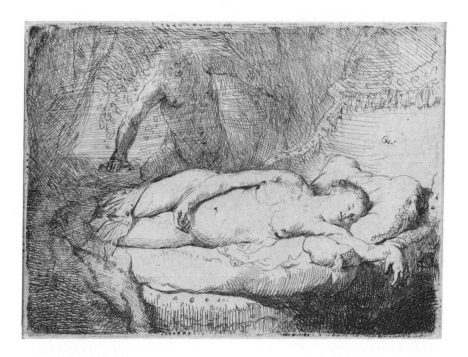

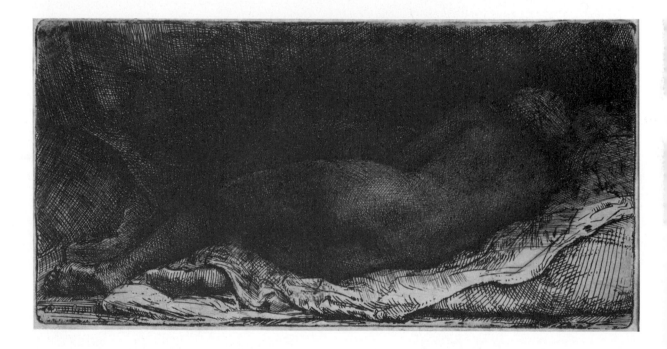

B 204
*Jupiter and Antiope: the smaller
plate*. Second state of two.
Signed *RHL*. Haarlem.
 About 1631.

B 205
'*Negress lying down.*' With
drypoint and burin. Second
state of three. Signed and dated
Rembrandt f. 1658. Haarlem.
 Bartsch's identification of the
figure as a negress rests on no
certain grounds. In the first
state, at least, she looks white.

Landscapes

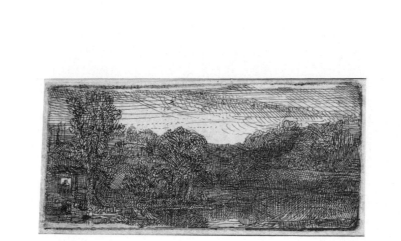

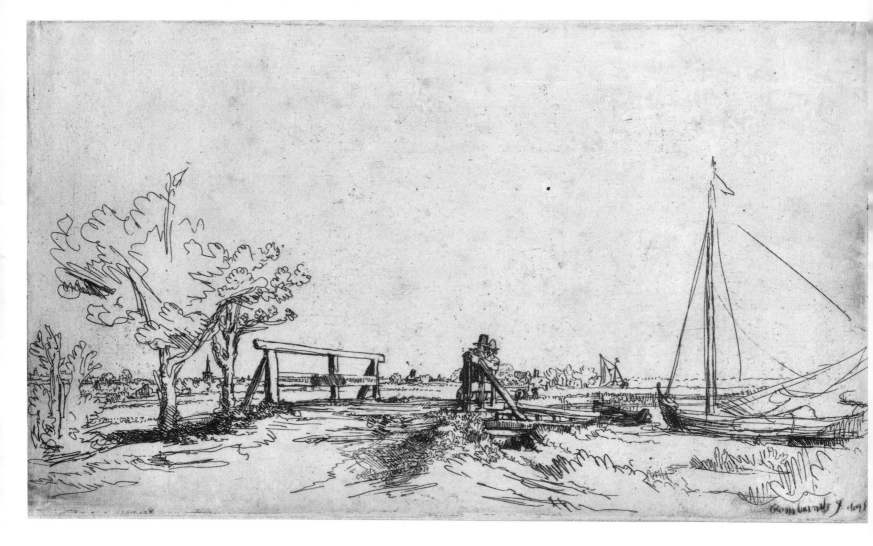

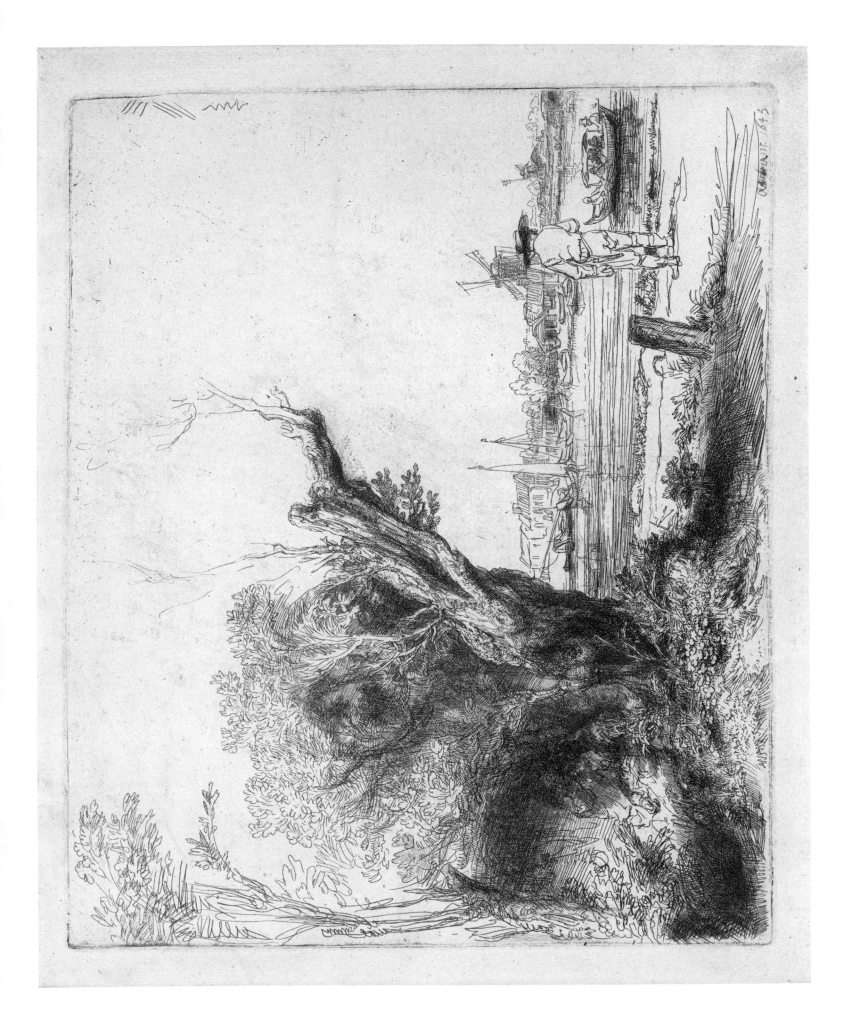

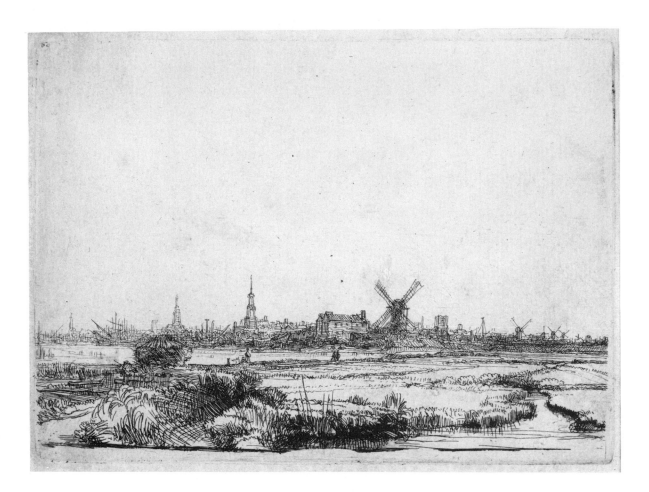

B 210
*View of Amsterdam from the
northwest*. Only state. Haarlem.
About 1640. The view is taken
from the Kadijk, on what is now
Bickers Island. See comment
under B 207.

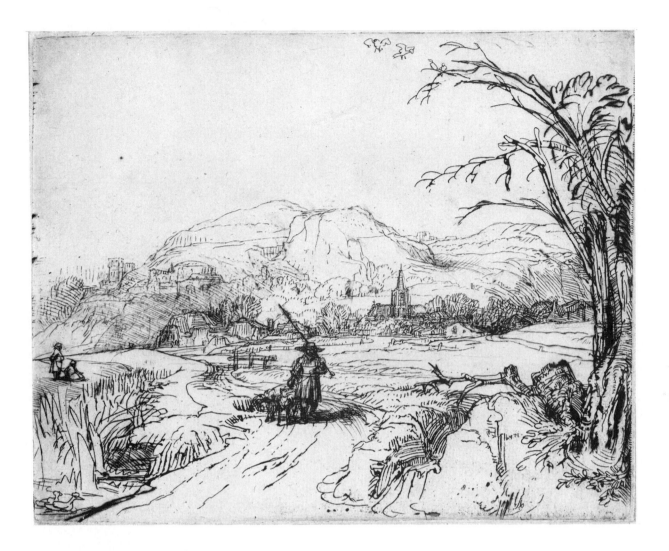

B 211

Landscape with a shepherd and dog ['*Het jagertje*']. With drypoint. Second state of two. Haarlem.

About 1653. The traditional title means 'The hunter.' This is probably the last of the landscape etchings.

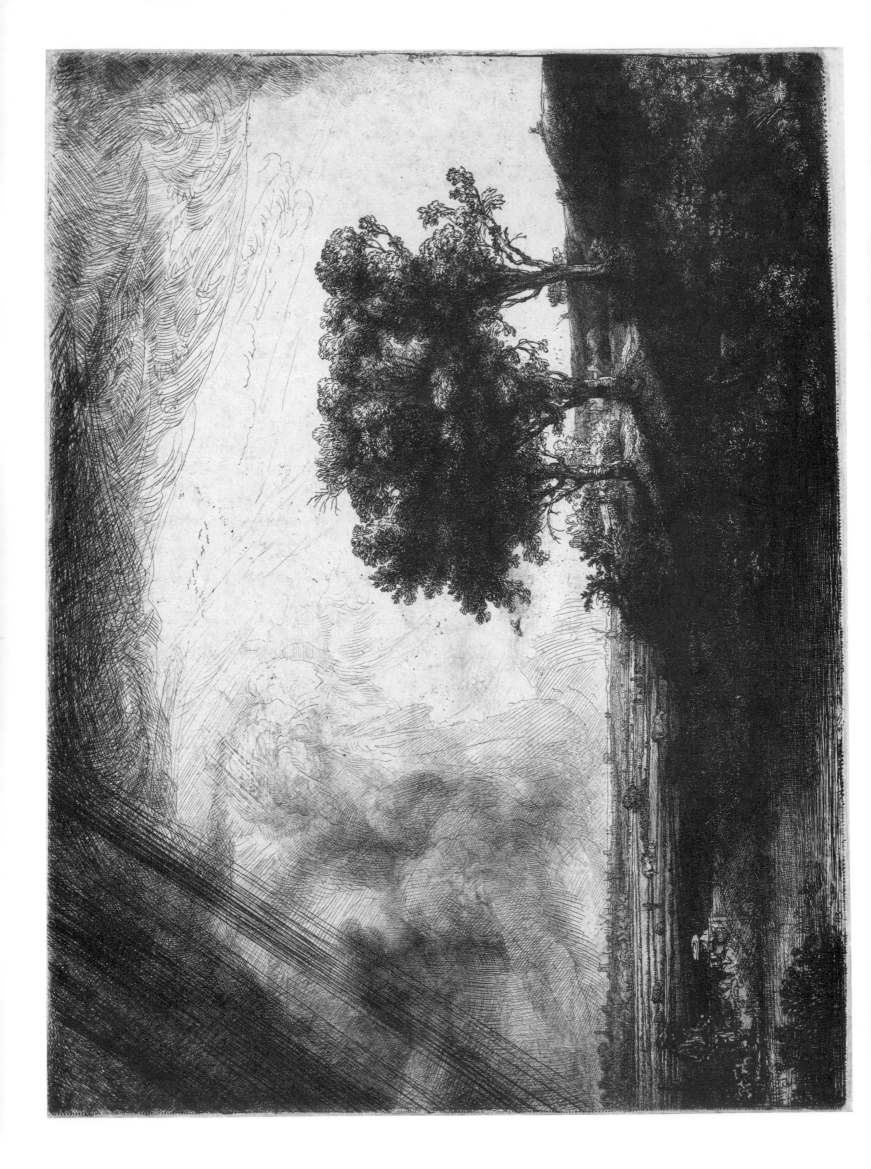

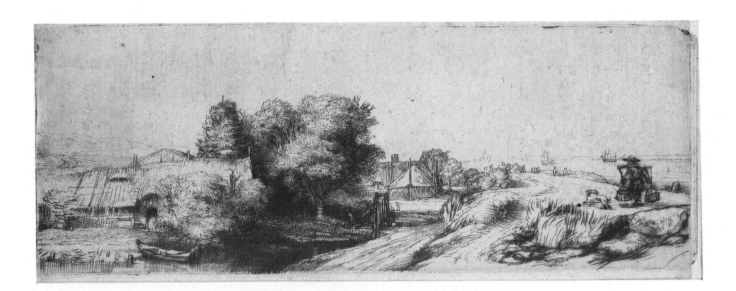

◀ B 212
The three trees. With drypoint
and burin. Only state. Signed
(barely visibly) and dated
Rembrandt f. 1643. Haarlem.
 On the horizon is the skyline
of Amsterdam.

B 213
Landscape with a fisherman
['*Het melkboertje*']. With
drypoint. Second state of two.
Haarlem.
 About 1652. The traditional
Dutch title means 'The
milkman.' Seems to be the same
farmhouse depicted in B 224.
The distant view at the left was
added in the second state.

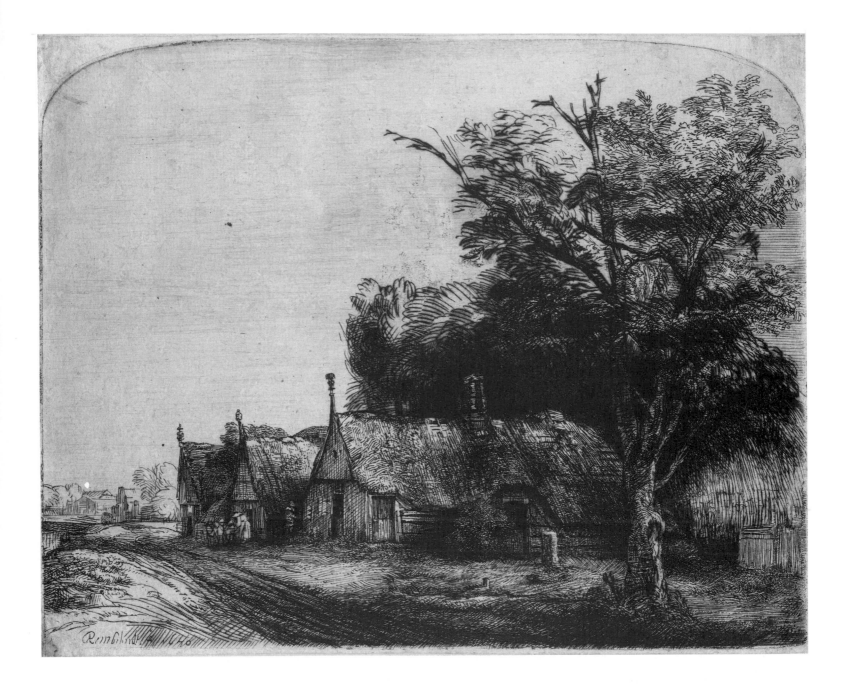

▶ B 218
Landscape with a square tower.
With drypoint. Fourth state of
four. Signed and dated
Rembrandt f. 1650. Haarlem.

B 217
*Landscape with three gabled
cottages beside a road.* With
drypoint. Third state of three.
Signed and dated *Rembrandt f.
1650.* Haarlem.

▶ B 219
*Cottages and farm buildings with
a man sketching.* Only state.
Haarlem.
 About 1645.

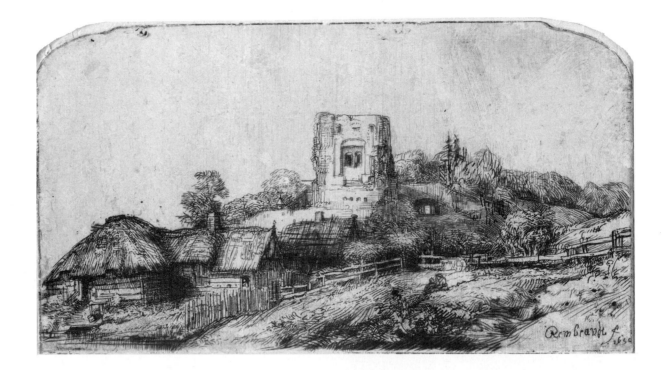

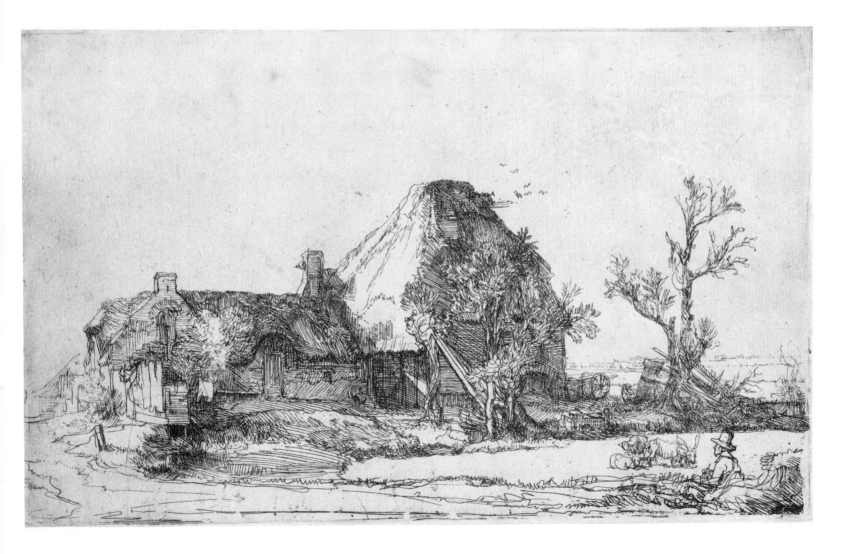

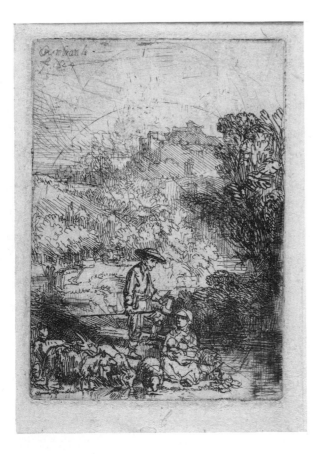

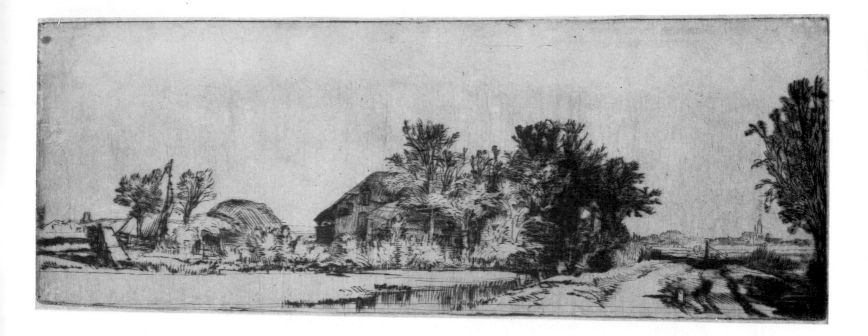

B 220
The shepherd and his family.
Only state. Signed and dated
Rembrandt f. 1644. Haarlem.
 The circles are part of the
markings presumably left over
from a previous use of the plate.

B 221
*Landscape with a road beside a
canal.* Drypoint only. Only state.
Printed on Japanese paper.
Amsterdam.
 About 1652. The typical effect
of drypoint with fresh burr can
be seen to good effect in this
early impression.

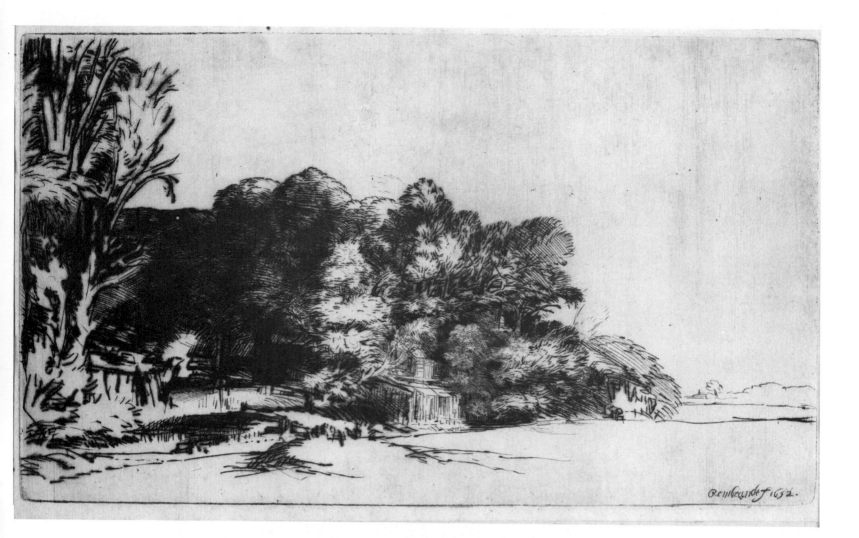

B 222
Clump of trees with a vista.
Drypoint only. Second state of
two. Signed and dated
Rembrandt f. 1652. Haarlem.
 The signature is lacking in the
first, unfinished state.

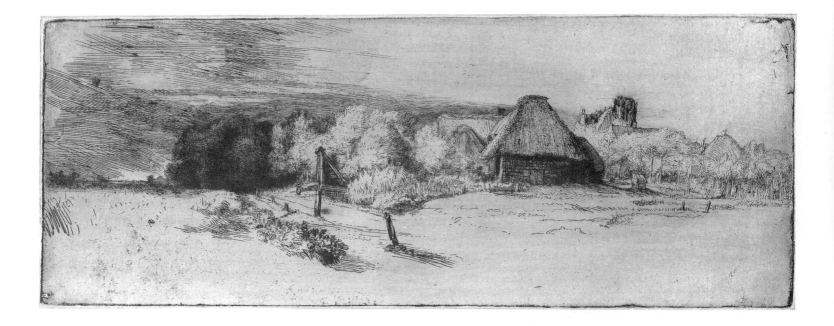

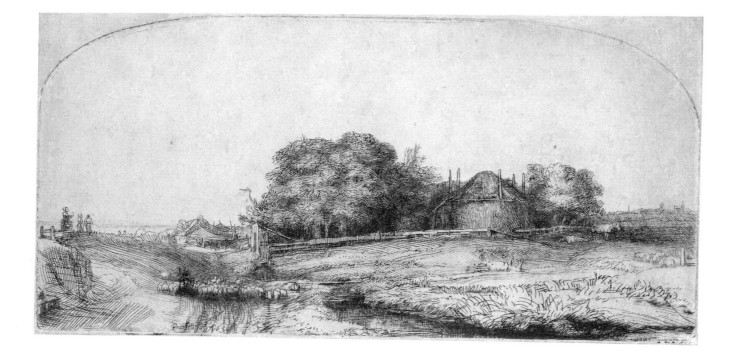

B 223
*Landscape with trees, farm
buildings and a tower.* With
drypoint. Fourth state of four.
Printed on Japanese paper.
Amsterdam.

About 1651. Probably depicts
a spot on the estate of Jan
Uytenbogaert (cf. B 234 and
B 281).

*This illustration is reduced. For
a full-scale reproduction, see
outsize sheets.*

Original size 12.3 × 31.9 cm.

B 224
*Landscape with a hay barn and a
flock of sheep.* With drypoint.
Second state of two. Signed and
dated *Rembrandt f. 1652.*
Haarlem.

See comment under B 213.

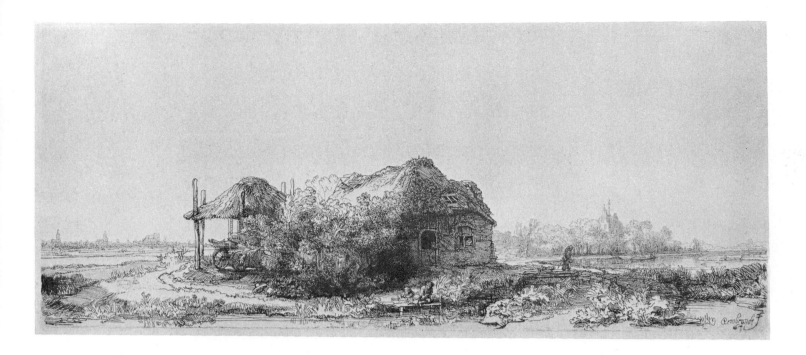

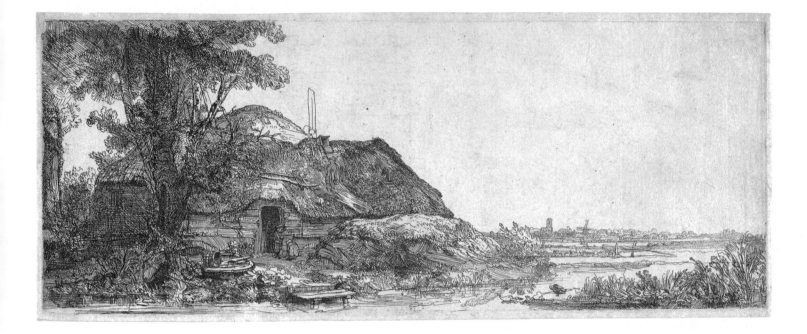

B 225
*Landscape with a cottage and
haybarn: oblong.* Only state.
Signed and dated *Rembrandt f.
1641.* Amsterdam.
 A fine early impression. This
etching and the following one
are semi-fictive landscapes,
combining several distinct motifs
in the outskirts of Amsterdam.
 *This illustration is reduced. For
a full-scale reproduction, see
the outsize sheets.*
 Original size 12.9× 32.1 cm.

B 226
*Landscape with a cottage and a
large tree.* Only state. Signed and
dated *Rembrandt f. 1641.*
Amsterdam.
 See B 225.
 *This illustration is reduced. For
a full-scale reproduction, see
the outsize sheets.*
 Original size 12.7× 32 cm.

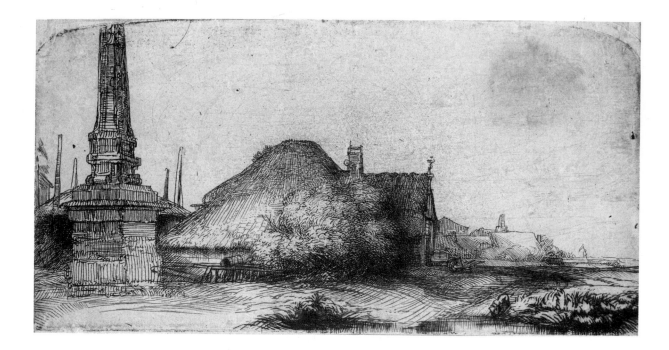

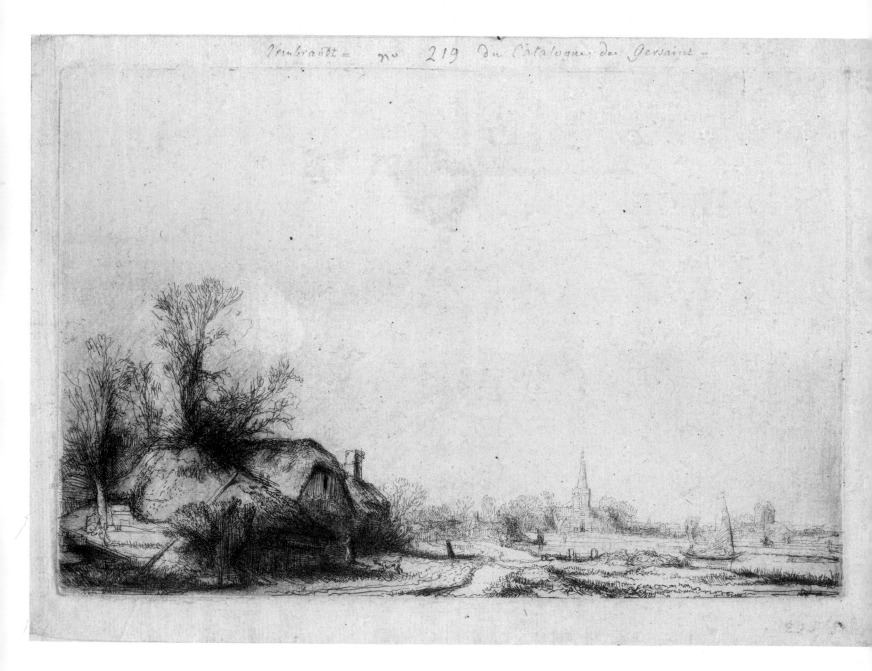

Rembrandt = no 219 du Catalogue de Gersaint =

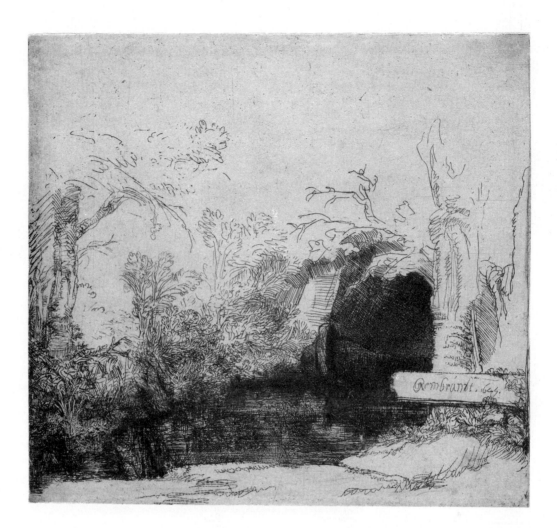

◀ B 227
Landscape with an obelisk. With
drypoint. Second state of two.
Haarlem.

About 1650. The stone marks
the boundary of the jurisdiction
of Amsterdam at Spieringhorn,
on the road to Haarlem. The
hairline in the upper left is due to
a slip of the needle.

◀ B 228
Cottages beside a canal. Only
state. Haarlem.

About 1645. Probably a view
of Ouderkerk aan de Amstel.
The inscription above refers to
the etching's entry in the
Gersaint catalogue (1751). An
important early impression.

B 231
The boat house [*Grotto with a
brook; 'Het spelonkje'*]. With
drypoint. First state of three.
Signed and dated *Rembrandt
1645*. Amsterdam.

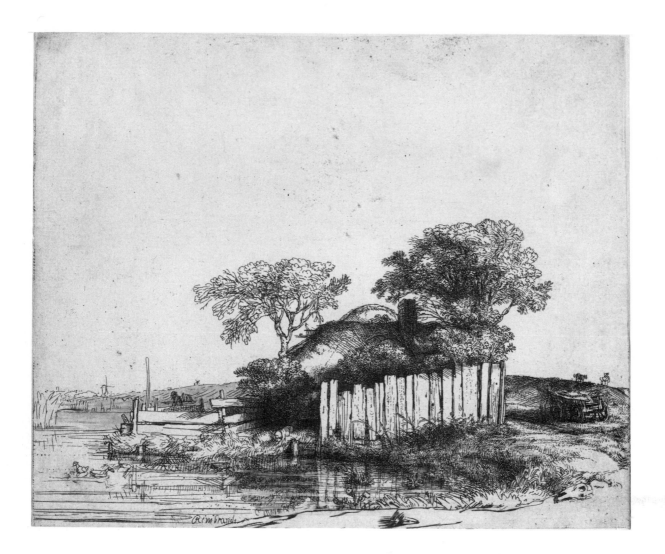

B 232

Cottage with a white paling. With drypoint. First state of three. Signed *Rembrandt f.* Haarlem.

The date 1648 was added in the third state. In this impression the areas that were to be shaded in in the second state have been washed in gray.

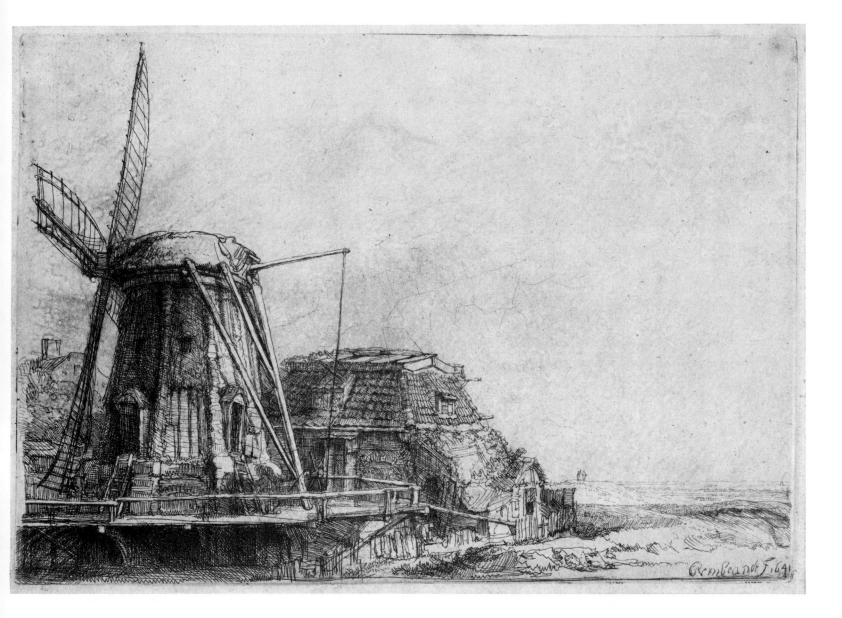

B 233

The windmill. Only state. Signed
and dated *Rembrandt f. 1641.*
Haarlem.

The mill depicted lay on the
fortifications of Amsterdam near
the Lauriergracht. The cracks in
the sky are probably the result
of craquelure in the etching
ground.

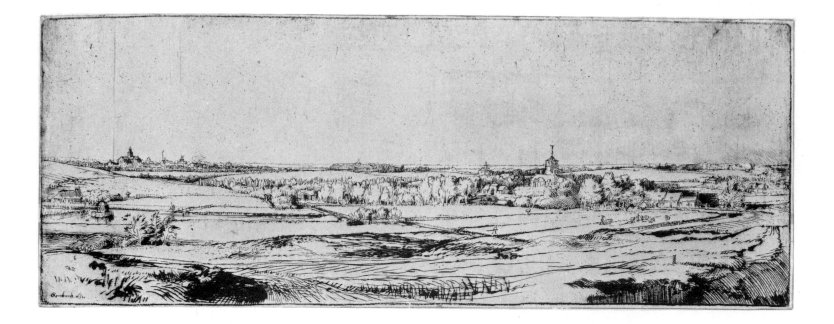

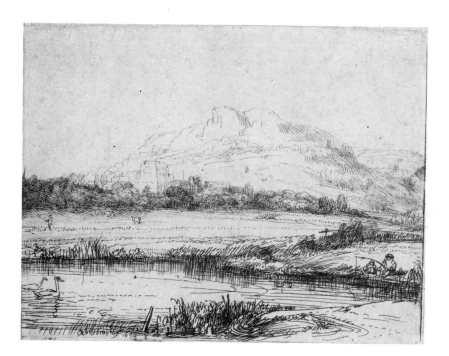

B 234

'The goldweigher's field.' With
drypoint. Only state. Signed and
dated *Rembrandt 1651*. London.

The estate in the foreground,
seen from a high point in the
dunes outside Haarlem, is
Saxenburg, which belonged in
1651 to Christoffel Thysz., one
of Rembrandt's creditors. The
etching was called *The
goldweigher's field* because it was
previously thought to depict the
estate of Jan Uytenbogaert
(cf. B 223).

*This illustration is reduced. For
a full-scale reproduction, see
the outsize sheets.*

Original size 12 × 31.9 cm.

B 235

*Canal with an angler and two
swans.* With drypoint. Second
state of two. Signed and dated
Rembrandt f. 1650. Amsterdam.

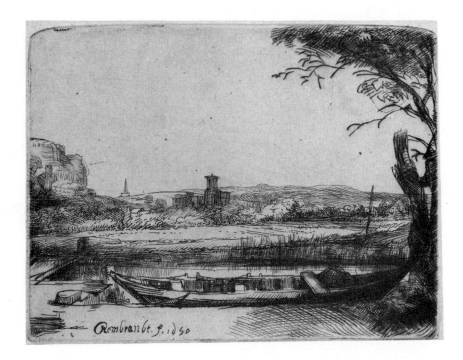

B 236
Canal with a large boat and bridge ['*Het schuytje op de voorgrondt*']. With drypoint. Second state of two. Signed and dated *Rembrandt f. 1650.* Haarlem.

The traditional Dutch title means 'The barge in the foreground.'

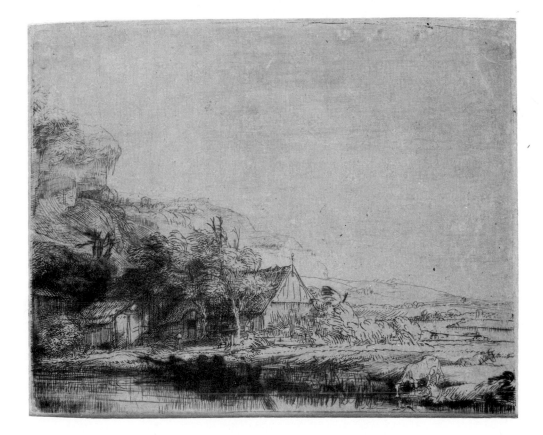

B 237
Landscape with a cow. With drypoint. First state of two. Printed on Japanese paper. Amsterdam.

About 1650.

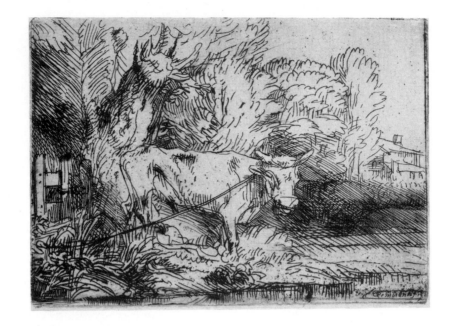

B 253
The bull ['*Het stiertje*']. Only
state. Signed and dated
Rembrandt f. 16-- (the third
digit is unclear and the fourth is
missing). Amsterdam.
 About 1650. One of three
known impressions.

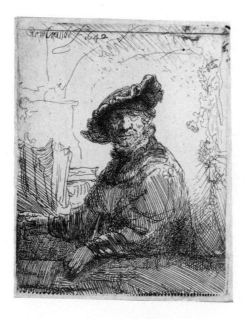

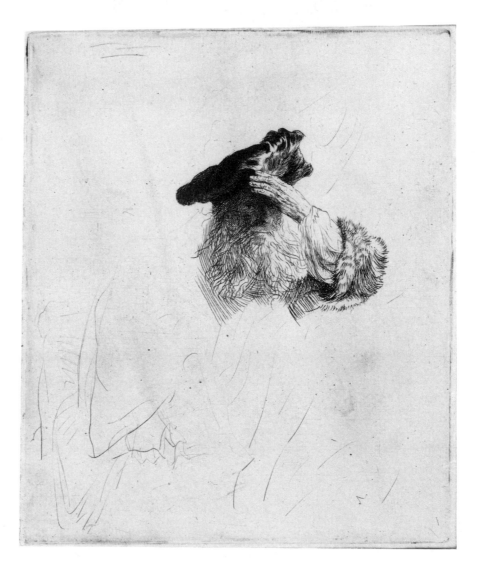

B 257
Man in an arbor. Only state.
Signed and dated *Rembrandt f.
1642*. Haarlem.
 The date appears to have been
changed from 1640.

B 259
*Old man shading his eyes with
his hand*. With drypoint. Only
state. Haarlem.
 About 1639. The plate was
eventually finished – not by
Rembrandt, who abandoned it
for unknown reasons, but by the
German etcher G. F. Schmidt in
1770.

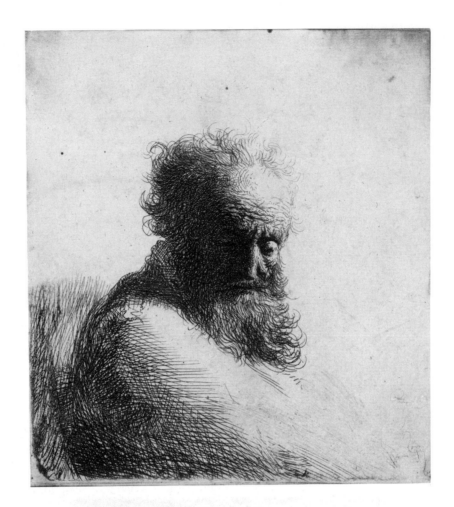

B 260
*Bust of an old bearded man,
looking down, three-quarters
right*. Third state of three. Signed
and dated *RHL 1631*. Haarlem.

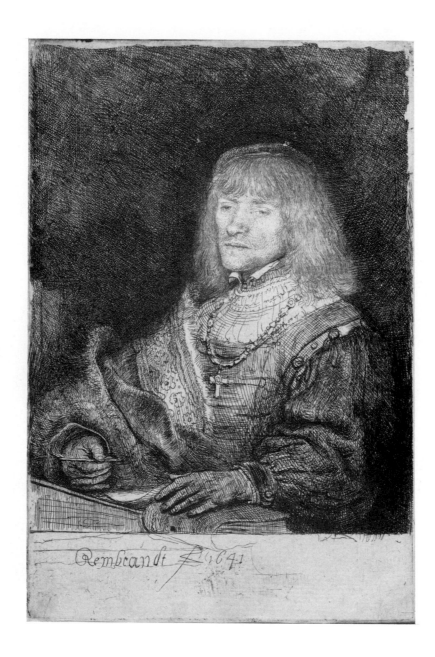

B 261
*Man at a desk wearing a cross
and chain.* With drypoint.
Second state of four. Signed and
dated *Rembrandt f. 1641.*
Haarlem.

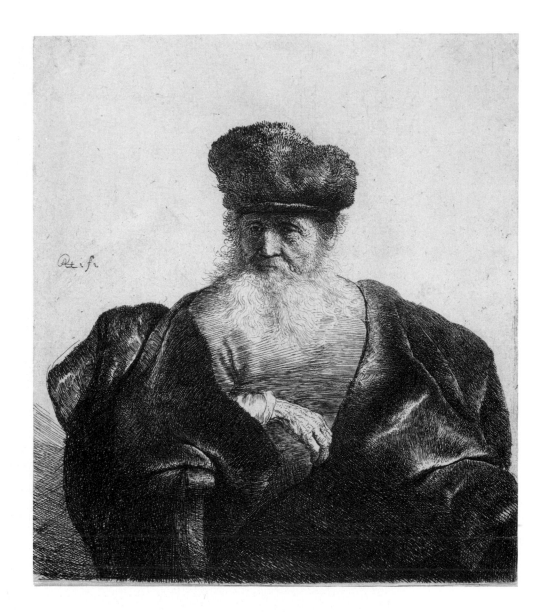

B 262
*Old man with beard, fur cap and
velvet cloak.* Second state of
three. Haarlem.
 About 1632.

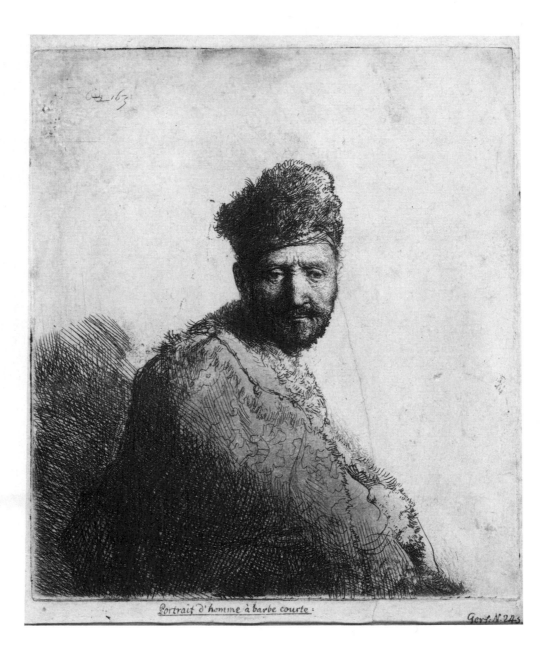

Portrait d'homme à barbe courte.

Gersl. N°. 245

B 263
Bearded man, in a furred oriental cap and robe [The artist's father?]. With burin. Third state of four. Signed and dated *RHL 1631*. Printed with surface tone. Haarlem.

The signature and date are lacking in the first state. The written inscriptions below were added in the 18th century. See comment under B 292.

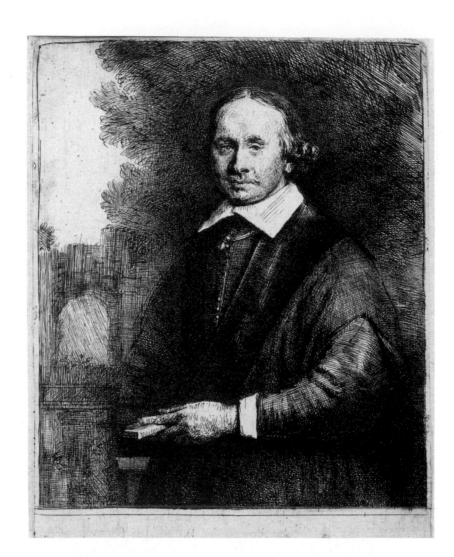

B 264
Jan Antonides van der Linden
[*1609-64*]. With drypoint and
burin. Second state of five.
Haarlem.
 About 1665. Rembrandt's last
known etching. Made for the
frontispiece of the sitter's
posthumous edition of the
writings of Hippocrates. It was
not used, however, since the
publisher required an engraving
rather than an etching.

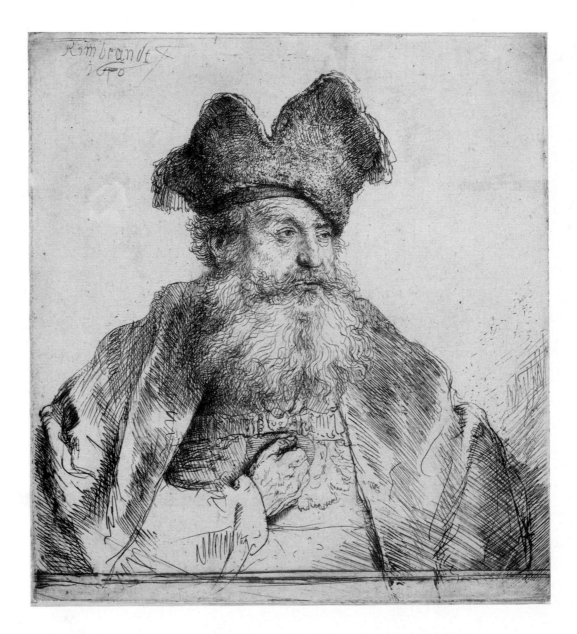

B 265
Old man with a divided fur cap.
With some drypoint. First state
of two. Signed and dated
Rembrandt f. 1640. Haarlem.

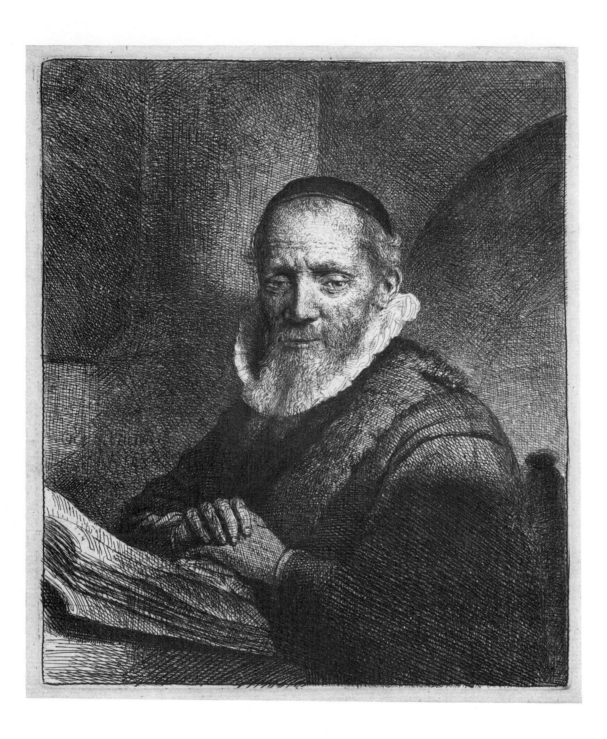

B 266
Jan Cornelis Sylvius, preacher
[*1564-1638*]. With burin. Second
state of two. Signed and dated
Rembrandt f. 1633. Haarlem.
See also under B 280.

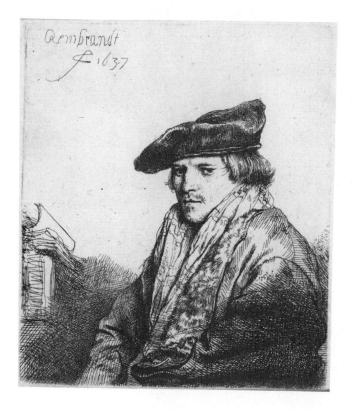

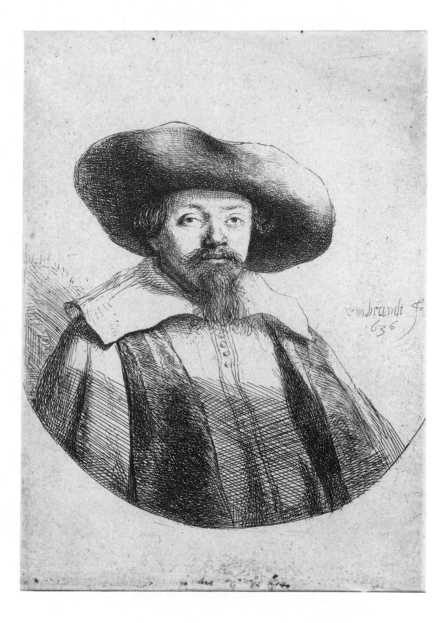

B 268
Young man in a velvet cap
[*Petrus Sylvius, preacher?;
1610-53*]. Second state of two.
Signed and dated *Rembrandt f.
1637*. Haarlem.

B 269
Samuel Menasseh ben Israel
[*1604-57*]. Third state of three.
Signed and dated *Rembrandt f.
1636*. Haarlem.
 The sitter was a famous
Sephardic rabbi and scholar.
See also B 36.

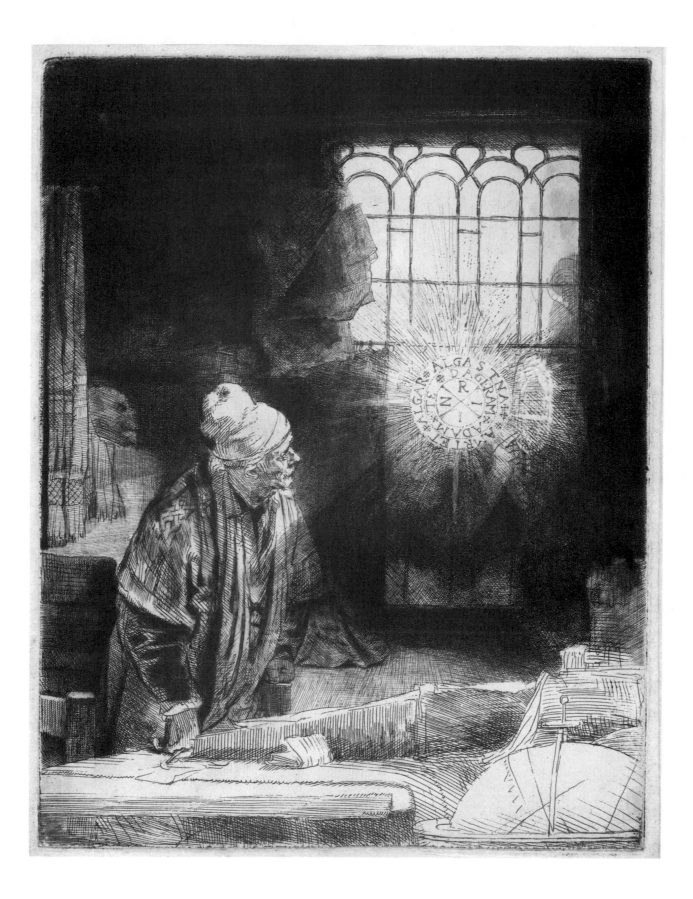

B 270

Faust. With drypoint and burin.
Third state of four. Haarlem.

About 1652. The title is not
older than the 18th century.
The figure and his fascinating
vision in the window have not
yet been conclusively explained.

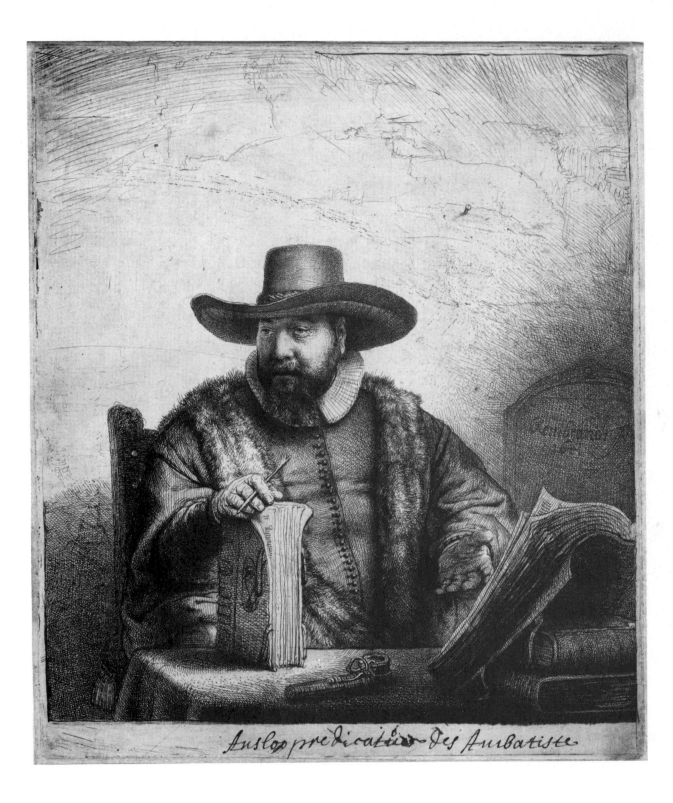

B 271
Cornelis Claesz. Anslo, preacher
[*1592-1646*]. With drypoint.
First state of two. Signed and
dated *Rembrandt f. 1641*.
Haarlem.

The penned inscription below
was added later.

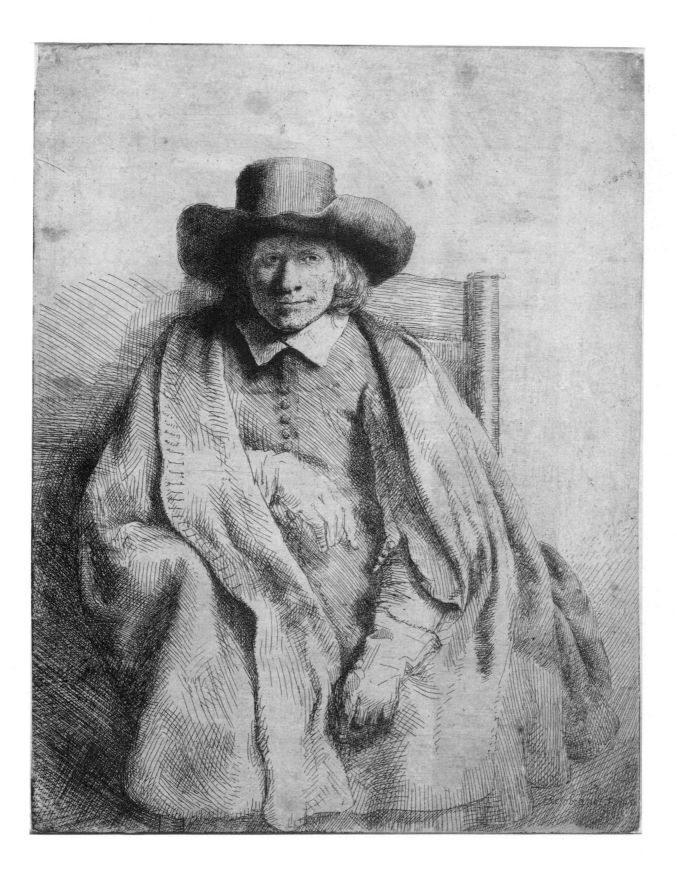

B 272
Clement de Jonghe, printseller
[*1624/25-77*]. With drypoint and
burin. First state of six. Signed
and dated *Rembrandt f. 1651*.
Haarlem.

De Jonghe's estate included,
upon his death, a good number
of plates of Rembrandt etchings.

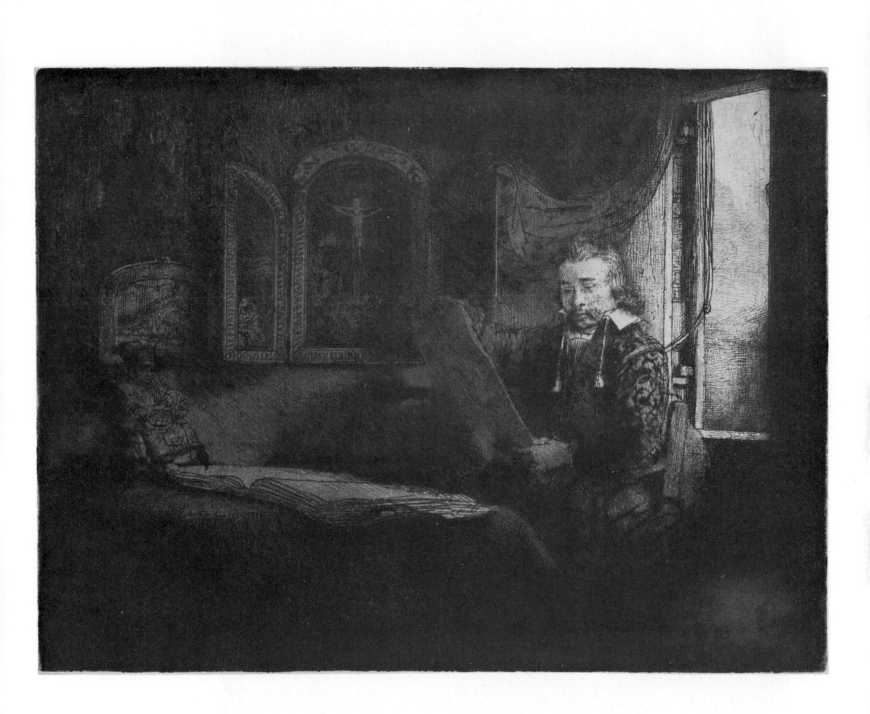

B 273
Abraham Francen, apothecary
[*born 1613*]. With drypoint and
burin. Second state of nine.
Haarlem.

About 1657. The many states
through which this plate went
include several in which the
motif of the drawing held by the
sitter can be seen to be a half-
length man.

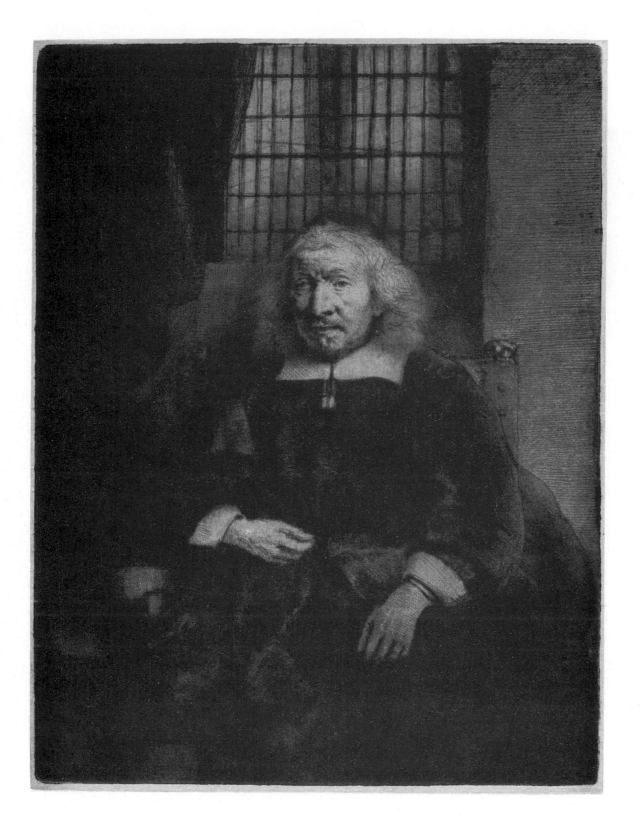

B 274
Thomas Haaringh ['*Old
Haaringh*'; *died 1660*].
Drypoint and burin only. Second
state of two. Amsterdam.

About 1655. The sitter was in
charge of the office that sold
Rembrandt's goods in 1657 and
1658 after the painter's
insolvency. See also B 275.

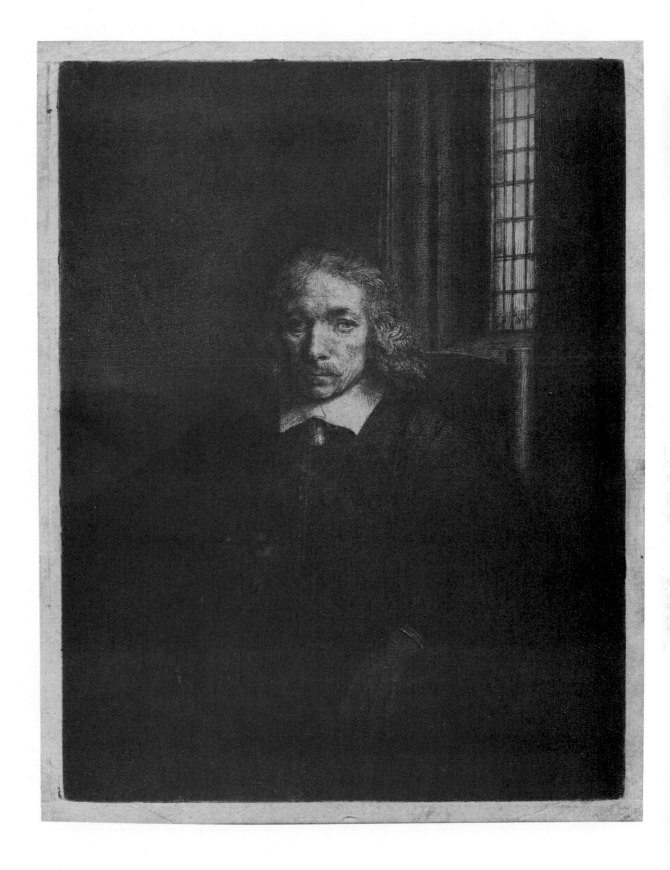

B 275
Pieter Haaringh ['*Young
Haaringh*'; *1609-85*]. With
drypoint and burin. First state
of five. Signed and dated
Rembrandt f. 1655, barely
legibly. Printed on Japanese
paper. Haarlem.

A distant relative of Thomas
Haaringh, portrayed in B 274,
Pieter was the auctioneer of the
Amsterdam insolvency chamber.
The sitter was formerly thought
to be Thomas's son Jacob
Haaringh.

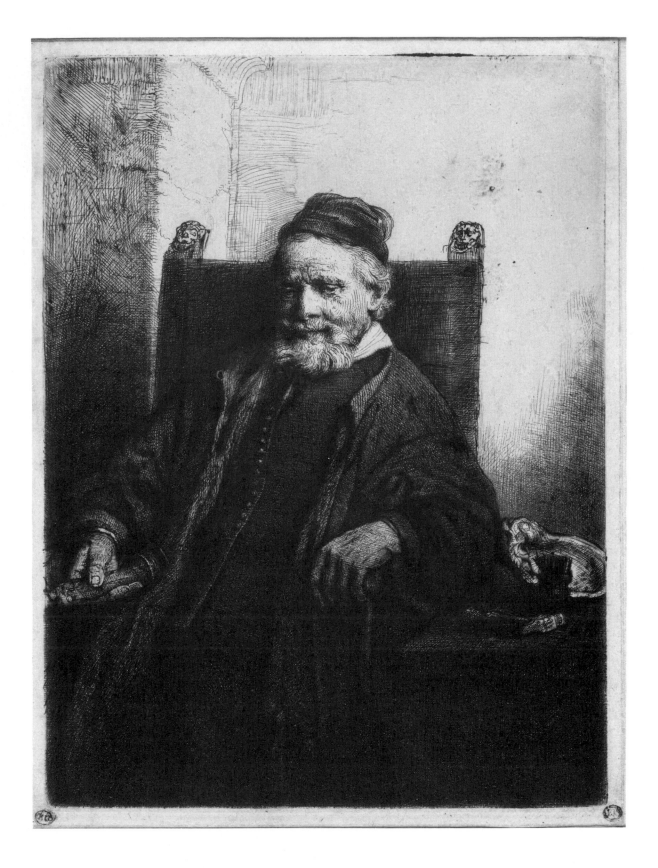

B 276
Jan Lutma, goldsmith [*1584-*
1669]. With drypoint. First state
of three. Haarlem.
 In the second state signed and
dated *Rembrandt f. 1656.*

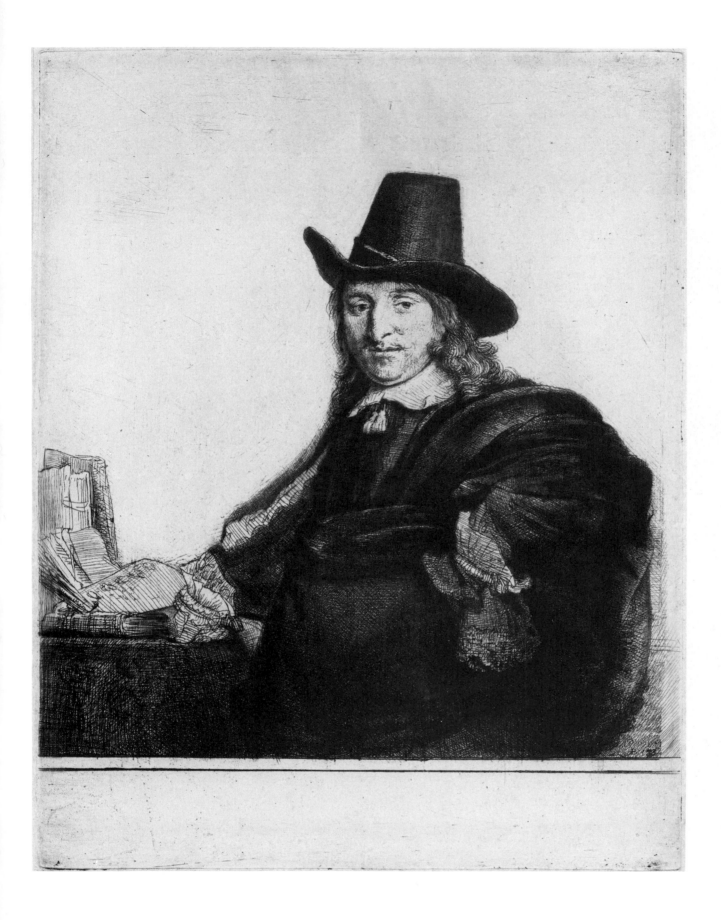

B 277
Jan Asselyn, painter ['*Crabbetje*';
1610-52]. With drypoint and
burin. Third state of three.
Signed and dated *Rembr f. 16--*
(the last two digits are illegible).
Haarlem.

About 1647. In the first state
there is an easel with a painting
behind the figure.

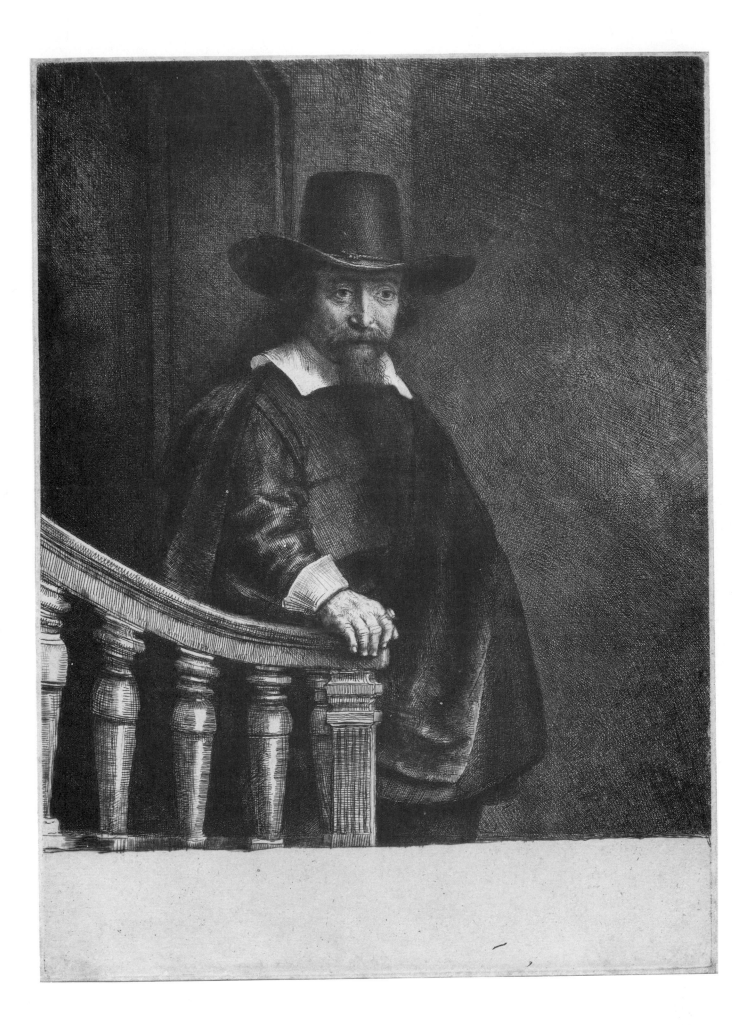

B 278

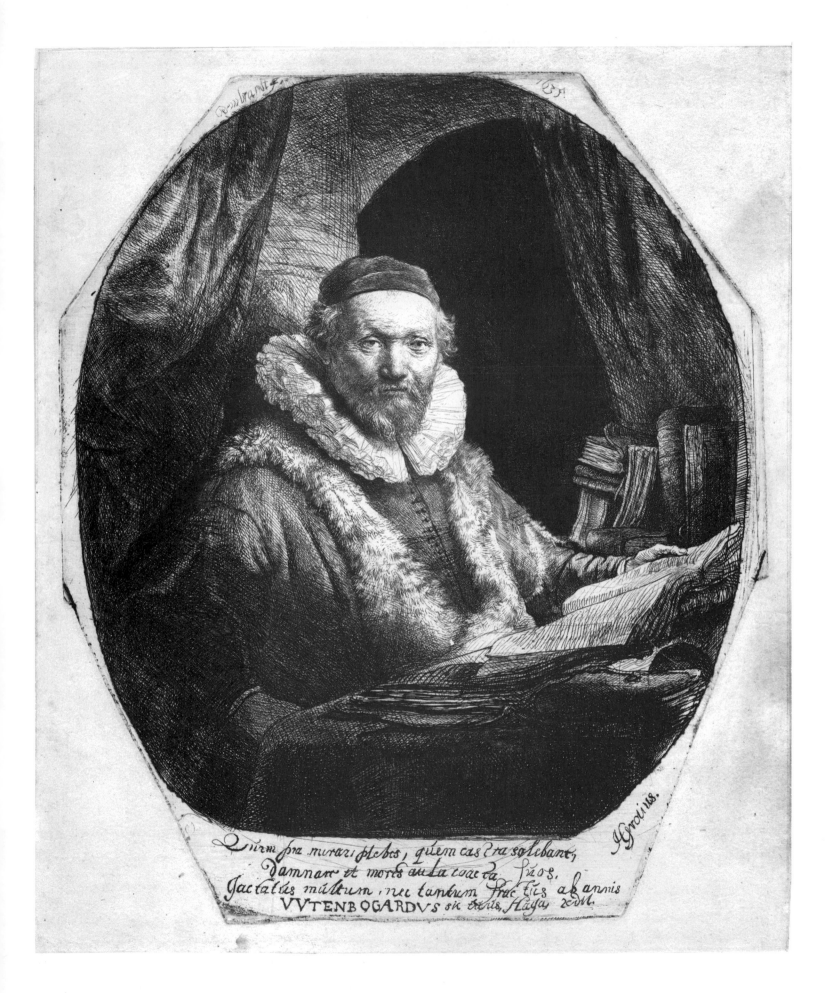

Quem pra mirari plebes, quem castra solebant,
Damnare et morte aula coacta suos.
Iactatus multum, nec tantum fractus ab annis
VVTENBOGARDVS sic erat. Hagae colit.

B 279

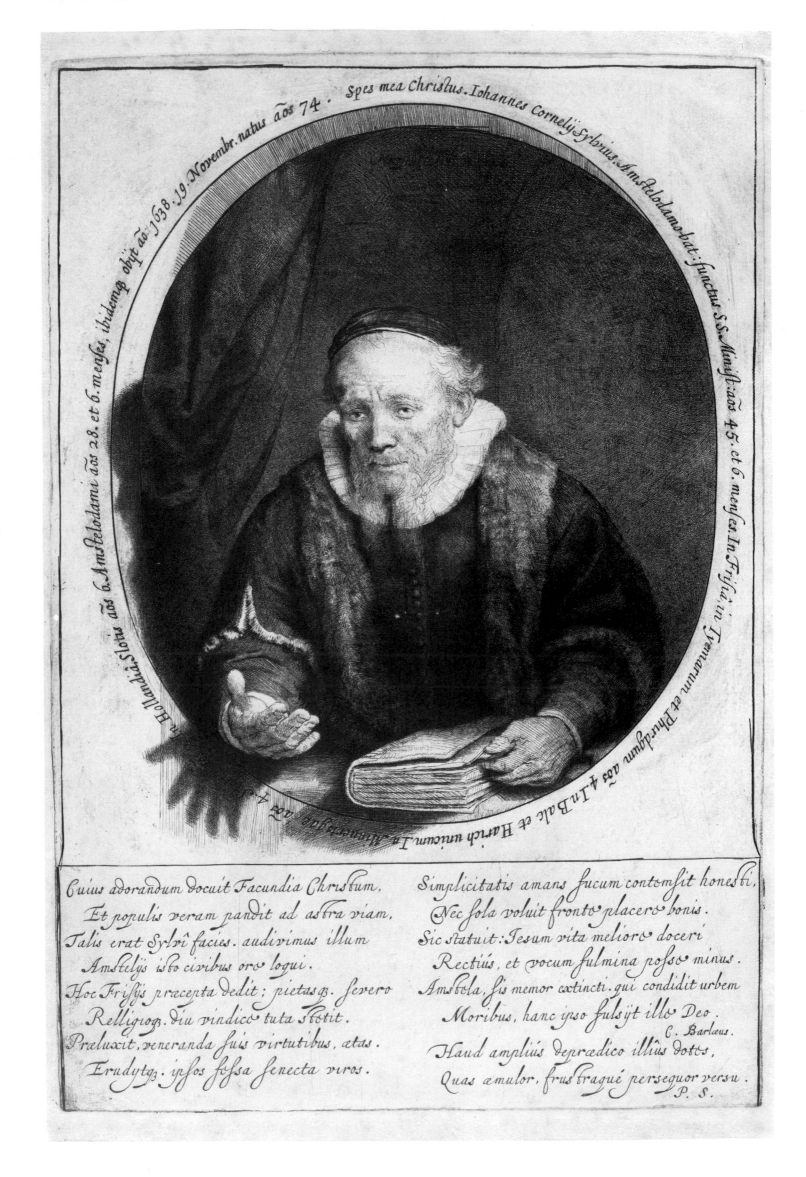

Spes mea Christus. Iohannes Cornelij Sylvius Amstelodamobat: functus S.S. Ministr:aõs 45. et 6. menses. In Frisiâ, in Tzummarum et Phirdgum aõs 4.In Balk et Harich unicum I. Ministesuq

aõs 28. et 6. menses, ibidemq obijt aõ 1638 .19. Novembr. natus aõs 74.

Hollandiâ Natus aõs 6.Amstelodami

Cuius adorandum docuit Facundia Christum,
 Et populis veram pandit ad astra viam.
Talis erat Sylvi facies. audivimus illum
 Amstelijs isto civibus ore loqui.
Hoc Frisijs praecepta dedit; pietasq. severo
 Relligioq. diu vindice tuta stetit.
Praeluxit, veneranda suis virtutibus, aetas.
 Erudytq. ipsos solsa senecta viros.

Simplicitatis amans fucum contemsit honesti,
 Nec sola voluit fronte placere bonis.
Sic statuit: Iesum vita meliore doceri
 Rectiús, et vocum fulmina posse minus.
Amstela, sis memor extincti. qui condidit urbem
 Moribus, hanc ipso fulsijt illo Deo.
 C. Barlaeus.
Haud ampliús depraedico illûs dotes,
 Quas aemulor, strus tragué persequor versu.
 P. S.

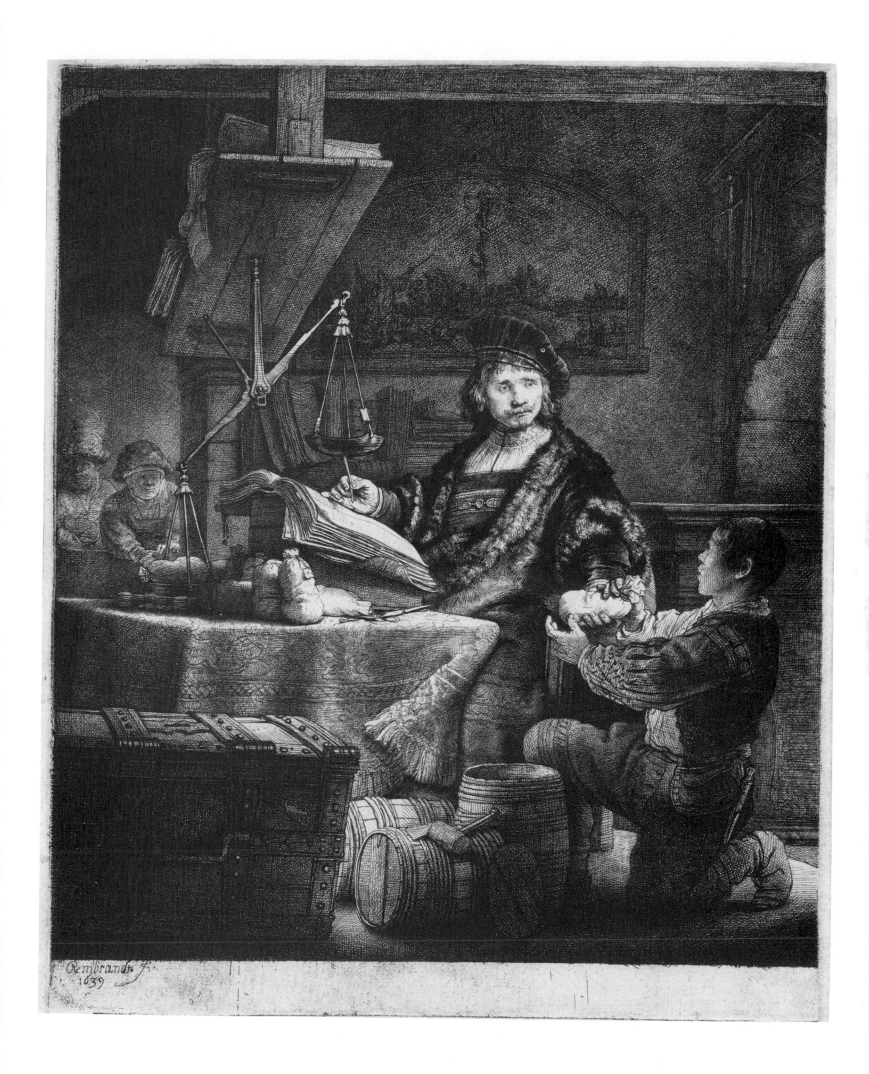

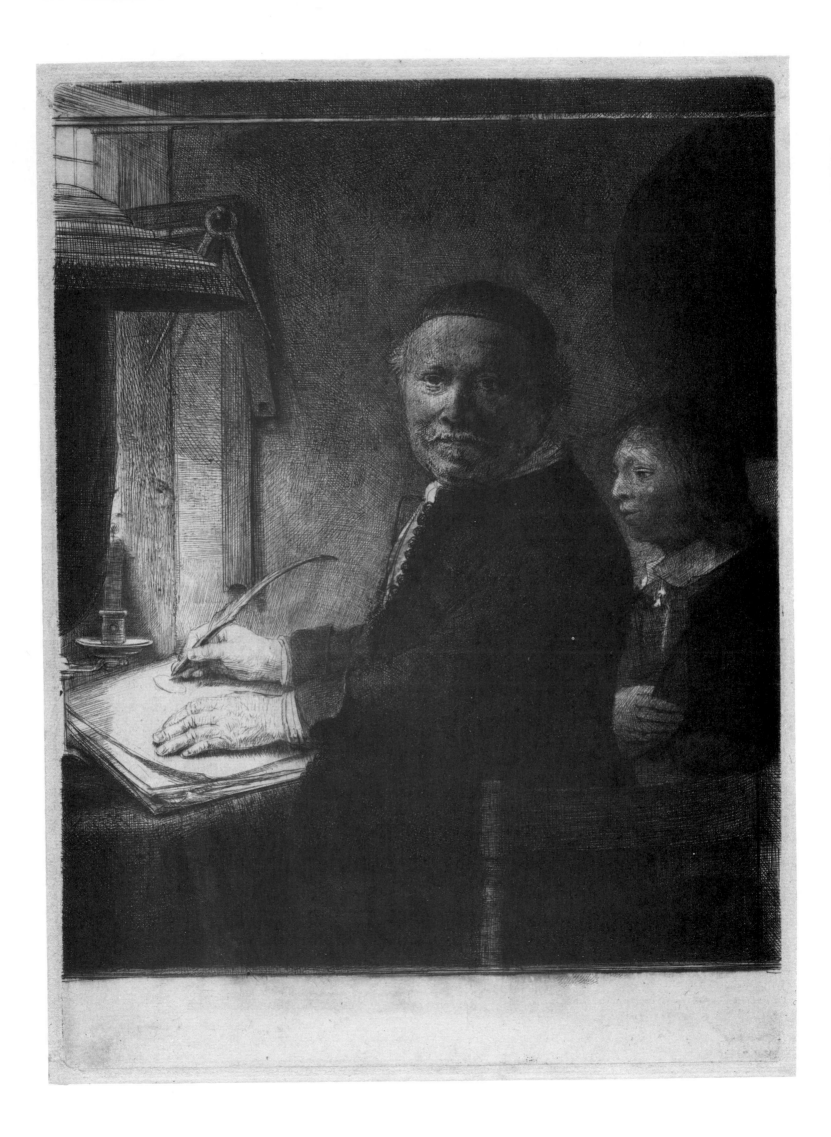

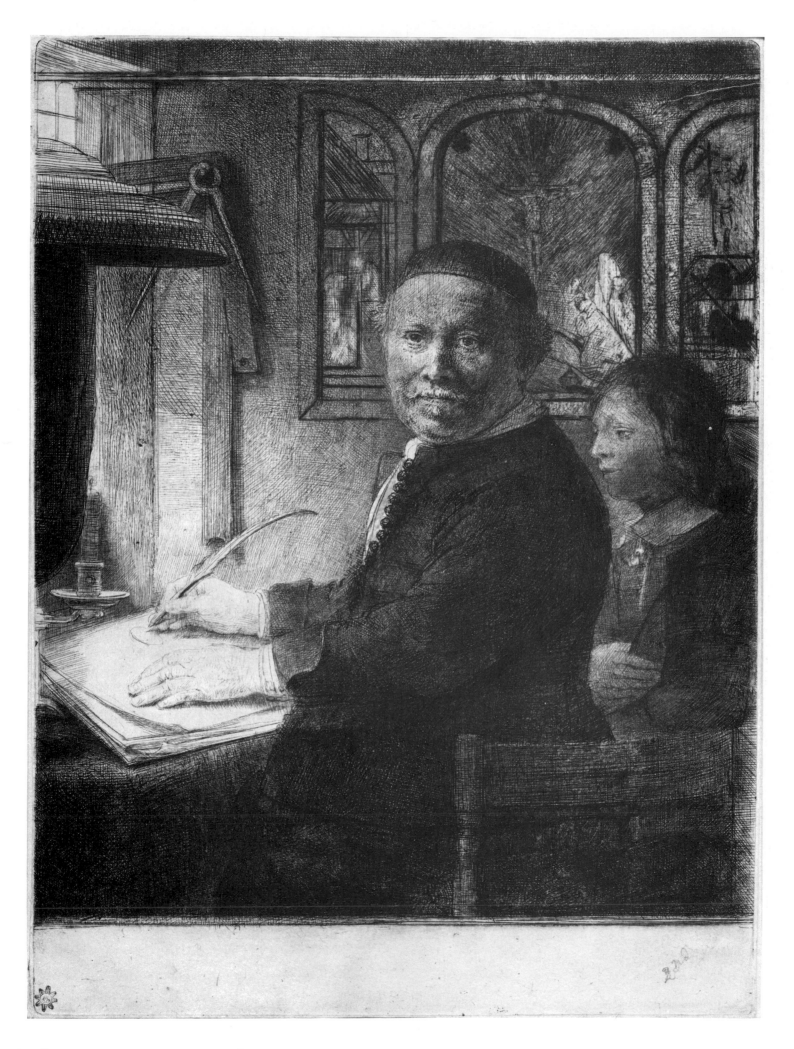

◄ B 278
Ephraim Bonus, Jewish physician
[*1599-1655*]. With drypoint and
burin. Second state of two.
Signed and dated *Rembrandt f.*
1647. Haarlem.

◄ B 279
Jan Uytenbogaert, preacher of
the Remonstrants [*1557-1644*].
Fourth state of six (with burin).
Signed and dated *Rembrandt f.*
1635. Haarlem.
 The plate started off
rectangular. It was cut to this
form, and the inscriptions were
added, in the fourth state.

◄ B 280
Jan Cornelis Sylvius, preacher
[*1564-1638*]. With drypoint and
burin. Second state of two.
Signed and dated *Rembrandt*
1646. Haarlem.
 Posthumous portrait of a man
whom Rembrandt had
portrayed in his lifetime in
1633 (B 266). Sylvius was
Saskia's cousin by marriage and
her guardian as a child.

◄ B 281
Jan Uytenbogaert [*1606-84;*
'The goldweigher']. With
drypoint. Second state of two.
Signed and dated *Rembrandt f.*
1639. Amsterdam.
 The sitter was receiver-general
of the states-general for the
province of Holland.

◄ B 282
Lieven Willemsz. van Coppenol,
writing-master [*1599- after*
1677]: *smaller plate.* With
drypoint and burin. Third state
of six. Amsterdam.
 About 1658. The boy behind
the sitter is apparently his
grandson Antonius. The circle
was replaced in the fourth state
by a triptych of the Crucifixion,
which was burnished out in its
turn in the fifth state. See also
B 283.

The same plate, in the fourth
state. Haarlem.

▶ B 283
Lieven Willemsz. van Coppenol,
writing-master: the larger plate.
With drypoint and burin. Third
state of six. Amsterdam.
 About 1658. Coppenol was in
the habit of ordering portraits
of himself from graphic artists
to be used as a form of
advertisement. This plate is more
typical of that genre than the
informal B 282.
 This illustration is reduced. For
a full-scale reproduction, see
the outsize sheets.
 Original size 34× 29 cm.

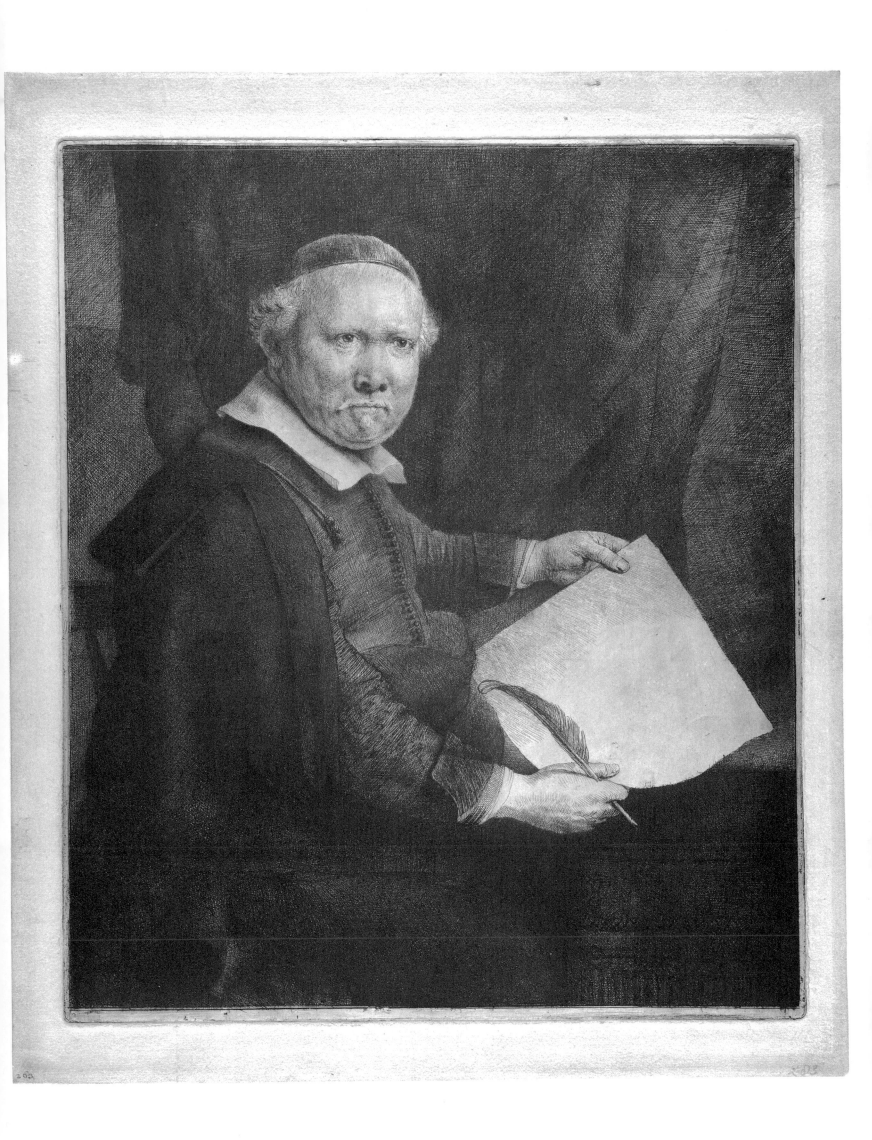

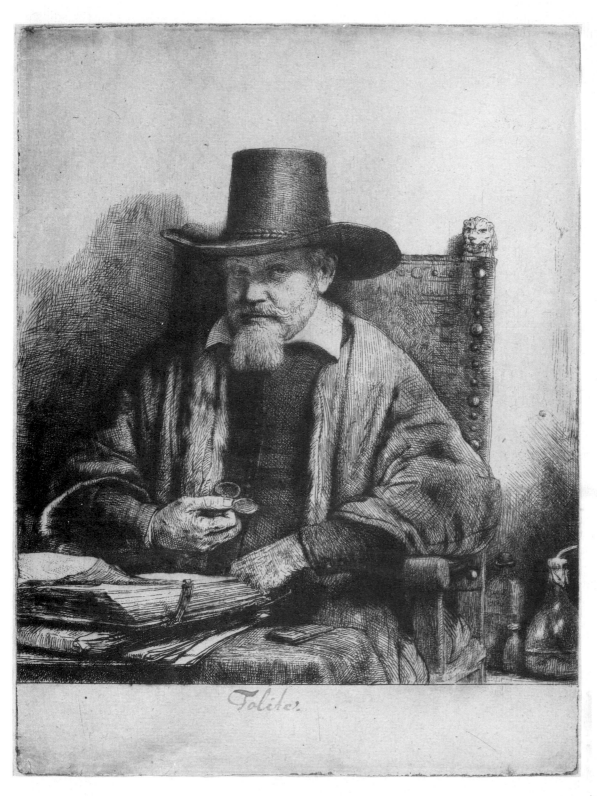

B 284
Arnold Tholinx, inspector
[*died 1679*]. With drypoint and
burin. Second state of two.
Amsterdam.

About 1656. The penned
inscription was added later. The
sitter was inspector of medical
colleges in Amsterdam.

▶ B 285
Jan Six [*1618-1700*]. With
drypoint and burin. Fourth
state of four. Signed and dated
Rembrandt f. 1647. Haarlem.

The signature appeared in the
second state, and in the fourth
the inscription with the sitter's
name and age: *JAN SIX AE. 29*.
The patrician poet Six was in
close contact with Rembrandt
over a long period of years (see
B 112).

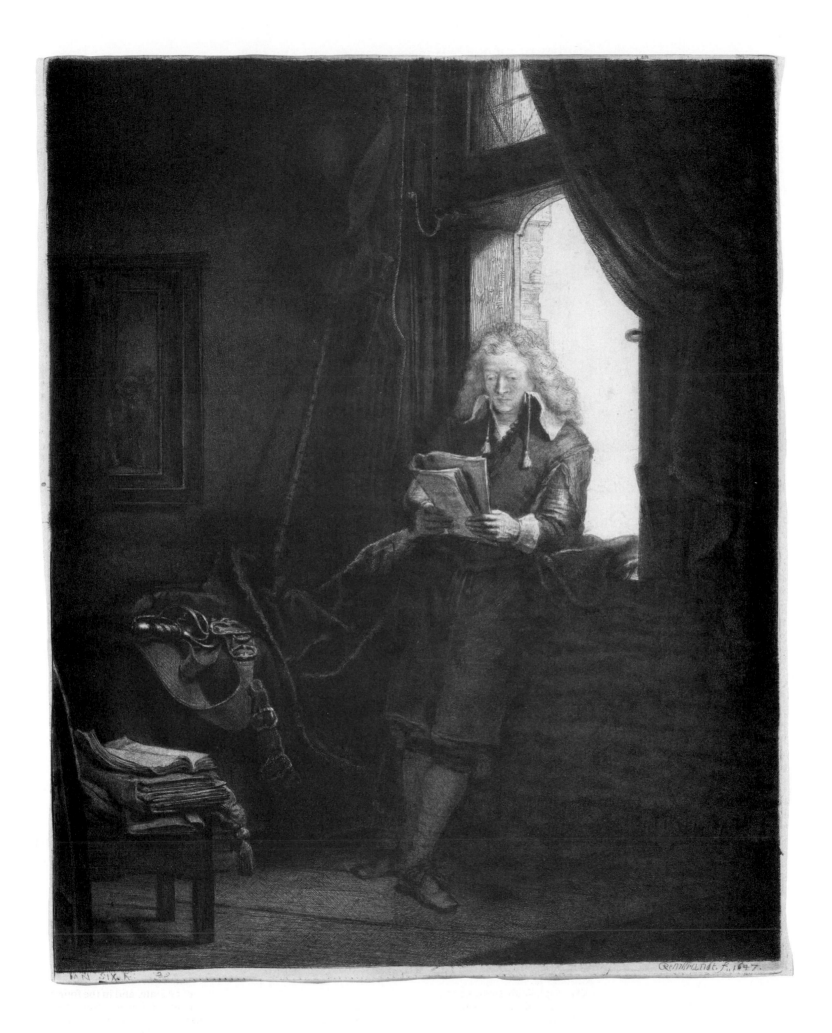

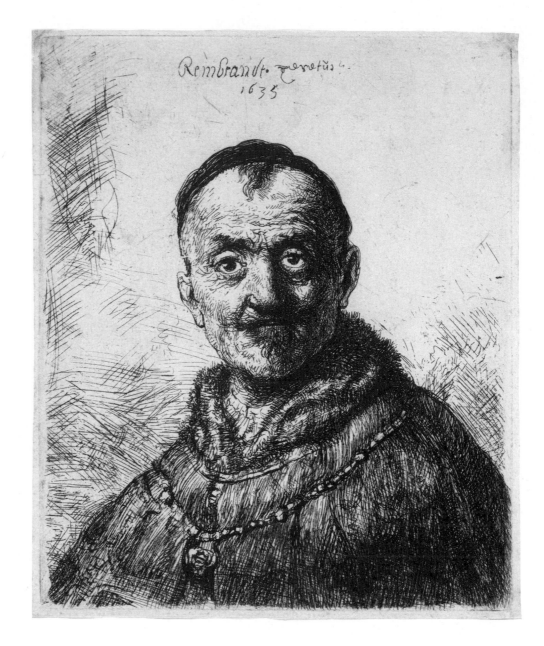

B 286
The first oriental head. With
some drypoint. Second state of
two. Signed and dated
Rembrandt geretuc. 1635.
Amsterdam.
 The inscription, with its
reference to 'retouching,' seems
to indicate that Rembrandt was
only partially responsible for
this and the following plates,
which are all free copies after
etchings by Jan Lievens.

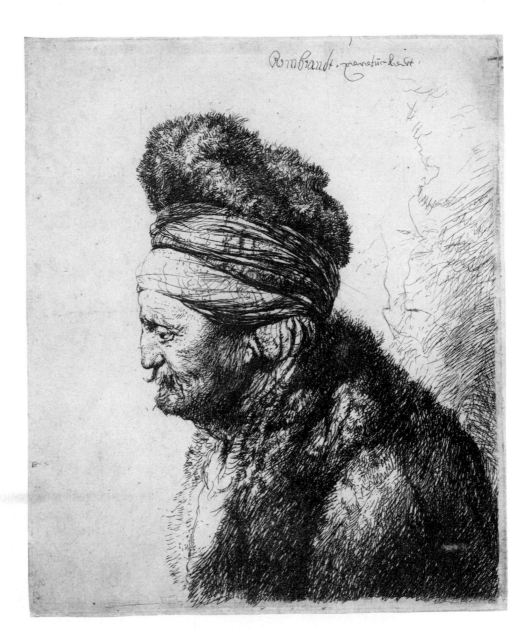

B 287
The second oriental head. Only
state. Signed *Rembrandt
geretuckert.* Haarlem.
 About 1635. See comment
under B 286.

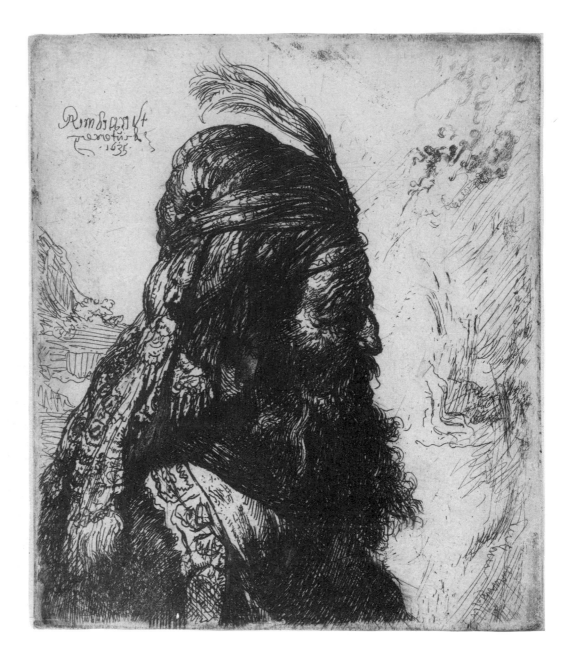

B 288
The third oriental head. Only
state. Signed and dated
Rembrandt geretuck 1635.
Amsterdam.
 See comment under B 286

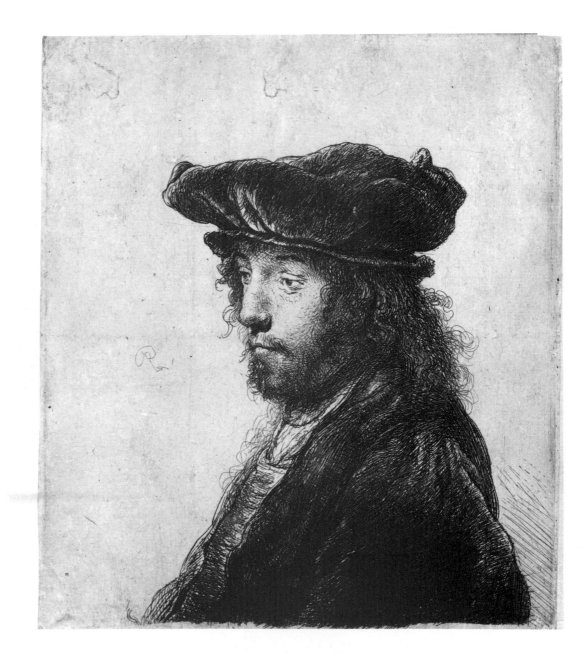

B 289
The fourth oriental head. Only
state. Signed (by Rembrandt?)
Rt. Haarlem.
 About 1635.

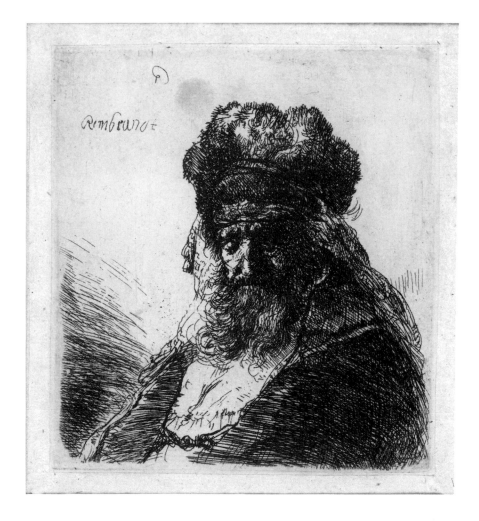

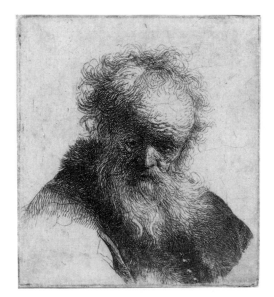

B 290
Old bearded man in a high fur cap, with eyes closed. Only state. Signed *Rembrandt*. Haarlem.
 About 1635.

B 291
Bust of an old man with flowing beard and white sleeve. Only state. Haarlem.
 About 1631.

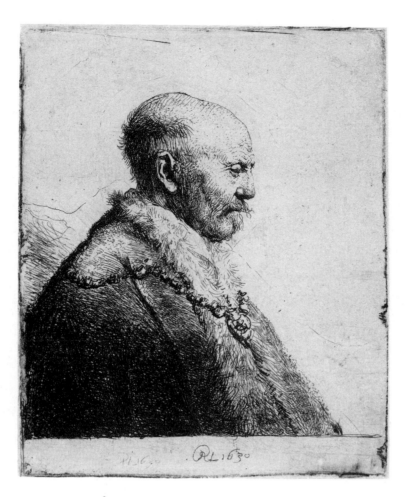

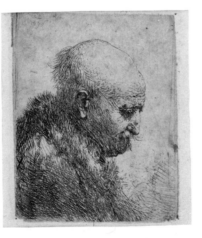

B 292
Bald-headed man in right profile
[*The artist's father?*]. Second
state of three. Signed and dated
RL 1630, twice. Amsterdam.

In the third state the plate is
cut down, and the signature is
changed to *RHL 1630*. None of
the suggested identifications of
Rembrandt's father in etchings,
drawings or paintings rests on
reliable evidence.

B 294
*Bald-headed man in right profile:
small bust* [*The artist's father?*].
Only state. Signed and dated
RHL 1630. Haarlem.

See comment under B 292.

B 302
Head of a man in a high cap.
Third state of five. Haarlem.

About 1631. The penned
numbers in the lower right are
those of the etching's entries in
the catalogues of Bartsch (1797)
and Gersaint (1751).

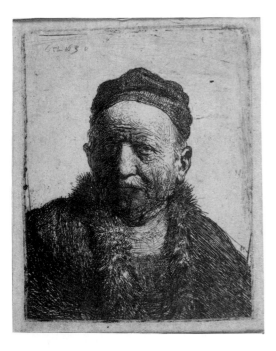

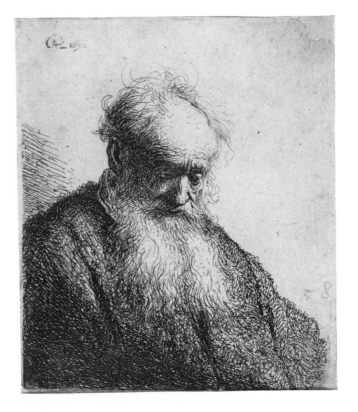

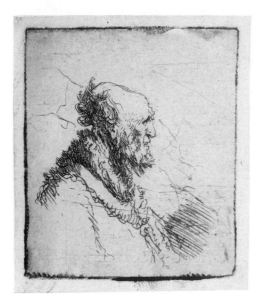

B 304
Man wearing a close cap: bust
[*The artist's father?*]. Third
state of five. Signed and dated
RHL 1630. Haarlem.
 Signature lacking in the first
state. See comment under B 292.

B 306
*Bald old man with a short beard,
in right profile*. Only state.
Amsterdam.
 About 1635.

B 309
Old man with a flowing beard.
Only state. Signed and dated
RHL 1630. Haarlem.
 The marks in the lower right
are written with a pen.

▶ B 310
Portrait of a boy, in profile. Only
state. Signed and dated
Rembrandt f. 1641. Haarlem.
 The cracks across the entire
surface are probably the result of
craquelure in the etching ground.

▶ B 311
Man in a broad-brimmed hat.
Only state. Signed and dated (by
Rembrandt?) *RHL 1638*.
Haarlem.
 Because the monogram *RHL*
never occurs after 1633 except in
this etching, the inscription and
the dating, if not the attribution
of this plate, should be regarded
with a certain suspicion.

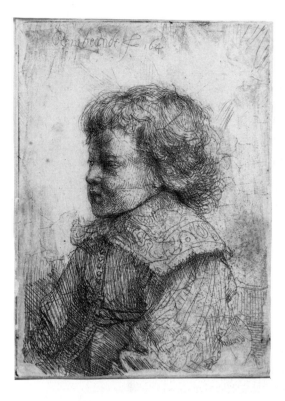

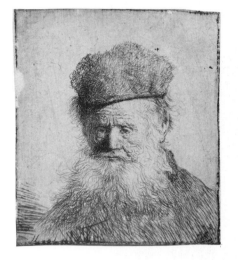

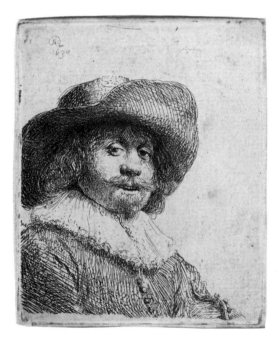

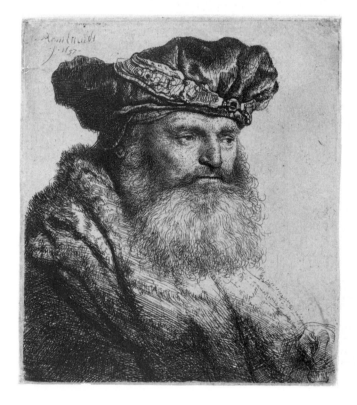

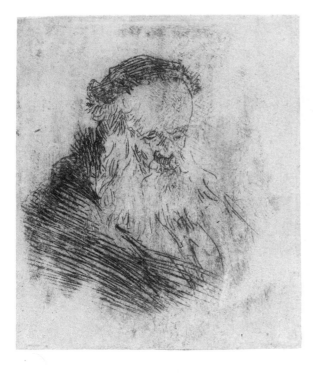

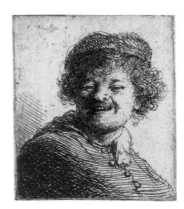

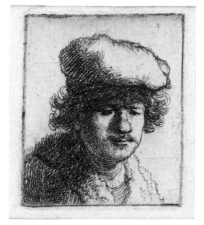

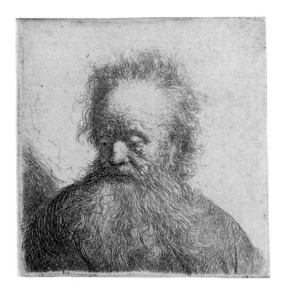

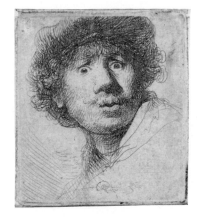

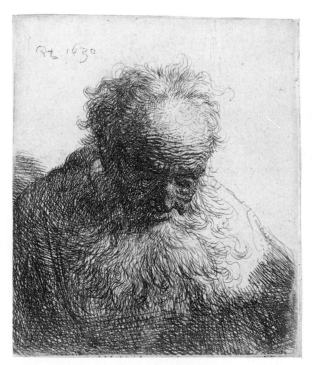

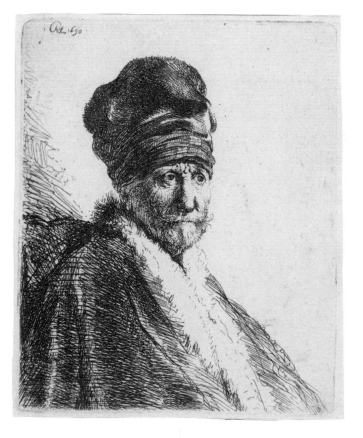

B 320
*Self portrait in a cap, with eyes
wide open.* Only state. Signed and
dated *RHL 1630.* Haarlem.

B 325
*Bust of an old man with a flowing
beard, the head bowed forward,
the left shoulder unshaded.* Only
state. Signed and dated *RHL
1630.* Haarlem.

B 321
*Bust of a man wearing a high cap,
three-quarters right* [*The artist's
father?*]. Second state of two.
Signed and dated *RHL 1630.*
Haarlem.

See comments under B 292.

B 327
*Head of a man in a fur cap,
crying out.* Third state of three.
Haarlem.

About 1629-30.

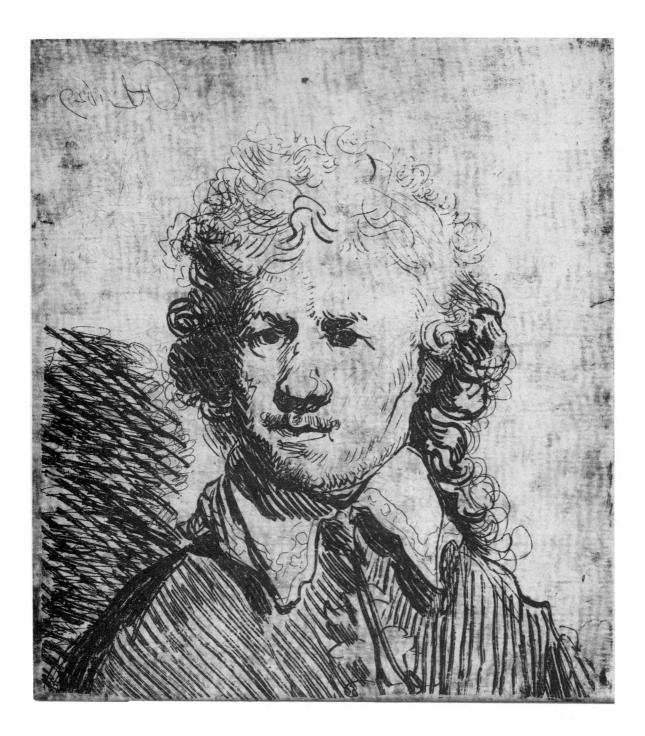

B 338
Self portrait bare-headed: bust,
roughly etched. Only state.
Signed and dated *RHL 1629*, in
reverse. Amsterdam.
 One of the two known
impressions.

▶ B 340
The great Jewish bride. With
some drypoint and burin. Fifth
state of five. Signed and dated
R 1635. Haarlem.
 The earliest two states were
unfinished and unsigned.

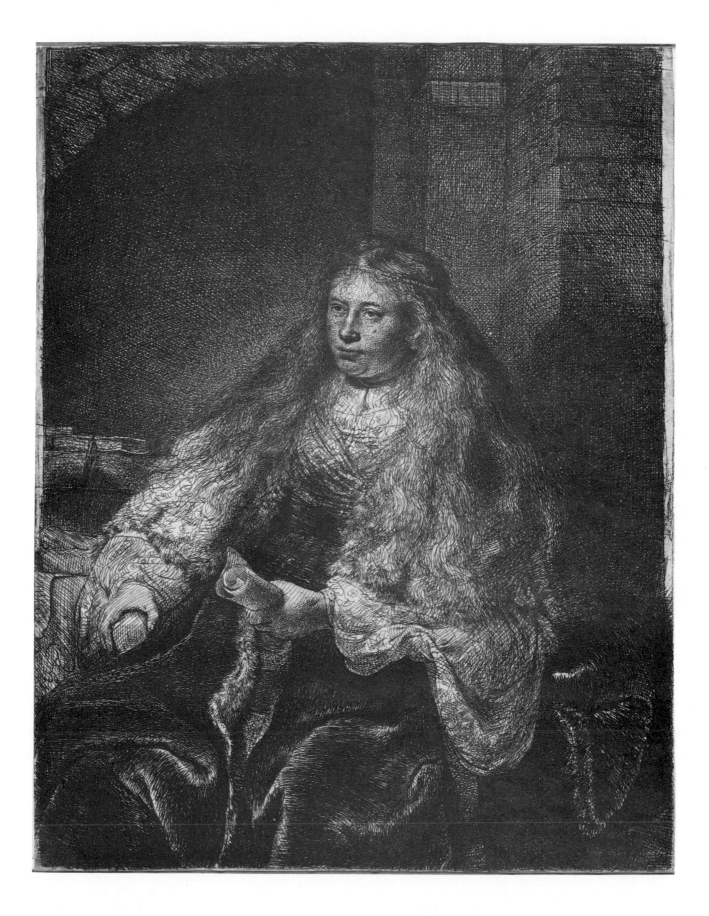

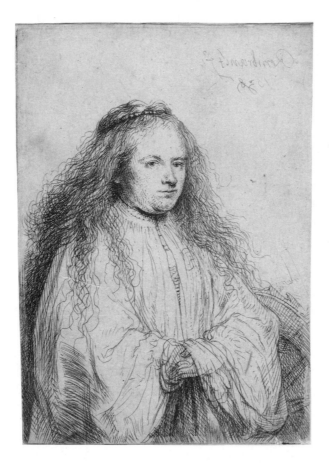

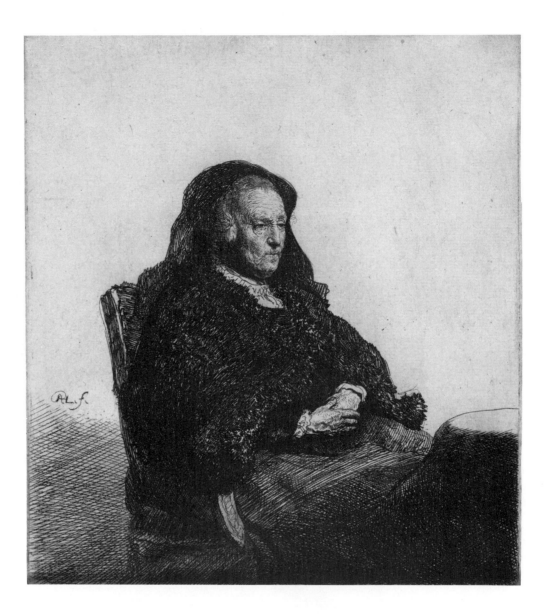

B 343
*The artist's mother seated at a
table, looking right: three-quarter
length.* Second state of three.
Signed *RHL f.* Amsterdam.
About 1631. Neeltgen
Willemsdr. van Zuytbrouck,
daughter of a baker, was the
mother of nine children, of
whom Rembrandt was the
eighth. She died in 1640.

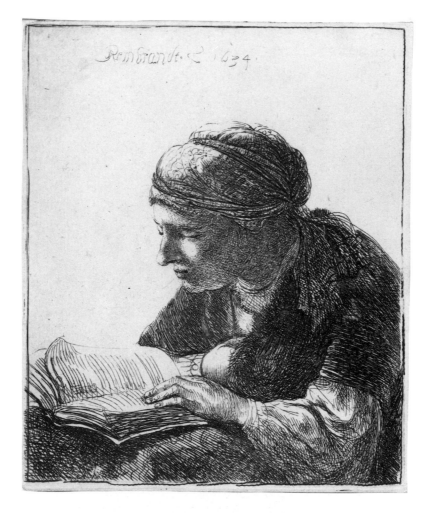

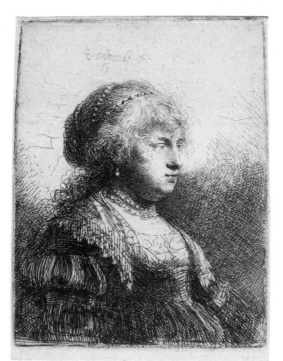

B 345
Woman reading. Third state of
of three. Signed and dated
Rembrandt f. 1634. Haarlem.

B 347
Saskia with pearls in her hair.
Only state. Signed and dated
Rembrandt f. 1634. Amsterdam.
Saskia van Uylenburgh was
the daughter of a burgomaster of
Leeuwarden. She married
Rembrandt in 1634 and died
after a lingering illness in 1642.

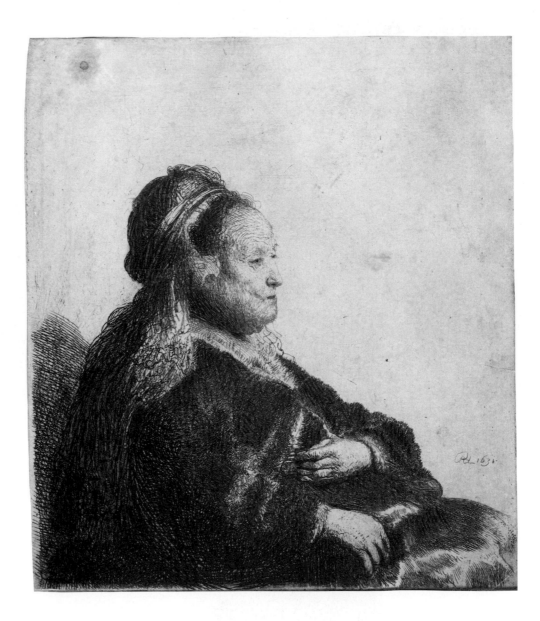

B 348
The artist's mother seated, in an
oriental headdress:half-length.
Second state of three. Signed and
dated *RHL 1631*. Haarlem.
 See B 343.

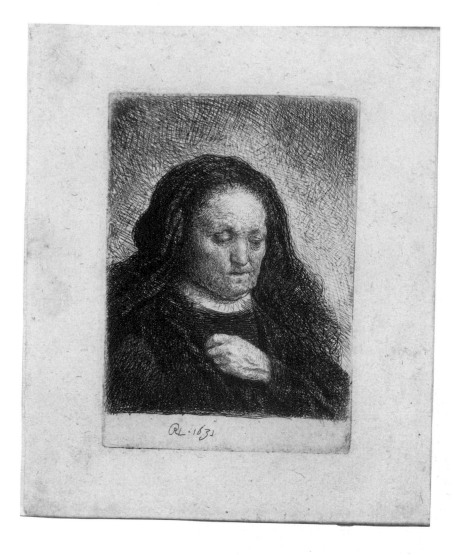

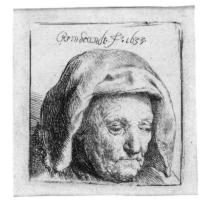

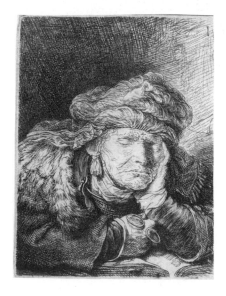

B 351
*The artist's mother in a cloth
headdress, looking down: head
only.* Second state of two.
Signed and dated *Rembrandt f.
1633.* Haarlem.
 See B 343. The signature is
lacking in the first state.

B 349
*The artist's mother with her hand
on her chest: small bust.* First
state of two. Signed and dated
RHL 1631. Haarlem.
 See B 343.

B 350
Old woman sleeping. Only state.
Haarlem.
 About 1635-37.

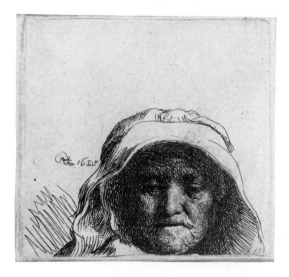

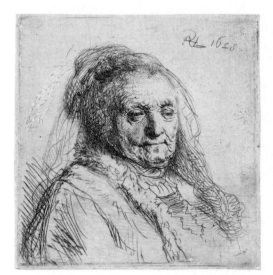

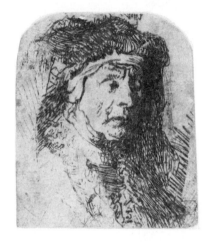

B 354
The artist's mother: head and bust, three-quarters right. Second state of two. Signed and dated *RHL 1628*. Haarlem.
See B 343.

B 352
The artist's mother: head only, full face. Second state of two. Signed and dated *RHL 1628*. Haarlem.
See B 343. The signature is lacking in the first state.

B 355
Bust of an old woman in a furred cloak and heavy headdress. First state of seven. Amsterdam.
This is the only impression of the first state. The later states, inscribed *RHL 1631*, are not by Rembrandt.

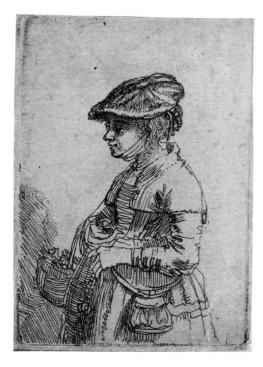

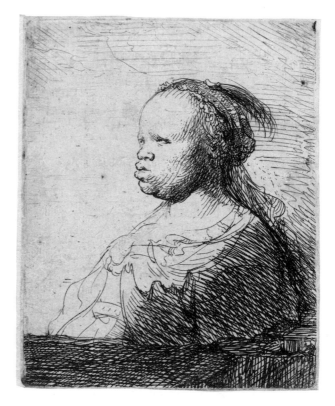

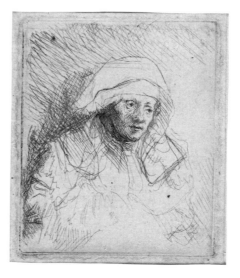

B 356
Girl with a basket. Second state
of two. Haarlem.
 About 1642.

B 357
The white negress. Second state
of two. Haarlem.
 The first state, somewhat
larger, is signed *RHL*. About
1630.

B 359
*Sick woman with a large white
headdress* [*Saskia*]. With touches
of drypoint. Only state.
Haarlem.
 About 1641-42.

Miscellaneous subjects [including sheets of studies]

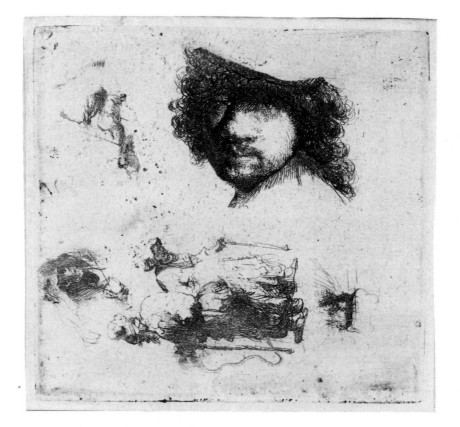

B 363
Sheet of studies: head of the
artist, a beggar couple, heads of
an old man and old woman, etc.
Second state of two. Haarlem.
 About 1632.

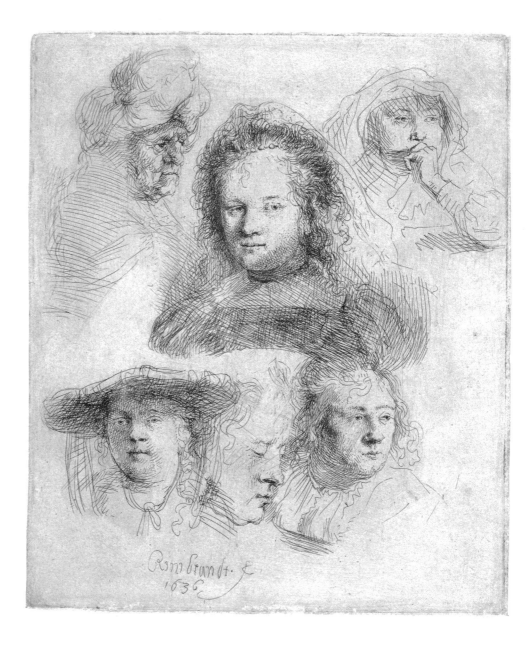

B 365
Studies of the head of Saskia and others. Only state. Signed and dated *Rembrandt f. 1636.* Amsterdam.

See comments under B 19 and B 347.

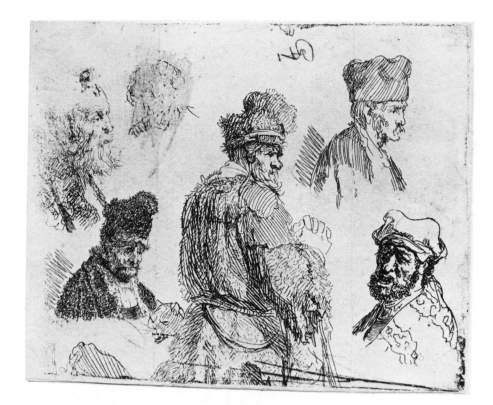

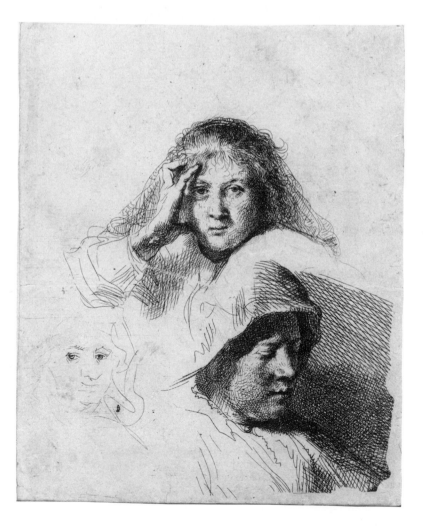

B 366
Sheet of studies of men's heads.
Only state. Signed *RHL*, in
reverse. Vienna.

About 1630-31. The plate was
later cut into five pieces, each of
which was printed separately.
This is the only whole
impression of the three that have
survived.

Reproduced from a photograph.

B 367
*Three heads of women, one
lightly etched.* Third state of
three. Haarlem.

About 1637. The second state
is signed *Rembrandt.* Probably
Saskia three times. See B 347.

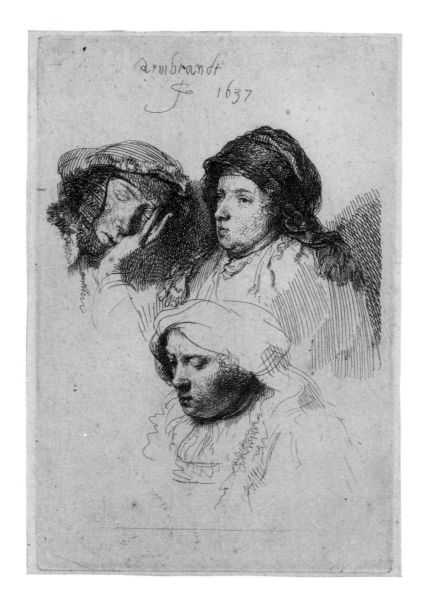

B 368
Three heads of women, one asleep.
Only state. Signed and dated
Rembrandt f. 1637. Haarlem.

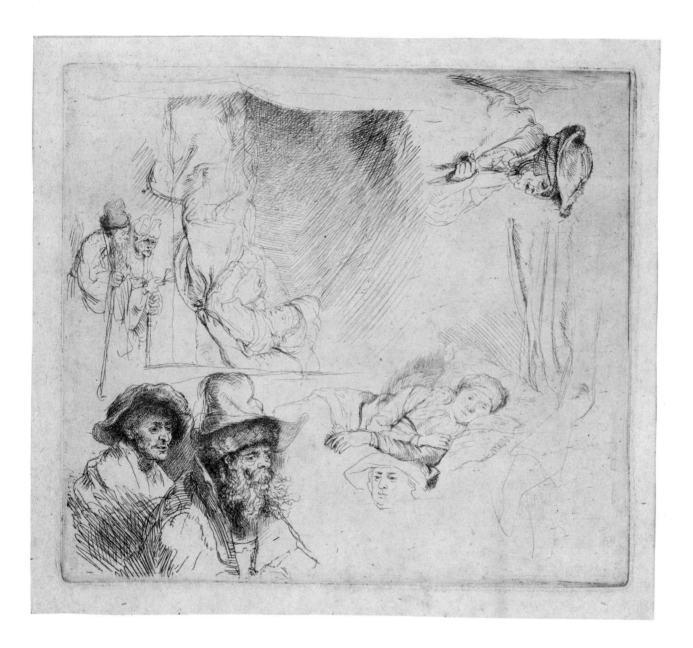

B 369
*Sheet of studies, with a woman
lying ill in bed, etc.* Only state.
Haarlem.
 About 1641-42. The two
sketches of women lying sick in
bed probably depict Saskia in
her final illness.

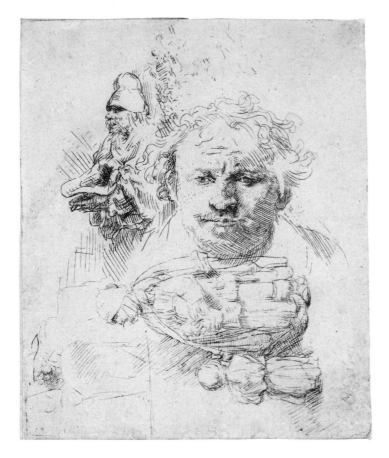

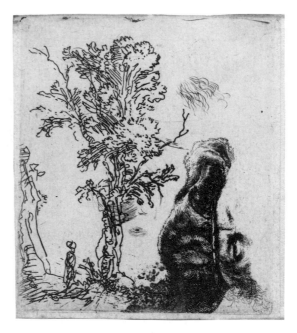

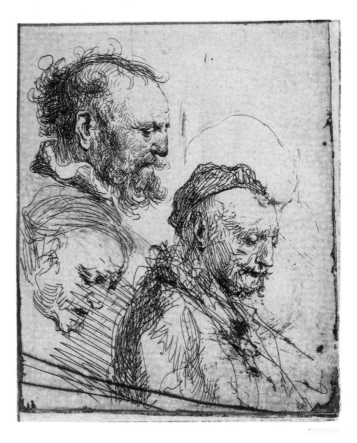

B 370
Sheet of studies with the head of the artist, a beggar man, woman and child. Only state. Signed and dated *RL 1651*, perhaps by another hand. Haarlem.

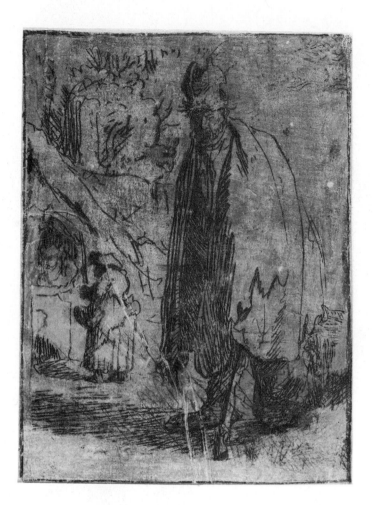

◄ B 372
Sheet with two studies: a tree,
and the upper part of a head of
the artist wearing a velvet cap.
Only state. Haarlem.
 About 1638.

s 376
A beggar in a tall hat and long
cloak, with a cottage and two
figures in the background.
Only impression of the only
state. Amsterdam.
 About 1629 or earlier.

◄ B 374
Three studies of old men's heads.
Only state. Amsterdam.
 About 1630.

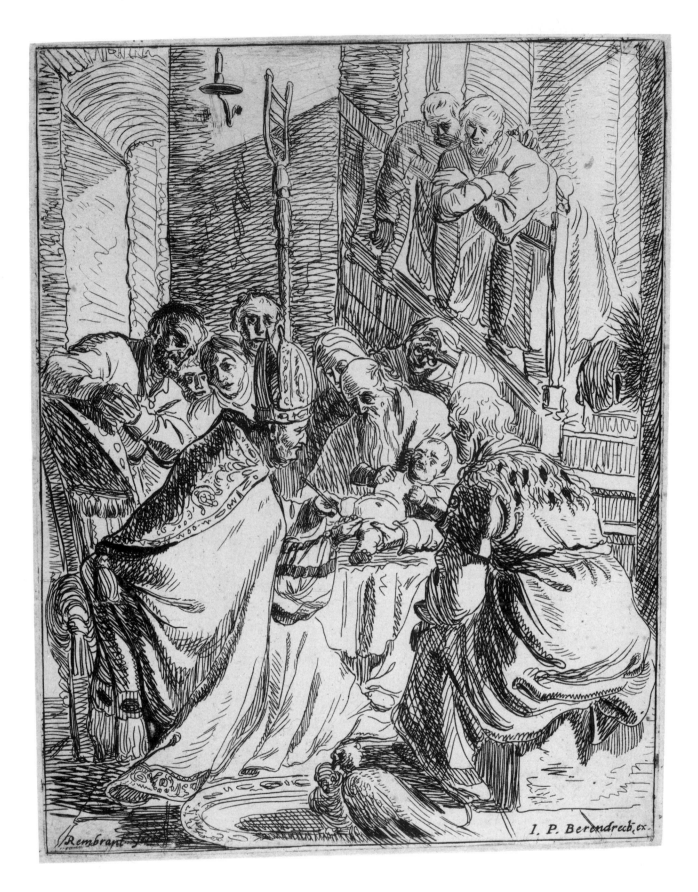

s 398
The circumcision. Second state of
two. Amsterdam.
 About 1626. Inscribed (not by
the artist) *Rembrandt fecit. I.P.
Berendrech ex*. Johannes Pietersz.
Berendrecht was a Haarlem
publisher of prints. He
apparently sold copies of this
plate, completely unchanged
from its first state except for the
addition of the inscriptions.
See comment under B 59.

s 399
Old man with snub nose. Only
impression of the only state.
London.
 About 1629.
 Reproduced from a photograph.